American & European Jewelry

1830-1914

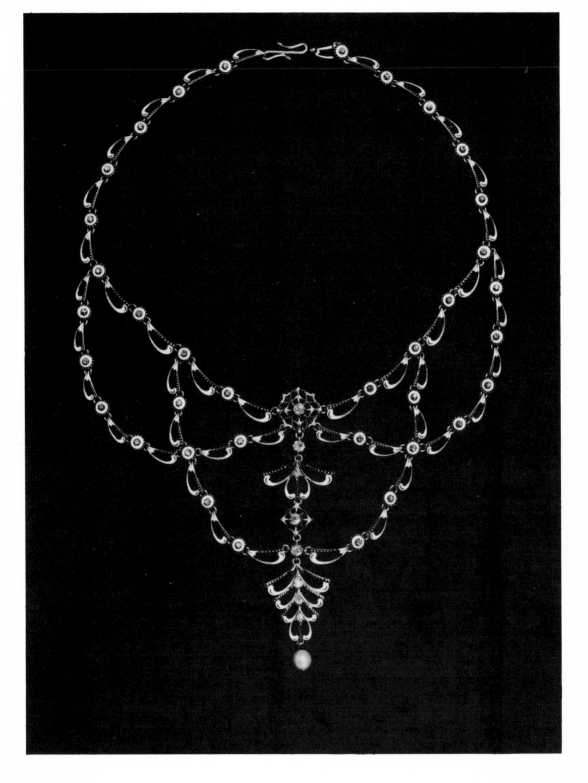

American & European Jewelry

1830-1914

Charlotte Gere

Crown Publishers, Inc. New York

Library of Congress Catalog Card No: 74–24776

ISBN: 0–517–518708

First published in the U.S.A., 1975, by Crown Publishers Inc.

*frontispiece: Festoon necklace by
Carlo Giuliano with black-and-
white enamelling, pearls and dia-
monds.*

Created by Walter Parrish International Limited, London, England

Designed by Judy A. Tuke

Printed and bound in Spain by Novograph S.A.,
and Roner S.A., Madrid
Dep. Legal: M 5838-1975

to C.E.G. and C.M.G.
in gratitude for their patience and forbearance

Contents

Author's Acknowledgements

I should like to thank the following people for their kind and patient help during the research and writing of this book, and particularly for their unfailing generosity in sharing hard-won knowledge: Michael Bell of S.J. Phillips; Cameo Corner; Malcolm Carr of Hancocks Ltd.; William Dane of the Newark Public Library; Mrs. Elaine Dee of the Cooper-Hewitt Museum of Design; James Draper of the Metropolitan Museum; Anthony Gardner of the Purple Shop; Mlle. Gary of the Musée des Arts Décoratifs; Percy Hennell of Hennell Ltd.; John Jesse; Mrs. Barbara Macklowe of the Macklowe Gallery, New York; Geoffrey Munn of Wartski's; Edward Croft Murray; Peyton Skipwith of the Fine Art Society; and Howard Vaughan.

I should also like to acknowledge the forbearance 'beyond the call of duty' of Timothy Auger and Jane Maitland Hudson of Walter Parrish International Ltd., and Mrs. Alexandra Webb, who had the unenviable tasks respectively of editing, picture-researching, and typing my manuscript.

C.G.
London, 1974

Picture Acknowledgements

Colour

For ease of reference within the book the colour illustrations have been numbered in sequence with the black-and-white. All the colour illustrations are listed below, with the names of those to whom acknowledgement is due for permission to reproduce.

6 Gold bracelets by Rundell and Bridge. Privately owned.

7 Gold mesh bracelet; English, c. 1830. Cameo Corner Ltd., London.

10 Brooch set with diamonds and emeralds; English, c. 1850. S.J. Phillips Ltd., London.

11 Enamelled gold brooches; English, c. 1840. S.J. Phillips Ltd., London.

14 Silver ring brooch set with Scottish stones; c. 1850. National Museum of Antiquities of Scotland, Edinburgh.

15 Garnet parure; English, c. 1840. Privately owned.

19 'Roman' mosaic jewellery; Italian, c. 1850. Anglesey Abbey, the National Trust.

20 Florentine intarsia parure; Italian, 1840–50. Harvey and Gore, London.

24 Mme. Moitessier, portrait by Ingres, 1856. Trustees of the National Gallery, London.

25 Miss Laing, portrait by Lord Leighton, 1854 (detail). Syndics of the Fitzwilliam Museum, Cambridge.

28 Emerald and diamond tiara; English, c. 1860. Christie, Manson and Woods, London.

29 Pencil and water-colour drawings of bracelets; J. Hardman and Co., 1860–70. Birmingham City Museums and Art Gallery.

32 Castellani 'archeological' jewellery. S.J. Phillips Ltd., London.

34 Gold brooch set with turquoises. Privately owned.

37 Tiffany silver ring set with sapphire; c. 1890. Bloom and Son Ltd., London.

39 Tiffany necklace, pendant and earrings; 1880–90. Bloom and Son Ltd., London.

42 Gold necklace and earrings decorated with cloisonné enamels; Alexis Falize, 1867. Ashmolean Museum, Oxford.

43 Bracelets and earrings in the Japanese taste; English, c. 1880. Fine Arts Society, London.

46 Etruscan-style gold necklace, bracelet and earrings; Italian, 1860–70. Birmingham City Museum and Art Gallery.

47 Gold pendant and earrings set with 'Roman' mosaic plaques; Italian, 1870–80. Armytage Clarke, London.

50 English mourning brooches and pendant. Author's family.

51 Jet necklace and pendant; English, c. 1870. Whitby Literary and Philosophical Society, Whitby, Yorkshire.

54 'Eve' pendant by Philippe Wolfers. Wolfers Collection, Brussels.

55 Mrs. Bischoffsheim, portrait by Millais. Tate Gallery, London.

59 Enamelled gold necklace, 1870–80. Fine Arts Society, London.

60 Gold pendant with preparatory designs, by John Paul Cooper, c. 1910. Birmingham City Museum and Art Gallery.

64 Mme. Adele Bloch-Bauer, portrait by Gustav Klimt, 1907. Österreichische Galerie, Vienna.

68 Liberty gold and silver jewellery, 1900–10. Fine Arts Society, London.

69 Bow brooch pendant with Montana sapphires. Johnson, Walker and Tolhurst Ltd., London.

72 Design for Lalique pendant. Calouste Gulbenkian Foundation Museum, Lisbon, Portugal.

73 Lalique enamelled gold pendant, c. 1900. Calouste Gulbenkian Foundation Museum, Lisbon, Portugal.

75 Pendant cross set with variously coloured sapphires. Crown copyright, Geological Museum, London.

76 Baltic amber pendant. Trustees of the British Museum (Natural History), London.

80 Brooch set with sapphire and rubies. Armytage Clarke, London.

82 Gold pendant set with oval carbuncle; English, c. 1870. Cameo Corner Ltd., London.

85 Gold fringe necklace by Robert Phillips, c. 1860, and enamelled gold pendant by Carlo Doria, c. 1870. Cameo Corner Ltd., London.

86 Gold 'archeological' jewellery by Giuliano, c. 1870. S.J. Phillips Ltd., London.

89 Ivory brooches and earrings; French or Swiss, c. 1850. The Purple Shop, London.

The following colour illustrations appear on the jacket, reading left to right, starting at the top.
Front: 80, 50, 163, 82.
Back: 85, 76, 34, 11, 95.

The following photographers were specially commissioned to take colour photographs for this book.
John Bethell, 19
Royston J. Dunn, 24
Gordon Roberton, A.C. Cooper Ltd., 6, 7, 10, 11, 15, 20, 32, 34, 43, 50, 59, 68, 69, 82, 86, 90, 91, 94, 101, 104, 105, 108, 155, 156, 160, 163, 170, 171, 194, 195, 199, 202.
R. Shone, 85
John Webb, 55
Charles Wolf, 109

Monochrome

Acknowledgement is due to the following for permission to reproduce black-and-white photographs.

Armytage Clarke, London, 47
Ashmolean Museum, Oxford, 142, 147
Bassano and Vandyk, London, 53, 57
Bayerische Verwaltung der staatl. Schlösser, Gärten und Seen, Munich, 4
Mrs. Bickerdike, 139
Birmingham City Museums and Art Gallery, 13, 31, 99, 115, 152, 164, 189, 190, 216
Birmingham Public Library, 148
Bloom and Son Ltd., London, 39, 83, 185
British Museum, London, Trustees of the, 62, 153, 221
Baron von Caloen Collection, 121, 184
Cameo Corner Ltd., London, 74, 79, 96, 150, 167
Chaumet, Paris, 158
Christie, Manson and Woods, London, 45, 147, 157, 173
Connaissance des Arts, Paris, 125
Cooper-Hewitt Museum of Decorative Arts and Design, Smithsonian Institution, New York, 38, 174, 188, 225
Danske Kunstindustrimuseum, Copenhagen, 143
Debenham Coe, London, 182
Ferrers Gallery, London, 12
Fine Arts Society, London, 44, 111, 131, 133, 136, 144, 183, 212, 223
Fitzwilliam Museum, Cambridge, Syndics of the, 220
Eila Graham, London, 123
Geoffrey A. Godden, 102
Geological Museum, London, Crown Copyright, 52, 127, 128, 129
Hancocks and Co. Ltd., London, 126
Hennell, Frazer and Haws Ltd., London, 22, 56, 191
Hessische Landesmuseum und Hochschulbibliothek, Darmstadt, 146, 172, 187, 192, 196, 205, 213
Horniman Museum, Forest Hill, London, 114
Johnson Walker and Tolhurst Ltd., London, 16
Museum of London Board of Governors, 88, 113
Macklowe Gallery, New York, 18, 66, 67, 70, 124, 186, 198
Metropolitan Museum of Art, New York:
 Whittelsea Fund (1953), 5
 Whittelsea Fund (1957), 209
 Whittelsea Fund (1959), 222
 Whittelsea Fund (1961), 35, 36
 Bequest of Mary Kellog Hopkins (1945), 71
 Milton Weil Collection, Gift of Mrs. Ethel Weil Worgelt (1940), 116, 117, 118, 215
 Gift of Mrs. Robert E. Rose (1967), 119
 Gift of Emily Crane Chadbourne (1952), 201
 Gift of Ronald S. Kane (1967), 224
Musée des Arts Décoratifs, Paris, 58, 81, 93, 134, 177, 178, 226
National Museum of Antiquities of Scotland, Edinburgh, 78
National Museum of Wales, Cardiff, 210
Newark Public Library, Newark, New Jersey, 65, 161
New York Public Library, 145
Nottingham Castle Museum, 49, 97
Private owners, 40, 41, 63, 84, 87, 106
Public Record Office, London (BT50/380, design number 352623), 135
Purple Shop, London, 219
S.J. Phillips Ltd., London, 1
Royal Society of Painters in Water-colour, London, Trustees of the, 122
Royal Academy of Arts, London, from Österreichisches Museum für angewandte Kunst, Vienna, 166, 193
Royal Institute of British Architects, London, 21
Staatliche Museen, Preussischer Kulturbesitz Kunstgewerbemuseum, Berlin, 162, 175
Stichting Historische Verzamelingen van het Huis Orange – Nassau, 3
Smithsonian Institution, Washington D.C., 48, 107
Sotheby's Belgravia, London, 8, 92, 110, 227
Tate Gallery, London, 17
Tessiers Ltd., London, 23
Twining Collection, the Worshipful Company of Goldsmiths, London, 27, 141
Howard Vaughan Ltd., Eastbourne, 103
Victoria and Albert Museum, London, 30, 120, 151, 200, 203, 211
Victoria and Albert Museum, London (Crown Copyright), 9, 21, 26, 61, 77, 98, 130, 140, 149, 169, 176, 179, 180, 218, 228
Vieyra and Co., London, 154
Wartski Ltd., London, 137
H.S. Welby Ltd., London, 112
Wernher Collection, Luton Hoo, Bedfordshire, 2
Whitby Literary and Philosophical Society, Whitby, Yorkshire, 51

The following photographers were specially commissioned to take black-and-white photographs for this book.
Royston J. Dunn, 30, 113, 151, 201, 203
John Freeman, 63, 84, 87, 120
Percy Hennell, 22, 56, 191
Gordon Roberton, A.C. Cooper Ltd., 1, 16, 33, 40, 41, 44, 96, 106, 111, 131, 132, 133, 136, 138, 139, 144, 167, 168, 181, 183, 211, 223

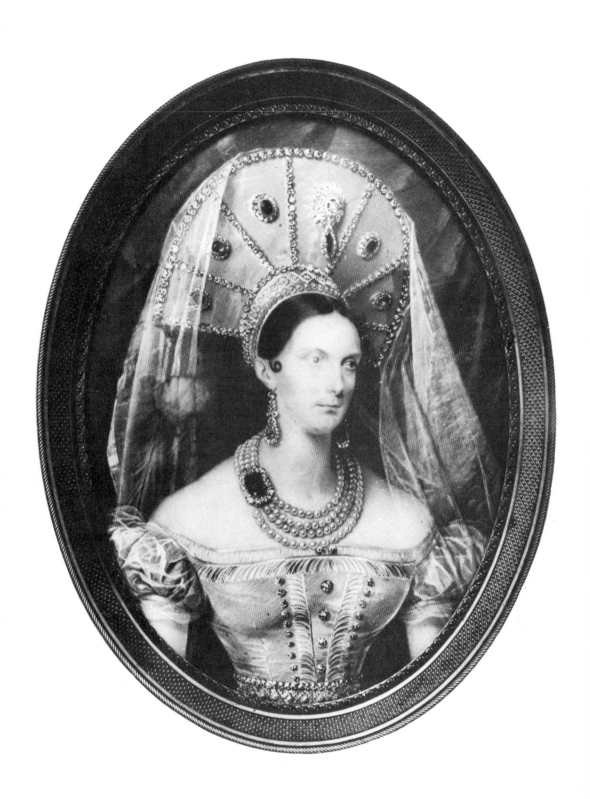

PART 1

Fashions and Styles

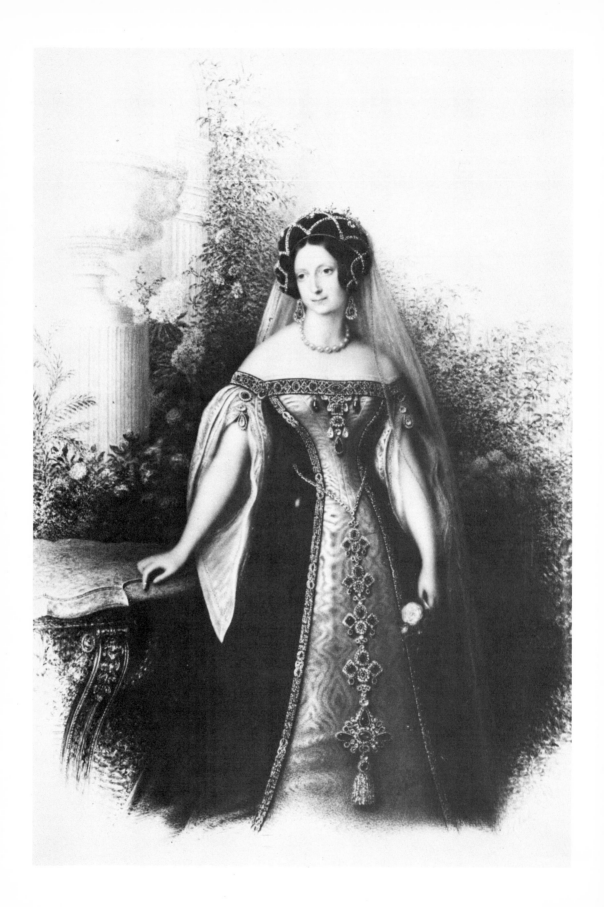

1830-1850

In the year 1830 William IV succeeded to the throne of England and Louis-Philippe was elected King of the French; their modes of accession were different, but in fact the life-styles of the two kings were surprisingly similar; both were conditioned by experience and force of circumstance to behave without pretension, and dedicated to erasing from their peoples' minds the extravagant or otherwise unsatisfactory behaviour of their predecessors. William was anxious to dispense with the coronation ceremony, previously used as an excuse for lavish expenditure on jewellery, regalia, and ceremonial clothing, although he was persuaded to go through with a very modified version of it using the least possible new regalia and dispensing with the costly Coronation Banquet. Louis-Philippe contented himself with a procession and a simple ceremony of investiture; during the whole of his reign a great number of the French crown jewels, which had been re-assembled and remounted by Charles X during his own brief reign, lay untouched in their cases in the Royal Treasury, only to be disinterred by Napoléon III after his marriage to Eugénie de Montijo in 1853.

It was natural that the most valuable stones should have been re-used, and circumstances at the end of the eighteenth century made it inevitable. As a result of the French Revolution a vast amount of diamond jewellery belonging to the aristocratic families of France was sold, much of it in England, where shrewd men like Philip Rundell, of Rundell and Bridge, and Mr. Jefferies of Cockspur Street, managed to obtain stones at very advantageous prices. The re-establishment of a court in France by Napoléon I had brought an enormous demand for stones, and every available piece of diamond jewellery was broken up and reset in the newly fashionable neo-classical style. The collapse of the Empire and the restoration of the monarchy brought another change in fashion, and the result was further alteration of all jewellery set with precious stones.

The process was to continue throughout the nineteenth century. Only one or two French royal pieces believed to be absolutely authentic survive from the *Restauration* period, between the First and Second Empires; one or two more pieces reputedly the property of members of the Bonaparte

2 overleaf: Czarina Marie Feodorovna; this miniature by Ivan Winberg, dated 1830, shows the Czarina wearing the traditional heavily jewelled kokoshnik *head-dress.*

3 opposite: The sister of Czar Alexander II, Queen Anna Pavlovna of the Netherlands, painted in Russian dress in 1846; the extravagant taste still displayed by some European royalty is apparent here.

family still exist, but the jewellery belonging to the Empress Eugénie that was left in France after the collapse of the Second Empire was sold by order of the Ministère des Finances in 1887, and the pieces which were smuggled out to England in the luggage of the Princesse de Metternich were sold over the years by the Empress herself.

Not all European royal families had been sufficiently unnerved by the French Revolution to dispense with lavish jewellery. Between 1830 and 1832 a number of stones from the famous Wittelsbach Treasury ruby collection were reset by Kaspar Rielander, the Munich jeweller, into a parure consisting of a tiara, necklace, bracelets and brooches for Theresa, wife of Louis I of Bavaria. Rielander also made for her an elaborate tiara of fine diamonds, which was sold, with a number of other Wittelsbach pieces, at Christie's in 1931.

4 Parure in rubies and diamonds made in Munich by Kaspar Rielander in 1830 for Queen Theresa of Bavaria.

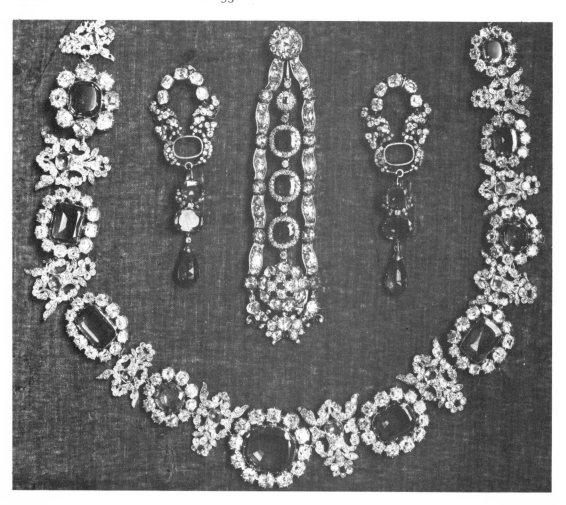

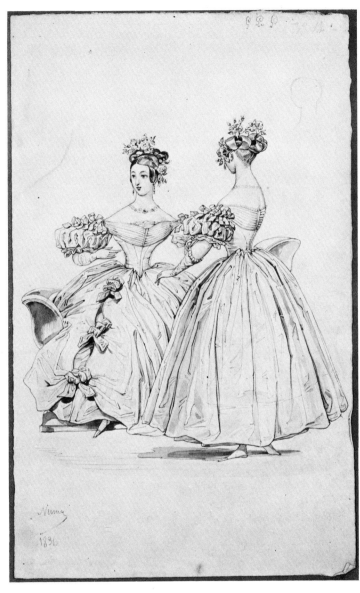

5 French fashion plate drawn by
Pierre Numa in 1836, showing hair
ornaments typical of the 'Romantic'
period.

On the whole, extreme modesty in personal ornament
became the fashion at this period. Portraits of both Queen
Adelaide of England and Queen Marie-Amélie of France
show them wearing either gold jewellery of great simplicity
such as a *sautoir* (a long chain or bead necklace usually
looped up and secured at the waist-band with a pin or
brooch) and a watch-châtelaine, or no jewellery at all; in
this they were followed by many of their subjects, partic-
ularly the Orleanist supporters in France who rejected the
vulgar, profuse display of precious stones which had

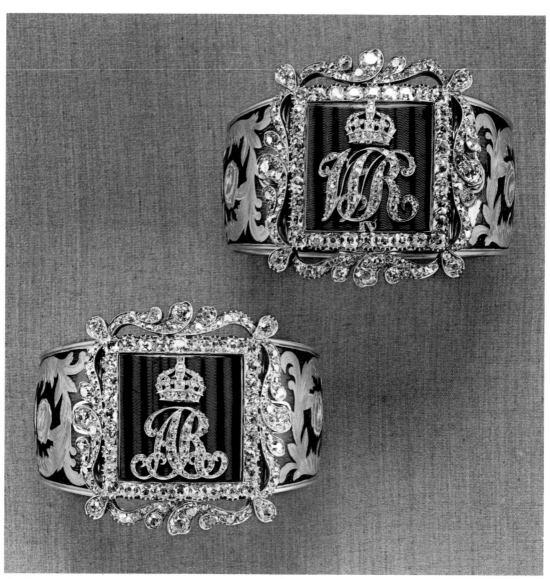

6 *Pair of bracelets in gold decorated with engraving and translucent enamels, the clasps of gold set with diamonds on* tour à guillocher *enamelling; made by Rundell and Bridge, 1830. The ciphers are those of King William IV and Queen Adelaide; the bracelets were given to Mrs. Fitzherbert by the King at the time of his accession to the throne.*

characterised the social gatherings at the court of Napoléon. Marie-Amélie generally wore no jewellery in public. This would have been a startling departure even for the wife of a moderately well-to-do landowner let alone the wife of a reigning king; it was moreover from discretion rather than necessity as she was found, at her death, to have owned seventeen complete parures, many of precious stones.

As with the sporadic attempts in the eighteenth century to regulate the extravagance of the court and the aristocracy by banning or discouraging the use of diamonds, the necessity to make the most of modest materials stimulated

invention in the jewellery trade. French gold jewellery of the period between 1830 and 1848 is usually very light in weight, being made up either of stamped and chased plaques united by delicate chain, or of filigree in elaborate coils and gold mesh both of which gave an air of substance to the smallest actual amount of metal. These jewels were often set with small, coloured stones of little value and decorated with translucent enamel in jewel-like colours, and were often quite large in size. Very long earrings and wide bracelets, fashionable at this time, were perfectly practicable in these materials as they were not unbearably heavy.

Both Louis-Philippe and, to an even greater extent, William IV have been largely ignored in the nomenclature applied by the historians to styles in the decorative arts. Only the use of 'Regency' and 'Victorian' is really recognised for English styles in the nineteenth century, and the style of Louis-Philippe is usually lumped together with its predecessors in the blanket term, '*Restauration*'. This is hardly fair to a period of considerable innovation, when a style quite distinct from the classicising styles of around 1800 was evolved and which furthermore does not simply anticipate the rococo and neo-Gothic decorative vocabulary of the early Victorian period, or the over-rich reinterpretation of the *style Marie-Antoinette* which was fashionable during the

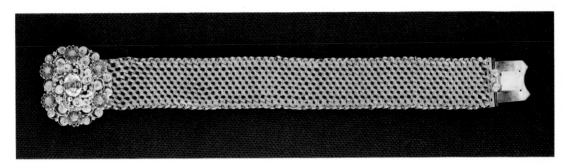

Second Empire (1850–1870). The period is sometimes referred to as the 'Romantic' period, which does suit the light-hearted, rather eighteenth-century use of exaggerated Gothic motifs and the very accurately observed botanical forms, which were used to make delicate flower or ivy-leaf brooches and necklaces. The Viennese excelled at making a type of very light botanical jewellery from textured and engraved gold, and by 1840 this had become very fashionable in Paris. Some of the Viennese and French pieces in this style are quite large. They were used quite impartially as brooches or hair ornaments as an extravagant substitute for the real

7 Bracelet of gold mesh and filigree decorated with gold beads, the clasp set with a topaz and turquoises; English, c. 1830.

flowers almost universally worn, in the evening as a corsage or in the hair, throughout the nineteenth century. English copies, or versions, of this type of work dating from the same period and slightly later are usually much smaller with the flowers often made of tinted ivory or pale coral and enriched with small coloured stones, either coral or turquoise being the most frequently used.

The cult of the classical remains of Rome, Pompeii and Herculaneum continued long after the severities of the true neo-classical style had been supplanted by the more exuberant Romantic style. Cameos, which, since about 1800, had been absolutely essential adjuncts to the costume of any woman with pretentions to a fashionable appearance, remained popular up to 1850 and for at least a further twenty years; but the latest fashion to originate in Italy was for mosaic jewellery. This was made from the little mosaic ornaments showing views of the Roman ruins or copies of motifs from the frescoes at Herculaneum and Pompeii which had been uncovered comparatively recently. These, with the similar intarsia ornaments from Florence which became popular a little later, were to remain in fashion for over thirty years. They were first widely worn in the 1820s and were still being imported into the United States with other 'fashionable' trinkets in the 1850s and 1860s.

With the accession of Queen Victoria in England some of the excessive caution of the late King was abandoned, and a more elaborate coronation ceremony was planned, which involved the resetting and remaking of some of the British crown jewels. A coronation banquet was planned in the form of a mediaeval tournament, for which mediaeval dress would have been worn; this was possibly inspired by the *Quadrille Marie Stuart* organised by the Duchesse de Berri in 1829, the first manifestation of the mania for Gothic accessories and ornaments which were to be fashionable all over Europe until the middle of the century. The Eglinton Tournament, which took place two years later, probably realised the plans for the coronation banquet with some fidelity, and also confirmed the fears of the Queen and her advisors by being immensely expensive. However, the Queen's wish to organise a mediaeval entertainment was eventually fulfilled in 1842 with the 'Spitalfields Ball', held with the admirable intention of benefiting the semi-moribund Spitalfields silk-weaving industry, for which all the guests were required to wear Plantagenet costume. Contemporary reports and pictures reveal the small extent to which actual Gothic ornaments were used as models for the jewellery. French experiments with the *style cathédrale*, a

8 An example of English botanical jewellery: a naturalistic brooch in the form of a convolvulus spray in gold and ivory; c. 1840.

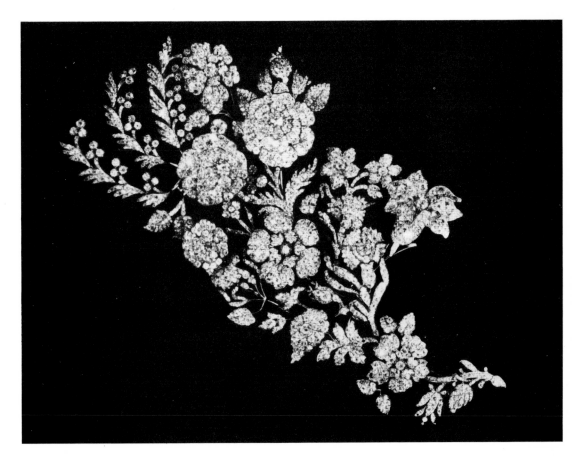

9 *Flower spray in diamonds;* c. *1850.*

very sculptural style based largely on details of mediaeval church architecture, were only just beginning (1839), and the Gothic marriage jewellery designed by Pugin, which was to provide the model for the English mediaeval style, was not yet made. Most of the jewellery worn at the palace was in the form of lavish pearl and diamond ornaments with a few concessions to historical costume in the shape of elaborate châtelaines and rosaries.

Despite the changes in fashion and the great technical advances which took place throughout the nineteenth century, the design of most diamond jewellery remained much as it had been towards the end of the previous century. The extensive experiments with form and techniques of cutting and setting in diamond jewellery had preoccupied the eighteenth-century jeweller almost to the point of excluding development in other materials like gold. So there was established a type of 'perfect' diamond jewel which was copied and re-copied throughout at least three-quarters of the nineteenth century. It is very hard to date the most

extensively used forms, the bouquet or flower spray, the star, the bow, or the girandole (the last is the least used in this period) with any real accuracy.

In the year of the young Queen's accession (1837), her grandmother's diamonds were finally sold by Rundell and Bridge, in an attempt to liquidate some of the debts incurred by George IV. But in spite of the dispersal of these valuable stones, which included the diamonds given to Queen Charlotte by the Nawab of Arcot, and the surrender after years of wrangling of the crown jewels claimed by the King of Hanover (the throne of Hanover had passed to one of the Queen's uncles, Ernest, Duke of Cumberland, in 1837, since it could not descend through the female line), the jewels owned by the Queen, both in the form of crown jewels and her own private property, added up over the years to a very magnificent collection. It included the jewellery from the East India Company's exhibit at the Great Exhibition; this the company presented to her in 1851.

Queen Victoria was not in any sense a leader of fashion. She did not even acquire a crinoline until her visit to Paris in 1855, and although she was relieved to think she had

10 Naturalistic acorn-spray brooch in diamonds and emeralds; English, c. 1850.

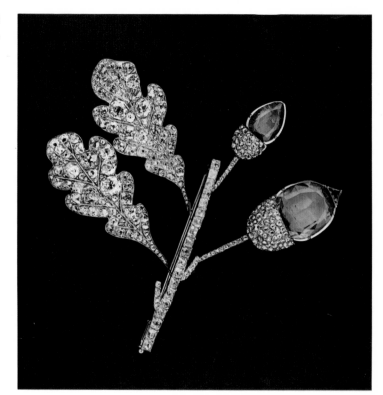

presented a sufficiently fashionable appearance to stand comparison with the intensely *soignée* figure of her hostess, the French themselves thought her clothes, and particularly her accessories, very dowdy. But her taste in jewellery had a considerable effect on the taste of her contemporaries, in England if not in America at this period, and her passion for tartan, copied by the intensely Anglophile French Imperial family, became for a brief time the height of fashion in France. The Queen's known preference for jewellery with sentimental associations made portrait miniatures, set to wear as brooches, pendants or bracelet clasps, very popular, and the great extent to which English widows wore commemorative jewellery in preference to any other ornament was certainly due to her example in mourning the Prince Consort so single-mindedly.

A passage in her will lists some of the presents of jewellery given to her by Prince Albert during their marriage, beginning with her wedding present, a brooch made of a large sapphire surrounded by diamonds, and also a suite of jewellery, consisting of a necklace, two brooches and a pair of earrings of opals and diamonds, which was designed by the Prince himself. (The Prince's passion for opals was

11 Pair of brooches in gold, decorated with translucent enamels over engraving and set with diamonds and rubies in the form of bouquets of flowers and leaves. These are typical of conventional jewellery of the period; English (?), c. 1840.

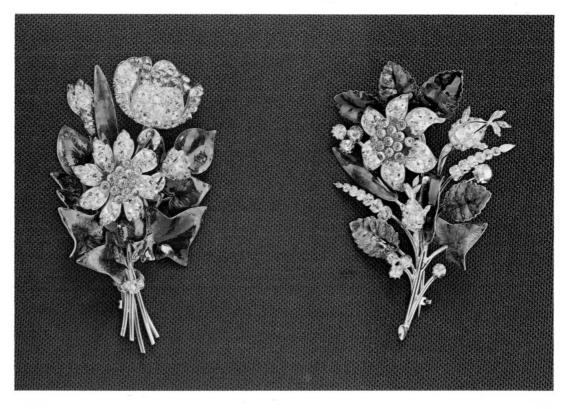

12 Portrait sketch of Queen Victoria by Winterhalter, showing the Queen's conventional taste.

not shared by his successors. The opals were all replaced with rubies, those of the main part of the set in 1902 and the remainder in 1920.) The seven other pieces on the list were as follows: a bracelet set with a portrait miniature of Prince Albert by William Essex given to the Queen at Christmas in 1844; a bracelet of gold and blue enamel set with portraits of the Queen's elder children (24 May 1845); a similar bracelet set with portraits of the younger sons (26 August 1856); a shawl pin in silver and carbuncles, an exact replica of an ancient Irish brooch in the library of Trinity College, Dublin (Christmas, 1849)—a similar piece is illustrated [14]; a cairngorm picked up by the Prince Consort at Loch-na-Gar, 27 September 1848, set in a ring-pattern Celtic style brooch with garnets and pearls in blue and white enamel flowers (21 November 1848, probably a more elaborate version of the Celtic

brooch illustrated [14]; a brooch made of diamonds, rubies and sapphires, in the form of the French and English colours with a Turkish crescent, bound by a Crimean ribbon (Christmas 1858); and lastly, a brooch in the form of Prince of Wales's feathers in white enamel, with a coronet of gold set with small pearls, and banded with a motto on a blue enamelled riband (10 February 1842).

The two most valuable of these presents, the sapphire brooch and the opal set, were left by the Queen to the Crown. Unlike the magnificent jewels, the remaining pieces, which were left to members of the family, are surprisingly modest for a royal person; they differ hardly at all from the kind of things that any reasonably prosperous nineteenth-century husband would have expected to give to his wife, and would certainly not have satisfied the more lavish ambitions of the Veneerings or Mr. Merdle. It was still customary at this period, when financial circumstances permitted, to present a bride with a *corbeille de mariage*, a jewel-casket containing some, at least, of the jewellery which her social obligations would make it necessary for her to wear. Perhaps this would include the basis, in the form of a brooch and a pair of earrings, of an elaborate parure, which would be added to on suitable occasions. It might eventually consist of a tiara and a jewelled comb-mount, a necklace with a detachable pendant and matching earrings, one or more brooches, and a pair of bracelets. The idea of the parure, or large matching set of jewellery, originated in the early eighteenth century, but the design of each piece in these early sets was not nearly so carefully matched as in the later sets, the only uniting factor in some cases being the use of, predominantly, one or two kinds of stone. In the nineteenth century the parure became increasingly rationalised with exact replicas of the motifs being repeated in each piece, a manifestation of modern taste which was deplored by Mrs. Haweis in *The Art of Beauty* (published in 1878), and which she blamed on the increased use of machinery in the jewellery trade. Mary Russell Mitford, writing to a friend in 1806, describes a parure of amethysts consisting of a necklace, bandeau, tiara, cestus (girdle), armlets, bracelets, brooches and shoe-knots. To judge from portraits of this date the set described here would not have matched in every detail, unlike the garnet set which dates from 1830–40, or the Florentine *pietra dura* set [20] probably made in about 1850.

As well as a set of jewellery designed to be worn on formal occasions the mid-Victorian lady would almost certainly have owned a number of very plain gold pieces which were

13 *Drawing of John Ruskin's wife Effie by Millais. She was later to become Lady Millais. Compare the eccentric naturalistic ornaments in the design of the tiara, the heavy necklace and shell-shaped earrings, and the armlets in the form of serpents, with the Queen's more traditional jewellery.*

worn during the day; matching brooches and earrings; pairs of bracelets—these were very fashionable in the 1830s and were often the only jewellery worn in the daytime; a number of fine gold chains of varying length, some of which had a practical purpose in holding eyeglasses, fans or muffs; and a châtelaine, worn suspended from the waistband, which could carry a watch and various other small useful articles such as a notebook and pencil, a vinaigrette or a pair of tiny scissors. An enormous polished steel châtelaine with long chains from which every manner of useful object is suspended was made by a Mr. Durham, a Sheffield cutler, and exhibited in the Great Exhibition in 1851, but it would already have been rather an anachronism at this date, as châtelaines went out of fashion in the forties, and were only revived with the taste for Renaissance ornament in the 1880s.

14 Engraved silver ring brooch, in the Celtic style, set with Scottish stones; c. 1850.

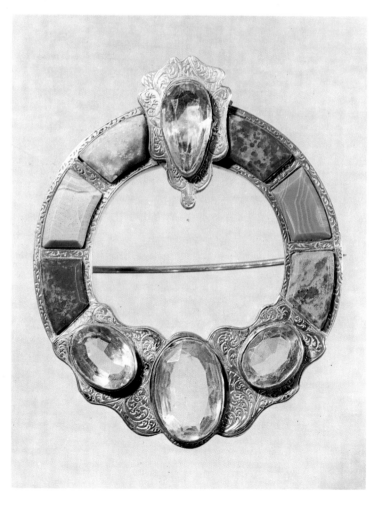

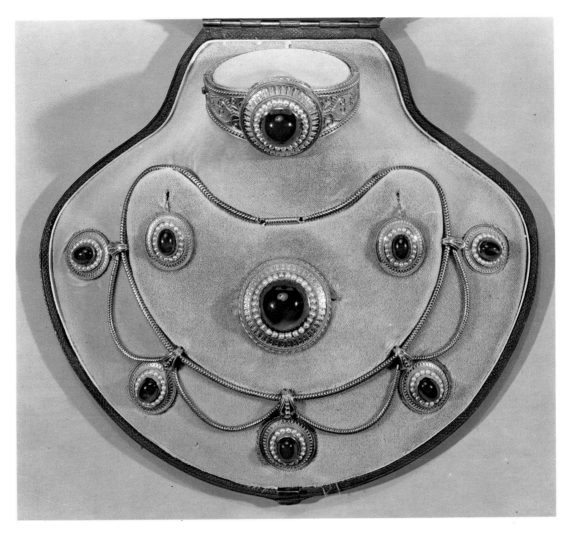

In addition to the simple gold jewellery worn during the day many women also owned souvenirs of travels in the form of mosaic-set jewellery from Rome, tiny enamelled pictures of famous views from Switzerland, and agate- and granite-set pieces from Scotland. Portrait miniatures of members of the family set as jewellery were widely worn, and these would be joined over the years by melancholy reminders of the passage of time in the form of mourning jewellery (see p. 56), of which every family seems to have retained at least one or two pieces. By 1830 men had almost entirely abandoned the wearing of any very elaborate jewellery and would probably only have, in addition to the necessary gold watch, a signet ring, a scarf- or tie-pin and a couple of fobs. Children were expected to begin

15 Parure consisting of a necklace, a brooch, a pair of earrings and a bracelet; pinchbeck set with pearls and carbuncles; English c. 1840. The set shows signs of having been assembled over a period of time.

16 *Swiss enamelled brooch and earrings, probably bought as souvenirs, showing local landscapes.*

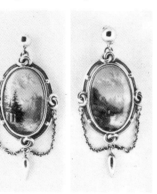

wearing jewellery at a relatively early age; the girl in *The First Earring*, painted by David Wilkie in 1834, appears to be about eight or nine. She is already wearing a gold bracelet and will soon have on quite substantial gold earrings, but children's jewellery was mostly very simple throughout the nineteenth century and was virtually unworn after 1900.

Queen Victoria's influence did not at this time extend greatly to America, where comparatively little jewellery was worn before the mid-nineteenth century. Until the American Revolution, English taste had been the dominant influence, but then for obvious reasons patriotism led many ladies to look elsewhere for their ideas—to France in particular.

At this period (i.e. during the 1830s and 1840s) the jewellery trade in the United States consisted, as in the eighteenth century, mainly of the manufacture by local silversmiths of small personal ornaments with some func-

17 The First Earring *by David Wilkie (1834).*

tional purpose, like buttons, clasps and buckles. This was supplemented by imports from Europe, good-quality jewellery from Paris, delicate gold costume accessories from Vienna, and inexpensive low-carat gold or pinchbeck jewellery from Birmingham in England and Hanau in Germany. Some of these imported pieces were only partly finished, and were mounted or supplied with chains or catches, and sometimes marked, in the United States.

Even in the early 1800s American women were, by European standards, very modestly adorned, and most of the jewellery they wore was imported. A number of American firms were established in principal cities, but few relied solely on jewellery sales for their income. The portrait painted by Henry Inman of Angelica van Buren (daughter-in-law of the eighth President) in 1842 (and still in the White House) is unusual in that the sitter's dress is much in the style of the young Queen Victoria—she had recently attended the Queen's coronation. But generally at this

18 American gold jewellery: earrings and bracelet, 1840–50.

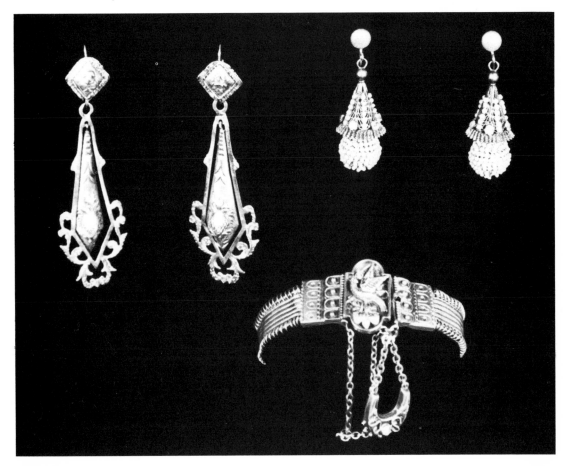

date Americans admired Parisian taste much more than English. Charles Lewis Tiffany was importing Parisian jewellery from 1841, but only concentrated on jewellery manufacture after 1850.

Contrary to popular belief jewellery was very expensive during almost the whole of the period covered by this book. It was not until the 1870s that mass-production of jewellery in Birmingham began to make any real impression on the English jewellery trade, and even at this date only the most

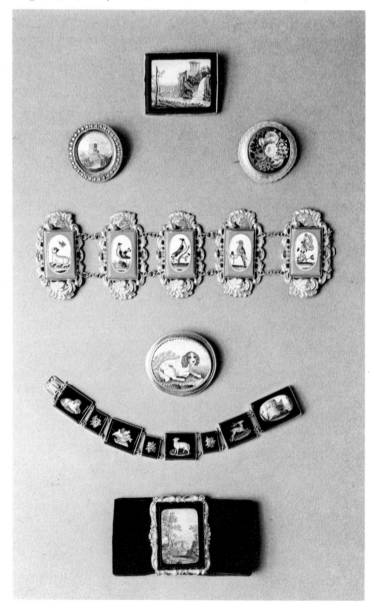

19 Many mid-Victorian ladies owned souvenirs of their travels, such as these brooches, bracelets, and a bracelet clasp in gold set with panels of 'Roman' mosaic; Italian, c. 1850.

20 opposite: Parure consisting of necklace, pendant, earrings, brooch, bracelet and studs, in gold decorated with filigree and set with panels of Florentine intarsia (pietra dura) work; Italian, 1840–50.

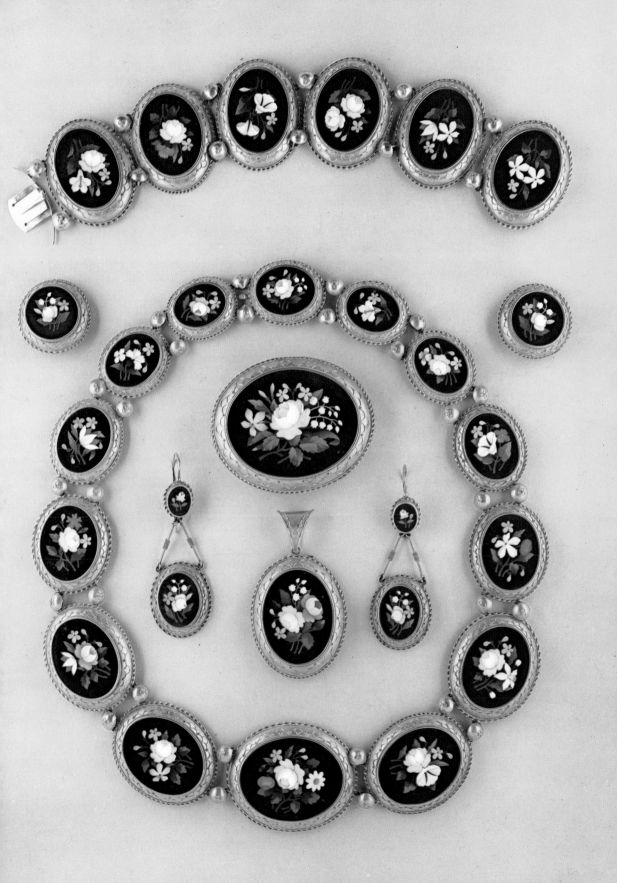

21 *This portrait of Queen Victoria was painted on the occasion of the first birthday of Arthur, Duke of Connaught; in the background Prince Albert considers the plans for the Great Exhibition. The Queen is wearing a version of the popular* tiara russe.

22 *A design for a* tiara russe, *a shape originating in the Russian court based on the traditional* koko-shnik, *from the nineteenth century design books of Hennell Limited, now Hennell, Frazer and Haws.*

insignificant, cheap and trifling pieces were produced entirely by machine. The kind of jewellery that was worn in the evening by ladies of the Court or at fashionable social gatherings was still made entirely by hand of precious materials whose cost, in real terms, would seem surprisingly high even today. It was only at the turn of the century that pieces of some merit, both technically and from the point of view of the materials employed, began to be produced very cheaply and in considerable quantities.

The widespread use of machinery in the manufacture of jewellery was to reduce the contribution of the individual designer or craftsman to a point where it became too insignificant to be recorded or used as a selling device by the retailer. One of the ways in which the period from about 1830 onwards differs so completely from the eighteenth century is in the cult of the individual designer, a revival of the Renaissance practice which was very appropriate to the introduction of the neo-Renaissance style into jewellery design which occurred at about this date (1830–40) and was to remain a chief source of inspiration for jewellery in the continuously popular historical revival manner until the late 1880s and 1890s. The cult of the individual was probably begun, or at least stimulated, by the many exhibitions which were mounted during the nineteenth century in an effort to improve standards in industrial design and to increase trade. From 1839 onwards trade exhibitions were held in Paris in a large *Palais de l'Industrie* at the Champ de Mars. It was the eleventh, and last, of these exhibitions which inspired the first, and probably the most famous, of the great International Exhibitions which occurred in Britain at regular intervals throughout the period, the Great Exhibition of 1851.

23 A tiara russe *shown here as it could be worn, as a necklace. An example of expensive diamond jewellery of the mid-nineteenth century.*

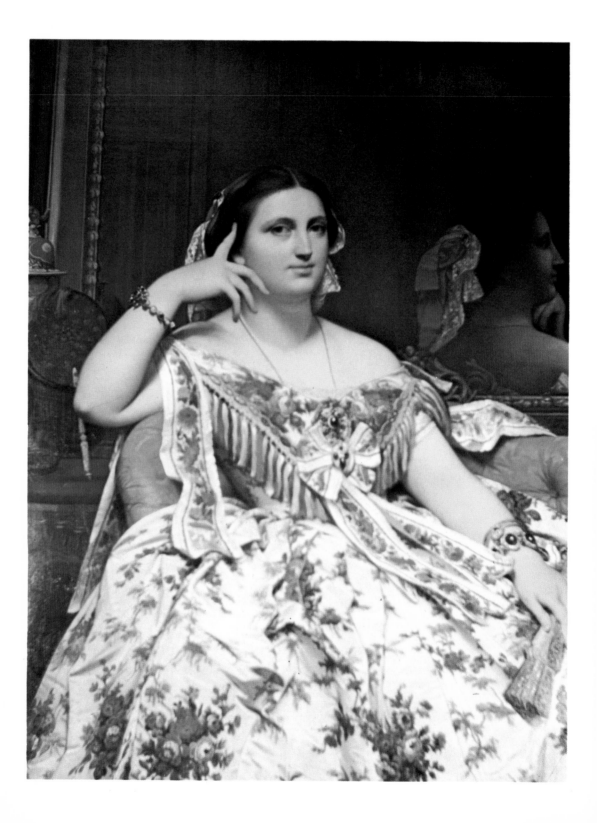

1851-1875

The mid-Victorian period might well be called the Age of Exhibitions, so much did the movement of fashion depend on what appeared at the many exhibitions which took place from the Great Exhibition of 1851 onwards. In the illustrated catalogues we have an extensive and unusually complete record of the work of nearly all the jewellery firms with any claim to importance throughout Europe and the United States, the sort of record of designers and makers that otherwise only exists in the inventories of royal or aristocratic collections, with the additional bonus of large numbers of illustrations of reasonable accuracy [26]. Fashions in inexpensive jewellery can be dated with some accuracy to the dates of publication of these illustrated catalogues which were widely used for the same purpose as the pattern books of engraved designs which circulated in the eighteenth century.

The first main exhibition to take place after 1851 was the Dublin International Exhibition of 1853. This was followed two years later by the first French international exhibition, the Exposition Universelle in Paris in 1855. The holding of three exhibitions in such quick succession led to a certain amount of duplication of the exhibits; Queen Victoria recorded in her diary when she visited the Paris exhibition that she recognised things she had already seen in London and in Dublin. In 1862 the second English International Exhibition took place after a delay of a year caused by the death of the Prince Consort. Here the Roman jewellers, the brothers Castellani, exhibited for the first time and were widely acclaimed; and, even more important from the point of view of decorative art in Europe, the prints and ceramics of Japan were put on show, confirming the interest which had been growing ever since the first Japanese objects had reached Paris a few years before. Three years later, in 1865, a second Dublin International Exhibition was staged, followed as in the previous decade by another Exposition Universelle in Paris in 1867, at which the English 'archaeological' jewellery was much admired, and the beautiful Japanese-style *cloisonné* jewellery made by Alexis Falize was shown [42].

Alongside these hitherto relatively unexplored avenues of design the magnificent display of the remounted *diamantes*

24 opposite: A portrait of Mme. Moitessier by J. A. D. Ingres (1856), showing French jewellery of the type worn in the mid-nineteenth century.

25 Detail from a portrait of Miss Laing by Lord Leighton (1854), showing the type of wide gold bracelet fashionable at that date.

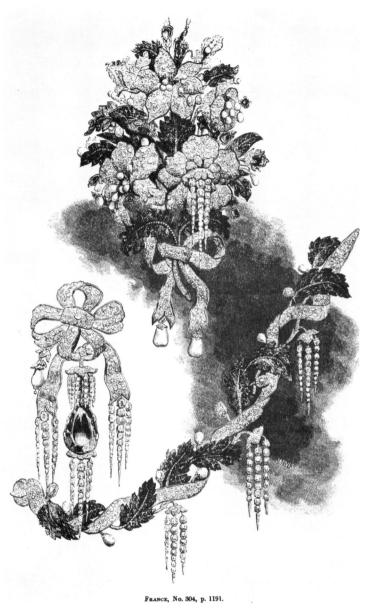

FRANCE, No. 304, p. 1191.
BOUQUET, COMPOSED OF BRILLIANTS AND PEARLS, AND OTHER JEWELS. LEMONNIER, *Paris*.
THE PROPERTY OF HER MAJESTY THE QUEEN OF SPAIN.

26 Bouquets of brilliants, pearls and other jewels designed by Lemonnier for the Queen of Spain, as illustrated in the Official Catalogue *of the 1851 Great Exhibition in London.*

de la Couronne, the crown jewels of France, reassembled and lavishly reset for the Empress Eugénie by order of Napoléon III, must have appeared rather conventional. They were largely designed in the 'revived' eighteenth-century taste, the *style Marie-Antoinette*; while this style was possibly not the height of fashion during the first half of the nineteenth century, it was continuously used for this kind of grand

precious jewellery from the 1780s until at least the early years of the present century. The task of remaking all the jewellery for the Empress was so great that no less than eight firms were employed as *joailliers de la Couronne* during the Second Empire. They were Maison Bapst, Lemmonier [27], Kramer, Mellerio, Baugrand (a firm much favoured by the Empress, which was acquired by Ernest Vever on the death of the owner in 1870) [225], Ouzille-Lemoine, Viette, and Fester. The large number of these jewels which remained in Paris after the fall of the Empire in 1870 were appropriated by the government and finally sold by order of the Ministère des Finances in 1887. The illustrated catalogue of the sale provides a valuable insight into the appearance of the type of jewellery considered suitable for the fashionable *grande tenue* in the second half of the nineteenth century.

Four South Kensington International Exhibitions followed, in 1871, 1872, 1873 and 1874. Serious critical interest in them had by this date visibly diminished with the increasingly commercial nature of what was shown, and the effect on current taste was less marked. The catalogues remain, however, good indicators of stylistic trends, the preponderance of neo-Renaissance and 'Egyptian'-style jewels reflecting their popularity with the general public. In 1872 Howell and James, a large commercial firm which sold jewellery among other things, showed jewellery in the Renaissance manner designed by Matthew Digby-Wyatt and Charles Eastlake. The latter was also the author of *Hints on Household Taste* and other books on decoration highly influential in America, which actually inspired a whole range of furniture designs in the 'Eastlake' style. T. and J. Bragg of Birmingham showed 'Egyptian' jewellery designed by the Birmingham painter, Walter Langley, in the same year.

In 1873 a Universal Exhibition was held in Vienna, and in 1876 the first International Exhibition was held in America, the Philadelphia Centennial Exposition. This is widely regarded as a crucial date for the decorative art movement in America, when dependence on European ideas and inspiration began to diminish, and a sense of a separate American cultural identity began to emerge. In 1878 yet another Exposition Universelle took place in Paris, which established the reputations of a number of designers who were to dominate the jewellery scene in Paris during the last quarter of the century, among them Lucien Falize, Jules Debût (for Boucheron) and Eugène Fontenay. After this none of the exhibitions attracted any serious critical

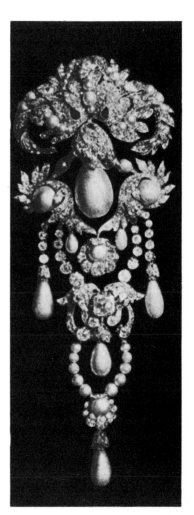

27 Brooch made by Lemmonier for the marriage of the Empress Eugénie. The largest pearl known as 'La Régente' came from the French crown jewels.

attention for many years. Reports completely lack the excitement of the earlier years, until the turn of the century when the 1900 Exposition in Paris, through the startling nature of the Art Nouveau objects on show, attracted the attention of the press throughout the world

The Great Exhibition of 1851 had afforded craftsmen and manufacturers of nearly all the countries of Europe, and the small contingent from the United States of America (who were actually showing no jewellery), the opportunity to make comparisons and take stock of achievements. In many cases this opportunity was to be the occasion of some unpleasant surprises. The English at least were forced to recognise the superiority of the French taste, though they could regard with some complacency the inferior workmanship of their rivals.

The cumulative effect of the jewellery displayed at the exhibition must have been magnificent. Some of the more lavish separate collections were individually of great value (even if this was exaggerated in many cases), and the value of the whole display must have been enormous. Although many of the styles shown were not absolutely new, in that they had first been used some years before, they were certainly new to many of the visitors who flocked to the Crystal Palace. Both neo-Renaissance and Gothic-style jewellery had been made in France since the very end of the 1830s, and Pugin's celebrated marriage jewellery [218] had been designed in 1846 and made in 1847; but the Exhibition (at which Pugin's jewellery was shown) afforded the first opportunity for many people of seeing these historical revival styles actually in use. It is significant that the fashion in England for Gothic and mediaeval-style jewellery, in spite

28 Emerald and diamond tiara which can be converted into a necklace, or separated to form brooches; English, c. 1860.

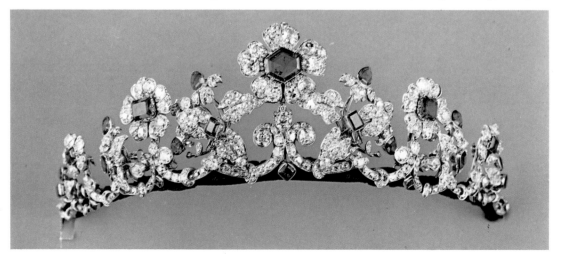

29 Drawings in pencil and water-
colour of medieval-style bracelets
from the stockbooks of J. Hardman
and Co.; 1860–70.

of mediaevalising social occasions like the Eglinton tourna-
ment and the Spitalfields Ball, dates from the mid-1850s
and not from the time ten years earlier when they were first
fashionable in France.

The same is true of the 'archaeological' jewels first shown
by the Castellanis in 1862; although F. P. Castellani claimed
to have been making copies of antique jewellery [32] since
1826 the fashion for jewellery inspired by the work of
the Greek and Etruscan goldsmiths of the Classical period
was at its height in the 1870s. The re-opening of the Castellani
workshops in Rome in 1858 must have made a considerable

30 Design in pencil and water-
colour for medieval-style bracelets by
William Burges.

stir, because by June 1859 *Punch* was already publishing an imaginary account of a visit to the shop by an impressionable young girl. Although intended to be humorous, this passage tells us a great deal. It is in the form of an imaginary letter from 'Mabel' to her mother, and is entitled 'letter from A Young Lady on the High Classical School of Ornament'.

' . . . *My* great object in Rome is to go, the very first thing, to that dear, delightful, interesting shop, CASTELLANI'S, in the via Poli, where, Imogen says, you have nothing to do but to lay down *scudi* enough, in order to be made perfectly classical in appearance and style. Only think of that! Everything there is taken exactly from the antique, so that you are quite safe in choosing whatever you like, and cannot go wrong.

'By the way, Imogen says, it is just as well to take a look at the Etruscan Room in the Campana Museum when you have a spare hour, that you may satisfactorily judge for yourself what perfect copies CASTELLANI'S ornaments are. Imogen's jewel-casket contains two or three handsome Bullas, one set with stones of lapis-lazuli, one with rubies, and all with those charming devices in raised gold letters, AEI, PAX, LUX, VIS, &c., &c. Also an immensely thick and massive gold circlet for the throat, in exact imitation of the cord round the neck of the dying gladiator—Etruscan arm-lets and fibulae of every possible pattern and device, rings for every day of the week with the name of the appropriate god engraved on each (as Saturn for Saturday, &c.), and as for Greek daggers and Roman pins for the hair, they are innumerable!

'Imogen, however, confided to me (and I am sure I am committing no breach of trust in imparting it all to you, dear), that the only drawback to her classical arrangements is her very small and diminutive stature. You know she has hitherto always rather piqued herself on her "fairy-like proportions", but on this occasion she has found them very inadequate to the massive, heavy, not to say ponderous, style of ornament, which it seems, a classical costume requires. Between ourselves, she confessed to me, that the weight of her Bullas, and her gladiator's necklace is positively distressing to the collar-bones; that her hair is visibly diminished since she took to wearing Greek daggers and Roman pins, both of which are so pretty and so antique, that she is unable to give a preference to

either, and thus is obliged to wear both at once; and even now (although it is some months since she underwent the operation of being bored), her poor little ears suffer martyrdom with the weight of her favourite earrings—exquisite flying figures of Victory which are supposed to be constantly whispering joyful tidings of new conquests . . . '.

The earrings mentioned in the last sentence must have been just the same as the ones illustrated [32] which are indeed both quite large and rather heavy. The drawing which accompanies the passage in *Punch* reproduced here [33], though cruel, is very informative, and is one of the very few pictures of a Victorian woman wearing this kind of classical jewellery.

C. L. Eastlake says in *Hints on Household Taste* (1868), 'It is a well-known fact that chaste and well-designed objects of jewellery—such as those, for instance, which have been reproduced from antique example—*will not sell* in the English market. There is a demand for rare and expensive gems, and a ceaseless demand for showy designs, provided they are *novel*; but for that exquisite school of the goldsmith's art which Castellani has laboured to revive in Rome, there is little popular appreciation in this country.' This was not strictly true as the Earl of Dudley had, in the previous year, bought a gold diadem shown by Castellani at the Exposition in Paris for the then considerable sum of £1,000, and English travellers in Italy did shop from the Castellani workshop and from the many other firms which made similar 'archaeological' jewellery. Eastlake condemns specifically the more

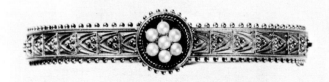

31 Examples of inexpensive English gold jewellery, made in Birmingham, in the Etruscan taste.

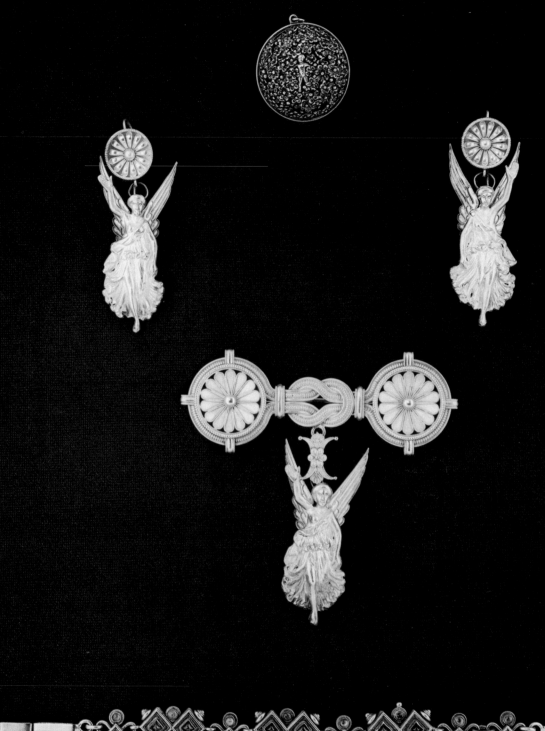

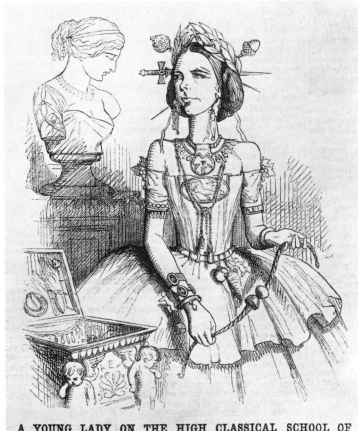

A YOUNG LADY ON THE HIGH CLASSICAL SCHOOL OF ORNAMENT.

32 *opposite: Group of jewellery in gold in the 'archeological' style by Castellani; top, circular pendant decorated with blue enamel; centre, set of brooch and earrings with pendant 'winged Victories', c. 1860; below, gold gem-set bracelet in the Italian medieval style, c. 1870.*

33 *The drawing accompanying Mabel's letter to her mother in Punch, June 1859 (see p. 40).*

34 *Brooch in gold decorated with wire filigree, the centre pavé-set with turquoises.*

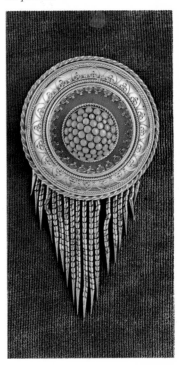

expensive manufacturers, claiming that they have been surpassed in taste by their cheaper colleagues. He goes on, '... I say expressly of expensive jewellery, that we shall look vainly for improvement in design for that which is of moderate price and exposed in ordinary shop windows is often in far better taste. The best examples are either directly copied or partially imitated from modern Roman work, the design of which is chiefly based on antique precedent. ... Bracelets, brooches, necklaces (with pendants in the form of ancient *bulla*), earrings, armlets, &c., of this kind may now be bought in many of the shops in Regent Street and Oxford Street.' It is perfectly true that a considerable quantity of inexpensive gold jewellery in the 'Etruscan' style was made in England, much of it in Birmingham, and a number of such pieces are illustrated, but it seems inexcusable in a man with opportunities to compare these with the work of the Italian goldsmiths to claim that they are really of the same quality either technically or artistically.

Eastlake was subsequently to be proved wrong, and archaeological-style jewellery, particularly the less rigorously antique in design like the stone-set and enamelled work of Castellani and Carlo Giuliano, became very fashionable, and remained so until almost the turn of the century.

It is sometimes difficult to remember how very different was the balance of commercial power in the mid-nineteenth century. The enormous size of the now vanished Austro-Hungarian Empire made the still partially undeveloped United States look small and unimportant in terms of world trade, which was really what the Great Exhibition and all the subsequent similar International Exhibitions were all about. In 1851 no jewellery was shown from America, in contrast with the large and enormously valuable exhibits from France, England, Russia and India. But there was already a hint of what the vast natural resources of the United States would later provide, in the solid gold tea-service made of gold from the recently (1848) discovered sources in California. Very little jewellery was, at this date, manufactured in America, most of the fashionable society women still preferring to shop in Paris, or to buy jewellery and clothes imported from France or (less desirable) England. Mrs. George Bancroft, wife of the American Minister to England (1844–1848), wrote in *Letters from England*, 'Their manners are perfectly simple and I entirely forget, except their historic names fall upon my ear, that I am with the proud aristocracy of England. The forms of society and the standard of dress are very like ours except that a duchess or a countess has more hereditary point lace and diamonds.'

Lady Stuart Wortley confirms this view of the highly 'Europeanised' aspect of American social life, saying in *Travels in the United States*, ' . . . Crowds of carriages, private and public, are to be seen in Broadway, passing and re-passing every moment, filled with ladies beautifully dressed in the most elaborate Parisian toilets.' When Tiffany first opened his shop in New York he sold jewellery and 'novelties' imported from Paris and Vienna, and continued to buy in Paris, from firms like Boucheron, well into the 1870s. Other jewellery shops throughout the United States were, as can be seen from advertisements which appeared in fashion magazines and newspapers, importing inexpensive jewellery in considerable quantities from London and Birmingham, and, while they remained fashionable, traditional and local ornaments in mosaic or coral from Rome and Naples. The commercial dangers of supplying the whole of the demand for jewellery by this large-scale and indiscriminate impor-tation of foreign goods, some of rather indifferent quality,

35 An American design for a pendant showing the influence of the English jewellery exported from Birmingham.

were early understood by the government, and a fairly heavy duty was imposed on imported jewellery in 1850. From this date the manufacture of cheap, fashionable ornaments began to increase in the traditional silversmithing centres in America, but the number employed in this trade remained very small compared with the large workforce employed by the English jewellery trade in Birmingham. The two main American centres for the manufacture of jewellery on a commercial scale during the nineteenth century were Newark in New Jersey, and Providence, Rhode Island. Records of the trade begin in both centres in the early years of the century, in 1801 in Newark, and in 1810 in Providence when there were 100 workmen employed in the manufacture of jewellery in the town. By 1876 'nearly 2,000' men and women were employed in the trade in Providence, and records in 1880 show that 2,163 wage-earners were absorbed by the jewellery trade in Newark. Whereas in England, even the jet industry in Whitby alone employed nearly 1,500 at the height of its prosperity and in the years between 1866 and 1886 the number employed by the jewellery trade in Birmingham rose from 7,500 to 14,000. In spite of this huge discrepancy in numbers employed, highly organised mass-production enabled the American manufacturers to export enough jewellery, and at competitive enough prices, to threaten seriously the prosperity of the Birmingham manufacturers. The result was to force the trade in England to increase mechanisation in all the manufacturing processes. The huge natural resources in their own country gave the American jewellers a further advantage, and by the last quarter of the nineteenth century American manufacturers were exporting the type of jewellery which had previously been imported.

L. C. Tiffany claimed that he had been the first designer to persuade the Americans that their native products in the form of luxurious and expensive pieces of jewellery were the equal of, if not superior to, those made in Paris. It is true that rich Americans had become, certainly by the end of the Second Empire if not before, the most valued customers of the Parisian manufacturers of all kinds of luxury goods; but a number of quite distinctive styles in jewellery had been evolved for fashionable American ladies from the 1860s onwards, for instance the large and elaborately gold-mounted tortoiseshell combs, and the stylish gold jewellery decorated with engraving and 'blooming' and rococo or classical patterns in black and white enamel, to name only two examples. American manufacturers had also been very quick to see the possibilities of the *Japonaiserie* designs, based

36 Another American pendant design; cf. the example opposite.

37 *Ring in silver set with a sapphire, made by Tiffany and Co., c. 1890.*

on the newly discovered decorative art of Japan, partly no doubt from a feeling of pride in the achievement of the American Commander Perry who had been instrumental in opening up trade with Japan for the first time since the seventeenth century. But the real sense of their artistic identity, in the decorative arts at least, seems to date from the great Centennial Exposition in Philadelphia which took place in 1876. For the first time American manufacturers were competing with their European rivals on their own ground. The need to evolve a purely American personality, independent of the enervating admiration for European, and particularly Parisian, styles in the design of personal ornaments as well as furniture, ceramics and glass, became a first priority with American artists and designers. The following years were to reduce American dependence on European guidance to a lower level than ever before.

38 *Two gold bracelets decorated with black enamel, one set with pearls; they are both of American manufacture; c. 1870.*

39 opposite: *Necklace, pendant and earrings, showing diamonds alternating with enamelled gold links in the neo-Renaissance taste; made by Tiffany and Co., 1880–90.*

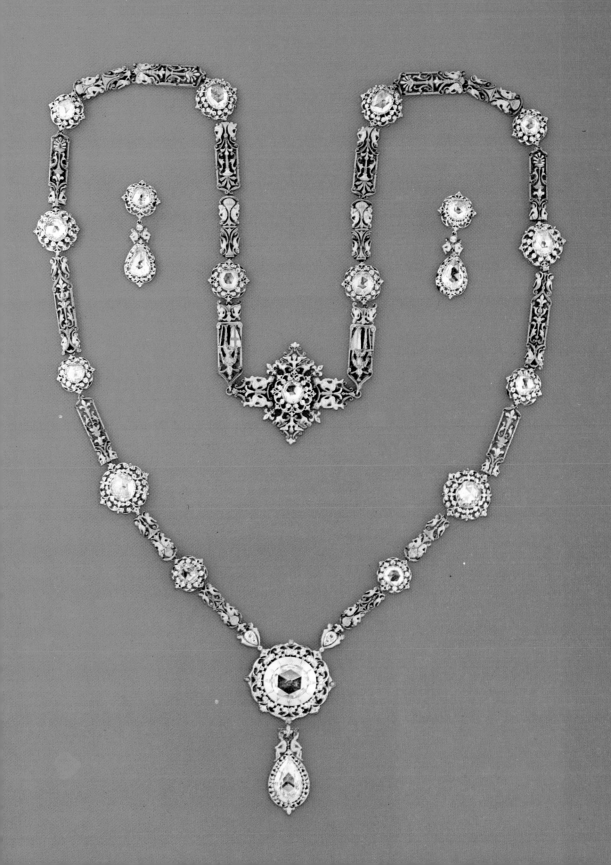

The oriental influence on jewellery styles was an important feature of this period, and not just in America. From the late 1850s when Japan first resumed trade with the western world until at least the early years of the present century, jewellery designers were fascinated with the decorative art and craft techniques of the East, particularly Japan. The two decades before this had already seen a number of tentative attempts to incorporate eastern motifs into the mainstream of European taste, at this period primarily obsessed with romantic historical revivals. This modified eastern style used the Hispano-Moresque decorative patterns, probably mostly taken from Owen Jones's book on Moorish pattern-making *(Plans, Elevations, Sections and Details of the Alhambra)* published in 1842, to decorate the settings of jewellery which was otherwise entirely western in style. In the 1840s and 1850s the French produced a number of pieces in the 'Algerian' style which were very similar to the Hispano-Moresque pieces; Sir Austen Layard's discovery of Nineveh prompted the use of decorative motifs taken from ancient Assyrian sculpture or goldsmiths' work, of which the horned ram's head is the most persistently recurring. These designs also used the eastern motifs within a completely western framework and, with the exception of the goldwork for which some attempt at research into ancient methods was made, the techniques used were also resolutely European and modern. With the spread of interest in Japanese decorative arts and crafts, the situation was completely changed and Japanese metalworking and enamelling techniques were studied carefully by any jeweller with any pretensions to working in the *Japonaiserie* style. One of the first and most successful adaptations of

40 Both this bracelet, in silver with coloured decoration, and the pendant on the opposite page [41] show a strong Oriental influence.

41 *Engraved silver pendant decorated with a bird and a butterfly, each in a different-coloured gold.*

Japanese methods to be used for jewellery in Europe was the *cloisonné* enamelling [123] which the French enamellists made their special province (see p. 123) [142], though a bracelet made by the London firm of Hunt and Roskell to go with a set of jewellery by Falize proves that the English were perfectly capable of producing work of a similar quality to the French. Jewellery designers in England and the United States were, from the beginning, more interested in the mixed-metal techniques at which the Japanese craftsmen excelled.

When the wearing of the Samurai sword was banned from the 1860s onwards many of the metalworkers who had made the beautifully decorated sword furniture turned to supplying the newly opened western market with small pieces of decorative metalwork in the same techniques and style of decoration; these were mounted in Europe as jewellery [43]. This Japanese work was copied by jewellery firms at every level: from Tiffany in America, whose experiments in these Japanese techniques were prompted by Edward Moore's interest in Japanese art (see p. 223) and probably carried out by the Japanese craftsmen employed by them, to the mass-production workshops in Birmingham, England

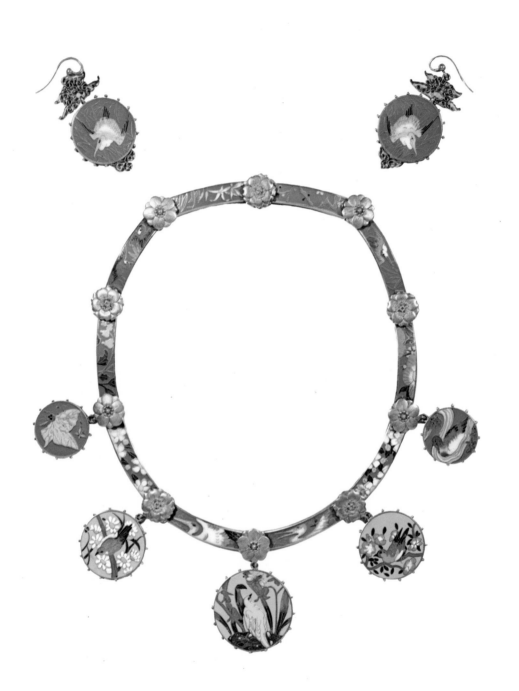

42 opposite: Necklace and earrings in gold, decorated on both sides with cloisonné enamels in the Japanese taste, made by Alexis Falize in 1867. The earrings are marked with the maker's mark and the Paris Assay Office mark for gold. Bought in Paris in 1867 by H. F. Makins for his wife Kezia, second daughter of John Hunt of Hunt and Roskell.

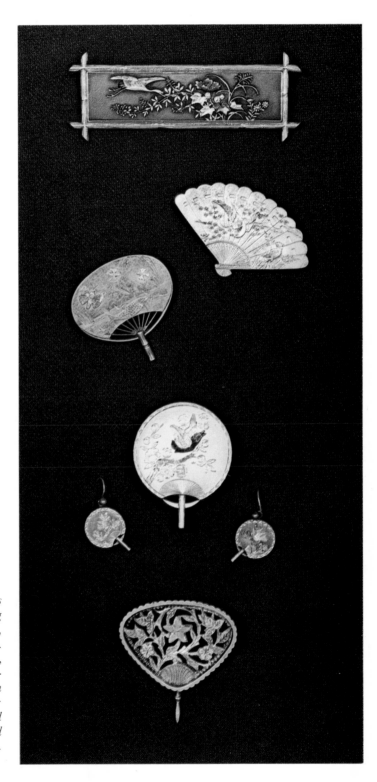

43 Group of brooches and earrings in the Japanese taste: top, oblong plaque of Japanese shakudo, mounted in gold in England, c. 1870; centre, three gold brooches, one with earrings en suite, decorated with Japanese-style motifs in coloured gold, English 1870–80; bottom, pierced silver fan-shaped brooch decorated with coloured gold in the Japanese taste, English c. 1880.

51

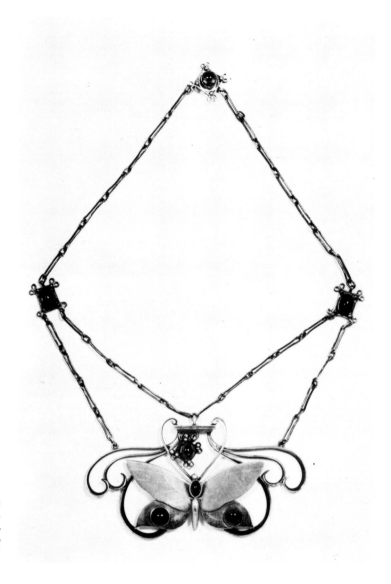

44 *Silver pendant in the shape of a butterfly and set with amethysts, designed and made in 1901 by Edgar Simpson; an example of the Oriental influence at a later date.*

which turned out a large quantity of silver jewellery during the 1870s and 1880s inlaid with *Japonaiserie* decoration in coloured gold (or copper and various alloys of metal less valuable than silver). This latter practice was against the assay laws in England but the work was probably done by Japanese craftsmen employed by English concerns who may—perhaps wilfully—have misunderstood the law. Much of this Japanese-style ornament, especially that used in the inexpensive silver jewellery, is taken practically unaltered from the Japanese metalwork. The repertoire is somewhat restricted, clinging to the more obvious and popular decor-

ative craftwork which was at this time (i.e. from the 1860s onwards) being imported into Europe and America on a large scale. Designs included the familiar branches of prunus blossom, with or without birds on them, the clumps of bamboo with a rather bored-looking stork standing beside them, the rather bloated fish of some unidentifiable species weaving its way through stylised waves, and fans held by or decorated with male or female oriental figures with inscrutable expressions.

Though Japanese taste had the most widespread effect on European and American taste and fashion, one should not underestimate the influence of both Indian and ancient Egyptian art on nineteenth-century jewellery design. Egyptian-style jewellery, like Assyrian- and Etruscan-style work, was really more a manifestation of the archaeological revival and, since very little attempt was made to revive the complex ancient methods used by the Egyptians to colour their jewellery with inlays of coloured compounds, glass and polished stones, the goldsmiths' techniques were in almost every respect identical to those used for mid-nineteenth-century neo-classical jewellery. Some of the 'Egyptian' jewellery is set with real ancient scarabs rather than modern hardstone imitations. From the point of view

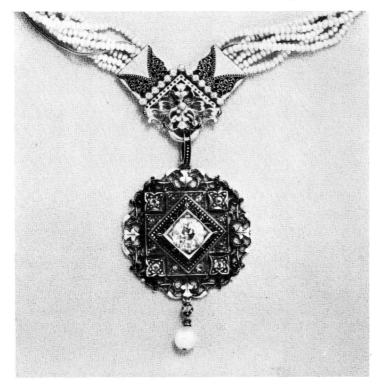

45 *Pearl chain, gold and enamel gem-set pendant by Giuliano, c. 1890, showing Indian influence.*

of the collector of nineteenth-century jewellery, this had the effect of raising the price quite artificially, and a piece containing a valuable scarab which is otherwise quite undistinguished will almost certainly cost far more than a piece of fine nineteenth-century goldsmiths' work.

Curiously enough, considering the close ties between Britain and India, and the long years of trading between the two countries, Indian taste made far less impression on nineteenth-century fashion than did the Japanese. Indian motifs were incorporated into jewellery designs, but it is much more usual to find small pieces of Indian work mounted in Europe without alteration; these were presumably regarded as charming but undistinguished curiosities. Anglo-Indians usually showed a profound indifference, tempered with faint distaste, for Indian work and where they were lucky enough to come into possession of pieces set with valuable stones, these were almost always broken up and reset.

46 Necklace, bracelet and two pairs of earrings in gold with filigree and granulated decoration in the Etruscan style; Italian 1860–70. This set of jewellery was bought in Italy in the late nineteenth century by Estelle Canziani, the painter.

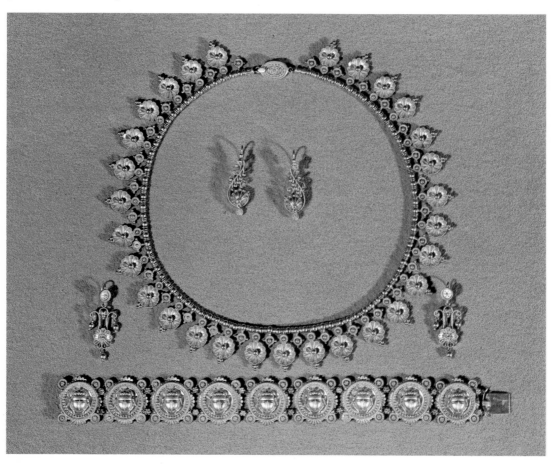

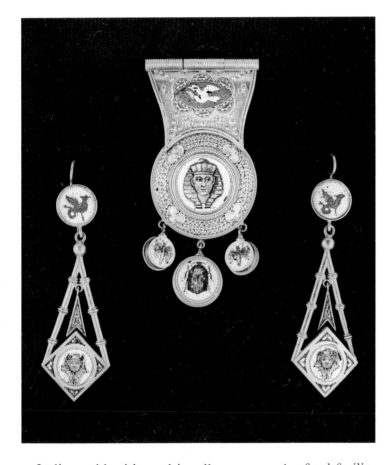

Indian goldsmiths and jewellers possessed a fatal facility for copying European work and all the energies of the European settlers in India seem to have been bent on perfecting the Indian craftsmen's mastery of western techniques to the impoverishment of the native abilities and creativity. Towards the end of the nineteenth century the aesthetes who had popularised the Japanese style became enthusiastic about native Indian jewellery, which became quite fashionable for a period, particularly after Queen Victoria became Empress of India in 1878; but the characteristic Mogul techniques of inlaying gems into jade, the delicate enamel-work from Delhi and Jaipur, and the pavé-set turquoise and gold jewellery from Madras were not imitated on a commercial scale in the same way as the Japanese work had been.

No account of the jewellery worn on both sides of the Atlantic in the mid-Victorian period would be complete without reference to the very Victorian phenomena of mourning and sentimental jewellery.

Observance of mourning was less important on the continent of Europe than in America or Britain. In America the tradition of mourning tended to persist longer than elsewhere, but it was based on the conventions observed in Britain. These were strict and usually rigidly followed, down to the smallest detail.

It is hardly likely that the members of the English Court, plunged into deepest black by the death of some distant member of the Royal Family quite unknown to them were always displaying their true feelings. But nevertheless court mournings were so frequent and so rigorously observed during the whole Victorian period that it was considered unwise to go on any journey with the Royal Family without the complete mourning equipage of dress and ornaments. These periods of mourning were absolutely dreaded by the ladies of the Court. The length of time varied considerably, from quite a brief mourning of three weeks for a second cousin, which was sometimes not observed at all, to the two years of full mourning followed by six months of half mourning demanded by convention of the widow.

' " . . . most thankful I shall be to see you with a couple o' pounds worth less of crape," said Tantrippe, stooping to light the fire. "There's a reason in mourning, as I've always said; and three folds at the bottom of your skirt and a plain quilling in your bonnet—and if ever anybody looked like an angel, it's you in net quilling—is what's consistent for a second year. At least that's *my* thinking," ended Tantrippe, looking anxiously at the fire; "and if anyone was to marry me flattering himself as I should wear those hijeous weepers two years for him, he'd be deceived by his own vanity, that's all." ' This passage from *Middlemarch* gives a wealth of information about nineteenth-century mourning etiquette, and indicates a fairly robust and untypical frankness about the burden of wearing unbecoming clothes for such a very long period of time. Though *Middlemarch* was published in the 1870s when observance of the strictest mourning practices was at its height, the action is set in 1831, when a more unsentimental attitude towards at least the outward show was common. From the death of the Prince Consort in 1861 until nearly the turn of the century the strict observance of mourning etiquette, particularly for a widow, became widespread. Queen Victoria, though only forty-two at the time of her husband's death, did not consider the

48 This scarf pin was issued in memory of President Lincoln after his assassination in 1865.

possibility of leaving off her mourning at any time; she imagined that any widow with proper feelings would feel the way she did, and she regarded the remarriage of widows as a wholly improper act. This rigid and unbending attitude on the part of the Queen greatly increased the wearing of mourning jewellery, and it is clear that many widows wore memorial brooches in preference to anything else for the rest of their lives.

On the whole, mourning, memorial, sentimental or commemorative jewellery was not very exciting or innovatory, rarely attracting the attentions of the designers who did so much to form the taste of the nineteenth century. Notable

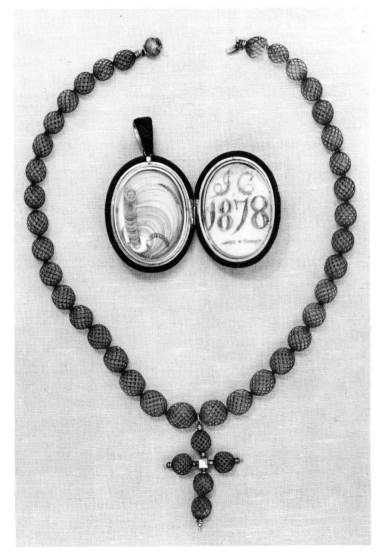

49 Whole suites of jewellery were made from the hair of dead loved ones; shown here are a necklace of openwork beads and a pendant cross made of blond human hair and fastened with a gilt clasp (English, 1830–50), and a gold pendant enamelled in black, opening to show panels decorated with hair (English, 1870s).

exceptions are the pieces of marriage jewellery designed by Pugin for his intended third wife, which were subsequently shown at the Great Exhibition in 1851 [218] and the marriage jewellery designed by Burges for Lord and Lady Bute in 1872. These sets of jewellery which, like the French presentation pieces designed by F.-D. Froment-Meurice were in the neo-Gothic style, were widely copied in England for a type of quasi-ecclesiastical jewellery of the kind made by Hardman's of Birmingham, some of which was certainly designed as memorial jewellery with compartments for hair and space for initials.

The form and ornamentation of all kinds of sentimental jewellery altered only slightly from the 1830s until the end of the century, using a restricted repertoire of symbolic designs carried out in an equally restricted range of materials which have been connected with the idea of jewellery of sentiment since the seventeenth century. These included the ubiquitous lock of hair; pearls, which are the symbol of

50 Group of English mourning brooches and a pendant; the three centre brooches have date inscriptions, top 1831, centre 1854 and 1848.

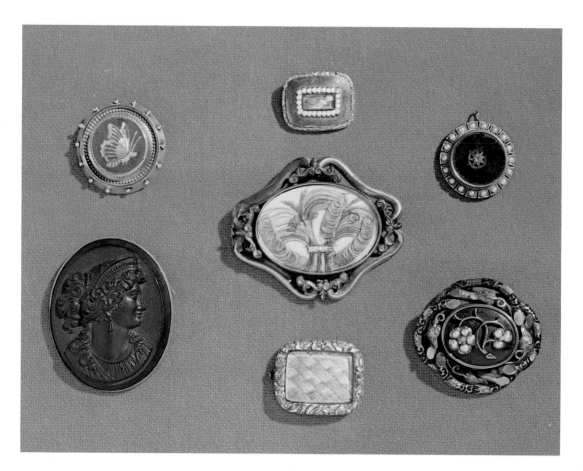

tears; and black, in the form of jet, onyx or enamel, as the symbol of mourning. The Victorian cult of hair grew to almost manic proportions, and whole suites of jewellery were made from the hair of a parent, a deceased husband, wife or betrothed. These comprised a necklace with a pendant cross, a brooch in the form of a lovers' knot, earrings, and bracelets of plaited hair with clasps in the form of miniatures backed with more hair, all mounted in gold. Hairwork of great elaboration was shown by Messrs. Forrer of Hanover Square at the Great Exhibition in 1851, but it was considered very dangerous to entrust the work of making up pieces of hairwork jewellery to some soulless commercial concern since there was a danger that hair other than that of the person to be commemorated might be used. Books of instructions existed to enable women to make their own hairwork jewellery (see, for instance, *A Jeweller's Book of Patterns in Hairwork* by William Halford and Charles Young, 1864; or *The Lock of Hair* by Alexanna Speight, 1871). Miniatures were often exchanged by engaged couples, as well as being worn as memorial jewellery in the form of brooches or bracelet clasps. These usually have a compartment at the back designed to hold a lock of hair. From the time of her marriage Queen Victoria nearly always wore a heavy bracelet with a miniature of Prince Albert in the centre.

For reasons of sentiment or family piety, and also perhaps because of the low intrinsic value of the materials used in its construction, a large quantity of nineteenth century commemorative and mourning jewellery has survived. and is now very properly valued and collected for its historical interest. Mourning jewellery is the best documented of any type of non-royal jewellery, since many of the pieces bear dated inscriptions, and the history of them is known, since they are often retained by a member of the family for whom they were made in the first place. It is ironical that this body of well-documented material should be of so little use with the dating of other types of fashionable nineteenth-century pieces.

Despite the doleful connotations of jet and other black stone jewellery, the combination of black and gold, either in the form of jet or onyx combined with gold, or of gold decorated with black enamelling, became very fashionable in the 1860s and 1870s. Much American jewellery survives in this combination of colours, carried out in gold decorated with engraving and contrasting areas of 'dead' or bloomed gold with burnished gold, set either with onyx or jet and further enriched with black enamel in a version of *taille*

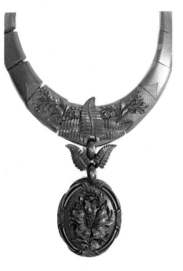

51 Necklace and pendant in matt and polished, carved jet, English, c. 1870.

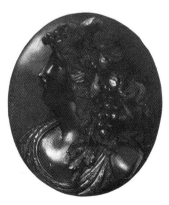

52 *Three carved jet brooches, two polished and one unpolished.*

d'épargne in bands of quasi-rococo or neo-classical ornament. This type of jewellery appears to have been popular over a long period of years, a number of pieces bearing dated inscriptions (which suggest that these at least may have had some sentimental or commemorative purpose) range in date from the 1840s until the late 1880s. These pieces are very like contemporary French or English commercial productions which were imported into the United States in considerable quantities, but they do seem to be unquestionably of American manufacture, a theory supported in the case of one or two pieces by the American patent office numbers which they bear.

Jet was already being recommended for mourning in 1827, but the fashion for jet in preference to the other permitted materials seems to have begun in 1850, when Queen Victoria wore a jet parure to a banquet when she was in mourning for her cousin the Duke of Cambridge. The demand for jet jewellery created by the Queen's example was to stretch the capacity of the industry in Whitby to its limits. In 1832 there were only two jet workshops in the town, employing in all twenty-five workers. By 1850 there were seven, including that of Thomas Andrews of New Quay, 'jet ornament maker to H.M. Queen Victoria'. In 1870 no less than 1,500 men and women were employed in the jet workshops. From the late 1860s until the 1880s there were at least fifteen jet ornament makers in London, but of these only one claimed to use 'best hard Whitby only'! By the 1880s, with the supply already diminishing rapidly, the demand for jet declined and the industry died away.

Both ivory and jet were worn primarily as mourning jewellery but became fashionable during the 1860s and 1870s with the new vogue for colourless ornaments. The demand for jet was so great that the industry in Whitby was quite unable to meet it and a great deal of so-called jet jewellery is in fact made from French jet (i.e. black glass), or the soft Spanish jet from Galicia. It was the low quality of much of the work produced in these materials which led to the decline in the popularity of jet. These formerly despised productions of the nineteenth century are, like memorial jewellery, now widely collected, and the best-quality work, which is very finely carved in minute detail, is now both scarce and expensive.

Perhaps the most interesting, and artistically satisfactory, of the mourning and sentimental jewellery of the nineteenth century is the ring. In the first place these are almost without exception (the exception being, in the author's view, the

very delicate black and gold enamelled snake brooches, but these are certainly not to everybody's taste) the most wearable of all types of sentimental jewellery, and the range of designs used is far greater than in brooches or lockets. Ring lore is very complicated and the design of most rings, with the exception of those used simply as a vehicle for fine large stones, has some sentimental significance, beginning with the ring shape itself which is the symbol of eternity. The form of 'Fede' ring (from the Italian 'Mane in Fede') with the symbol of the clasped hands, found in Roman rings of the second and third centuries B.C., has been used continuously since mediaeval times, and very delicate examples were made during the nineteenth century, this style being particularly popular in the period *c.* 1825–1840. These 'Fede' rings were often made in the form of a 'Gimmel' ring in two parts which fit together to symbolise the relationship between two people, and have a heart, or heart-shaped stone, between the two clasped hands. Other rings bear semi-cryptic inscriptions, including the word 'Mizpah' (from the passage in Genesis, 'The Lord watch between me and thee when we are absent one from another') which was popular in the 1860s and 1870s, or the letters A E I, from the Greek word meaning 'forever'. The initial letters of the names of the gems with which the ring is set sometimes spelt out a message or a name, as in the 'REGARD' rings which were traditionally given at the birth of the first child. These rings and other pieces of sentimental jewellery with inscriptions of this kind were far more popular in England than on the continent, and on the rare occasions when French firms made such pieces the inscriptions were often in English. Princess Mathilde owned a bangle in black enamel with the word 'Remember' spelled out in diamonds on it. These were probably a manifestation of the great mania in France during the 1860s for English things, which also brought the *bijoux sports* and *bijoux hippiques* into fashion, rather than strictly sentimental pieces, but the use of the English word seems to indicate that this type of commemorative jewellery was one of the few contributions made by English jewellers to high fashion, a distinction usually reserved for the French, and to a lesser extent, the Italians.

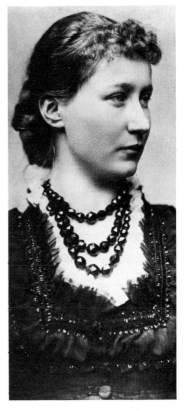

53 A photograph of Princess Augusta of Schleswig-Holstein-Augustenberg, the wife of Kaiser Wilhelm II, taken in the 1890s; she is wearing a mourning necklace of jet beads.

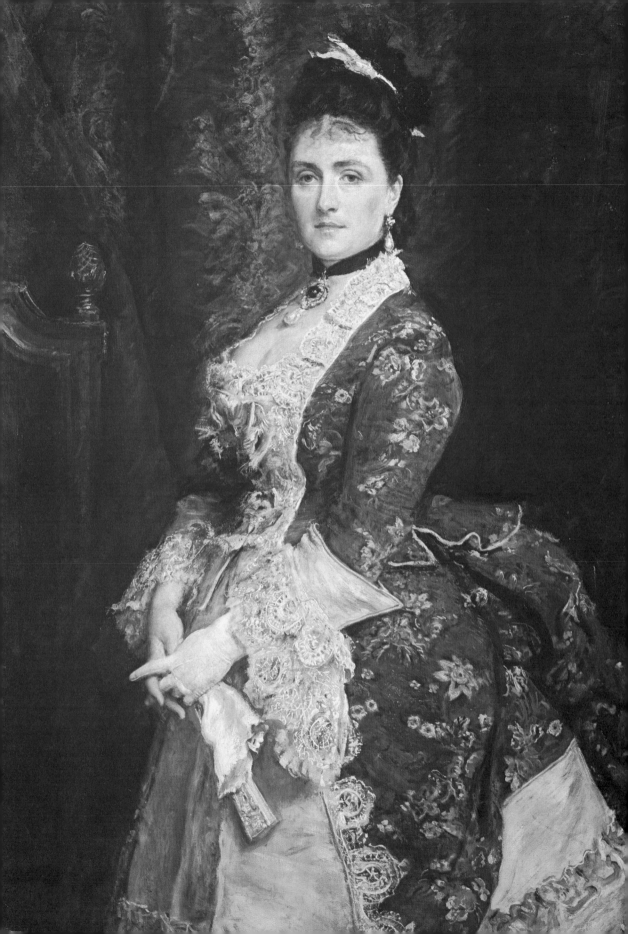

1876-1914

Any account of jewellery design in the late-Victorian and Edwardian periods is almost bound to dwell disproportionately on the work of the Arts and Crafts Movement in England and America, the Art Nouveau designers in France and Belgium and the designers connected with the *Jugendstil* in Germany and Austria. As far as the development of fashionable taste is concerned these movements, with the exception of the Art Nouveau work produced in France, are of minimal importance. Certain commercial firms, notably Liberty's in London and Unger Bros. in the States, produced jewellery based on Art Nouveau and Arts and Crafts forms, rationalised and simplified for mass-production, and this became very popular at the turn of the century. However, the general trend in expensive fashionable jewellery continued on the lines laid down at the end of the eighteenth century, and followed fairly faithfully ever since. Jewels were thus largely composed of pearls and diamonds or other precious stones, elaborately facet-cut to display to best advantage their colour and internal fire, set in precious metals, the settings sometimes enriched with coloured enamelling, or delicately chased and engraved. While 'archaeological' jewellery, which had been adopted somewhat in the spirit of *faut de mieux* by the 'aesthetic' coterie who were later to patronise the Arts and Crafts jewellers, largely ignored the decorative possibilities of precious stones, it was nevertheless technically very sophisticated and made of fine gold.

The end of the eighteenth century and the first half of the nineteenth saw the development of some of the technically most sophisticated jewellers' work to be attempted since

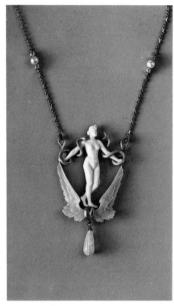

54 'Eve' pendant and chain in red gold set with opals, tourmaline, pearls, sapphires, diamonds and ivory, designed and made by Philippe Wolfers, 1897–1908.

55 opposite: Portrait of Mrs. Bischoffsheim by Millais; the sitter is wearing a heavy Renaissance-style pendant and earrings.

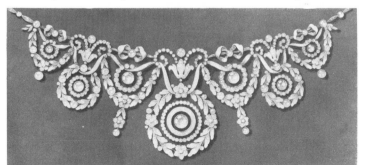

56 Design for a diamond necklace very similar to that worn by Queen Alexandra [57] from the nineteenth-century design books of Hennell Limited, now Hennell, Frazer and Haws.

57 Queen Alexandra photographed in 1883 when she was Princess of Wales; she epitomised the rich, fashionable woman of her day, unaffected by the ideals of the Arts and Crafts movement.

the Greek and Roman periods. Even Cellini admitted that to his chagrin he had been unable to achieve the characteristic granulation found on Etruscan goldwork, that which Castellani and his imitators managed to copy with some success. The expertise needed for the most complicated work was very great, and this led to a hitherto unknown degree of specialisation in the trade. The result was that

four or five men might be involved in the production of one piece of jewellery. The names of the separate artists and craftsmen concerned in making some of the elaborate neo-Renaissance pieces designed by Alphonse Fouquet in the late 1870s and 1880s are recorded. They include for instance in the case of the *grande châtelaine Bianca Capello* the sculptor Carrier Belleuse, the enamellist Grandhomme, and the *ciseleur* Honoré, as well as the designer Fouquet himself. It is not surprising that the name of the *ciseleur*, i.e. the chaser and engraver, is given, as well as the sculptor; this branch of the art of the goldsmith was much more highly regarded in France than elsewhere. A period of training with a *ciseleur* was accepted as an essential part of the jeweller's apprenticeship. Fouquet had himself been trained by the famous French *ciseleur* Jules Chaise (1807–1870), who also took Frédéric Boucheron as an apprentice. Two of Boucheron's craftsmen, Louis Rault and Jules Brateau, who became admired *ciseleurs* with their own workshops at the turn of the century, were trained by the other well-known mid-nineteenth-century chaser and engraver, Honoré-Séverin Bourdoncle (1823–1893), who did the work on the Fouquet châtelaine and other Fouquet pieces. It is certainly this insistence on the importance of the engraver that gives French goldsmiths' work the stylish and refined finish that was so much admired during the nineteenth century.

This necessary specialisation was widely deplored by such influential critics as John Ruskin and William Morris, who tirelessly campaigned for the return to what they believed to be the mediaeval workshop practice of entrusting the whole of the work on a piece of jewellery, including the design and all the manufacturing processes, to the hands of one man, preferably an artist. The favourite examples cited in support of this ideal were Botticelli and Francia, both of whom are known to have trained as goldsmiths, and who are believed to have made pieces of jewellery. It is significant that neither Ruskin nor Morris, nor indeed other adherents to this idea such as Charles Eastlake and Oscar Wilde, had any actual experience of goldsmith's work or jewellery making.

William Morris trained as an architect in the office of G. E. Street where he met Philip Webb, one of his associates in the firm of Morris and Co. (founded in 1861) which was to prove widely influential on the decorative art of the second half of the nineteenth century. Morris's great reputation as a craftsman has led to every kind of craft revival object being attributed to him, either as a designer or manufacturer. Wide though his capabilities were, he was not

58 The grande châtelaine Bianca Capello, *designed by Alphonse Fouquet and made in 1878. The design is also illustrated [134].*

able to encompass more than a limited number of techniques and it seems that he never experimented with making jewellery. The design of one piece is credited to him, however: it was a necklace made by Margaret Awdry and exhibited at the Grafton Galleries in 1906.

The craft revival jewellers of the turn of the century who were inspired by these ideals were hampered at every turn by their lack of sophisticated technical knowledge. Charles Ricketts, who designed a number of pieces of jewellery for his friends, is known to have been highly dissatisfied with them once they were actually made up, probably because his lack of technical knowledge meant that he was ignorant of both the possibilities and the limitations of working with precious stones and metals.

As the craft jewellers were to discover, largely through a process of trial and error rather than through the long professional training which was required on the continent, it was actually possible to acquire a sufficiently professional standard of technique for working in metals and enamels to make products saleable without formal instruction of any

59 opposite: Necklace with five pendants in enamelled gold set with pearls in the manner and technique of John Brogden; 1870–80. It is interesting to compare this with the Japanese-style necklace by Falize [42].

60 Gold pendant set with emeralds, sapphires, moonstones and garnets designed and made by the craft-revival jeweller John Paul Cooper, c. 1910. The pendant is shown with two preparatory designs by him.

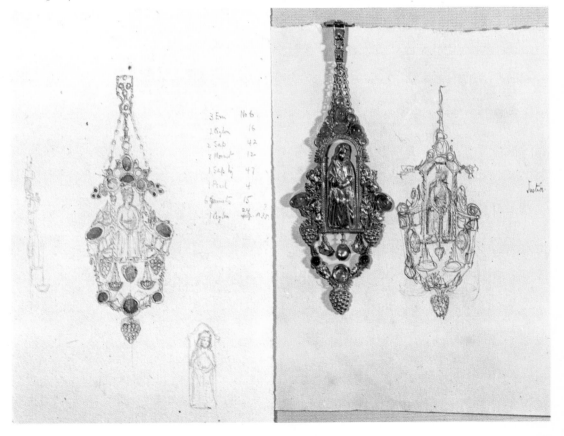

kind. But even in their chosen field of working mainly in silver and enamels set with plainly polished stones, the standard of work generally fell below that maintained by most nineteenth-century commercial firms. The incredible technical facility of the commercial craftsmen, particularly those working in gold and silver, had by the middle of the century come to be taken for granted. It is not unusual to find highly professional technique being spoken of disparagingly as of no importance, and it was in this climate of opinion that the craft revival flourished in England and in the United States. The products of these artist-craftsmen were greeted with sympathetic appreciation, largely because the ideas of artistic and social reform proposed by Morris and Ruskin had already begun to make a considerable impression on a number of people whose consciences were not entirely clear, particularly in the matter of the scandalous conditions of work in the factories where much of the inexpensive decorative work of the period was produced. Whatever the ideals of the early supporters of the Arts and Crafts movement may have been, the inescapable fact remains that the commercially most successful of the many craft jewellery ventures that were set up at the turn of the century were the largely mass-production operations master-minded by shrewd businessmen like Arthur Liberty, William Hutton, William Comyns and Charles Horner, using the well-tried machinery of the Birmingham and Sheffield workshops, which had earlier been called despairingly by Pugin 'those inexhaustible mines of bad taste'. Whatever else the idealism of the craft

62 Sketches by Ricketts to show three views of a pendant, from a sketchbook dated 1899.

63 opposite: Three necklaces made by Gaskin for members of the Gere family, c. 1904.

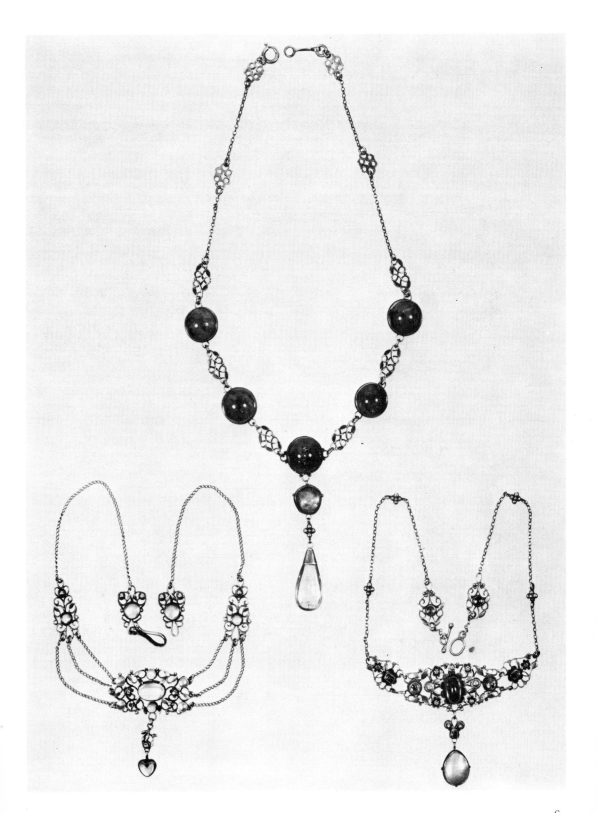

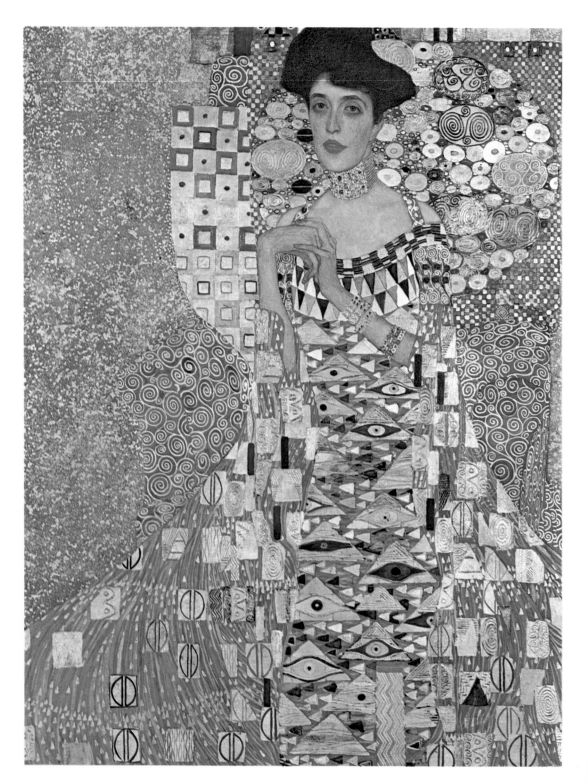

64 opposite: Portrait of Mme. Adele Bloch-Bauer, by Gustav Klimt (1907). The minutely realistic painting of the 'dog collar' necklace and the bracelets contrasts strangely with the stylized dress and background.

65 Designs for plaques de cou *(these were elaborately worked central sections of the 'dog collar' necklace) by Colonna; c. 1900. This style was made fashionable by the then Princess Alexandra whose neck was scarred by an operation.*

revivalists produced in the way of ideas for easily imitated and cheaply manufactured silverware and jewellery, their refusal to be bound by the conventional value-orientated assessment of the jewel's artistic worth enabled them to demonstrate the remarkably rich effects which could be obtained with very inexpensive materials. Both French and English designers at the end of the nineteenth century were experimenting with unusual combinations of heavily flawed or unevenly coloured stones; they used materials of no intrinsic value, like horn, and glass, all enriched with

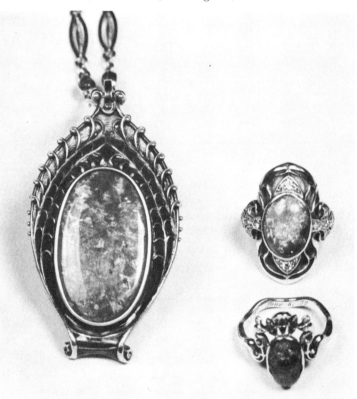

66 Two rings: the upper, black opal, enamelled gold, and diamonds, c. 1899; the lower, emerald scarab, enamelled gold, diamonds, and rubies, actually dated 1899; and a black opal and enamelled gold peacock-feather pendant, c. 1899; all by Marcus and Co.

enamelling; or the newly fashionable colourless materials like silver with moonstones and mother-of-pearl. The buckles, waist-clasps and cloak-clasps which were widely worn in this period show particularly well the use of silversmithing techniques in the manufacture of jewellery, and it is this re-thinking of the function of silver in jewellery design—formerly used as a cheap and unsatisfactory substitute for gold—which brought silver back into fashion.

Silver was widely used for jewellery in the 1840s and again in the late 1860s and 1870s (coinciding with the commercial exploitation of the rich 'Comstock Lode' which

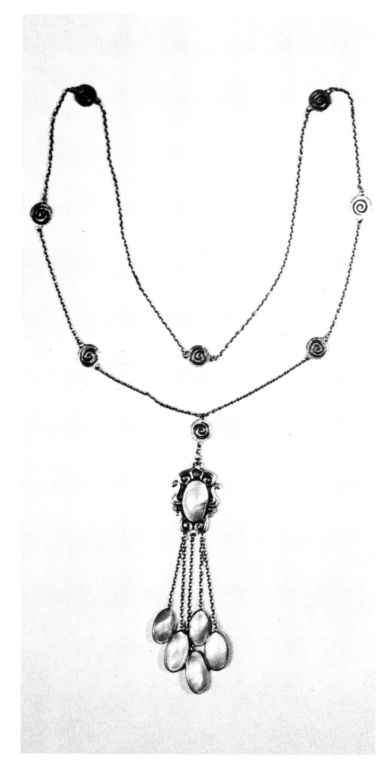

67 *American necklace and pendant in green enamel on gold, set with blister pearls; made by Marcus and Co. (?), possibly from a Tiffany Studios design. The piece is very close to English craft-revival style.*

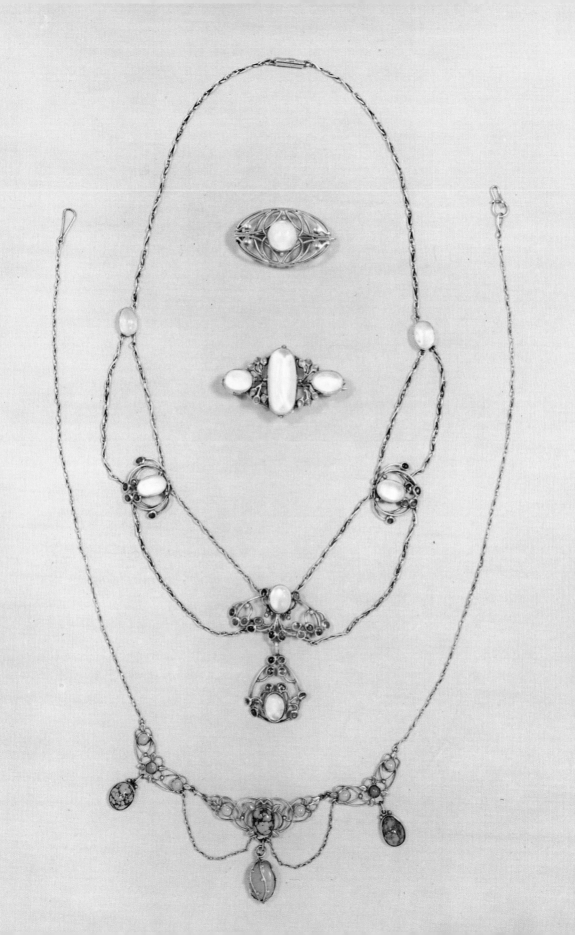

was discovered in 1860), but by the 1890s it was regarded with horror by fashionable women. Mrs. Gereth, in *The Spoils of Poynton*, by Henry James, speaks of her son's future mother-in-law whom she loathed and despised, as being the type of woman to wear silver jewellery. The great extent to which craft-revival jewellery was copied, both commercially and by innumerable semi-amateur silversmiths up and down the country both in Britain and in America, gives an idea of how popular it became in the early years of the present century. On the whole this experimental work was widely commended by contemporary critics, but even the *Art Journal* and the *Studio*, generally staunch supporters of the Arts and Crafts movement, occasionally sound a warning note of criticism. In 1901, reporting on the Glasgow International Exhibition, the *Art Journal* critic wrote: 'Among women's work jewellery appears to take, considering the small size of the objects, a rather conspicuous place. It is mainly in silver, not as a rule wrought with the delicacy which it is polite to attribute to the fingers of the delicate sex. The impression it conveys is, rather, how easily the modern craftswoman is satisfied, as well in the matter of design as of workmanship. The first effect of the work is pretty enough—a welcome change, it would be, from the trade types, were it not that it falls too readily into a mannerism of its own which ceases, at last, to be interesting. Enamel, upon which great reliance is placed, gives scope for characteristically beautiful colour and is often distributed with taste but the more one looks at the buttons, clasps, plaques, pendants and so forth, the more one is disposed to resent the carelessness (or is it incompetence?) of the workmanship.

'There was a need for the protest of modern craftsmen and craftswomen against trade jewellery; but it is a pity that many of them have yet so much to learn from the trade workman they look down on, who, for his part, is not entirely without reason when he looks down on them.'

This serious criticism of the technical abilities of the craft jeweller, voiced by many other commentators on other occasions, can be taken to be directed mainly at the many completely untrained student or amateur exhibitors; the well-established workshops who relied on selling their products to keep going were forced to attain a reasonably professional standard of workmanship if they were to remain in business. By 1901, the date of the comments quoted above, a considerable number of these workshops, or Guilds, had already been set up. Examples were the Art Workers' Guild in 1885, the Guild of Handicraft in 1887, the Arts and

68 opposite: Jewellery in gold and silver, set with turquoises and moonstones and decorated with enamel, made by Liberty and Co., 1900–10.

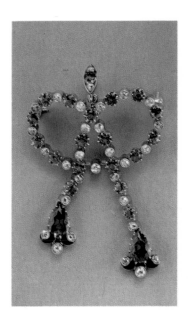

69 Bow brooch in diamonds and sapphires, advertised in the Johnson, Walker and Tolhurst catalogue, c. 1900, priced at £24. It is set with stones from the New Mine Sapphire Syndicate mine in Montana.

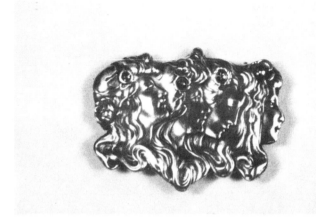

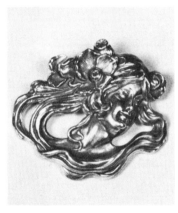

70 Three American Art Nouveau brooches; top, by Unger Brothers, above by Kerr, below by Gorham. All are examples of American mass-production.

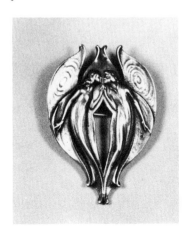

Crafts Exhibition Society in 1888, and many others in Britain. In America the Philadelphia Centennial Exposition in 1876 had been the starting point for a whole spate of native artistic activity, beginning in 1879 with the establishment of L. C. Tiffany's interior-decorating workshop, Associated Artists, which was quickly followed by a number of craft revival workshops including the Art Workers' Guild in Providence (established in the mid-1880s), the Chalk and Chisel Club in Minneapolis (1895, changed to The Minneapolis Arts and Crafts Society in 1899), the Boston Arts and Crafts Society and the Cicago Arts and Crafts Society (both established in 1897), and the Guild of Arts and Crafts of New York (set up in 1900). In both Germany and Austria a similar wave of artistic activity was sweeping across the country, the Vereinigten Werkstätte were founded in Munich in 1897, and the Grand Duke of Hesse's artists' colony was set up in Darmstadt in 1899. The Vienna Secession Movement dates from 1897, and this was followed in 1903 by the setting up of the famous Wiener Werkstätte.

With the exception of the Art Workers' Guild, which is still in existence, the Wiener Werkstätte was one of the longest lasting of these ventures, closing down only in 1937. Founded by Josef Hoffmann and Koloman Moser in imitation of C. R. Ashbee's Guild of Handicraft, the workshops avoided the pitfall of failing to maintain an acceptable technical standard of work, by employing professionally qualified craftsmen to carry out the designs supplied by the artists associated with the venture. The craft ethic, so enthusiastically embraced in Britain and the United States, was quite alien to continental taste. Almost without exception French and Belgian jewellery designers connected

with the Art Nouveau movement were either professional jewellers themselves or were employed by professional firms whose standards were maintained by rigorous training in both the craft and, as often as not, fine art as well. Criticisms of English or American craft jewellery often contain a reference to René Lalique, whose work, though widely regarded as unpleasantly decadent, was recognised as being of superb technical quality. This is true of most of the other Art Nouveau jewellers, who also, while being prepared to make experiments with hitherto neglected materials, often used fine precious stones in their pieces, a practice almost completely abandoned by the English craft jewellers in protest against materialist standards of judgement. In fact, when Arthur Gaskin was commissioned to make a piece which was to be set with diamonds he had to find a special

71 An enamelled gold chain set with pearls and diamonds, designed by René Lalique in 1900. It is interesting to compare this highly sophisticated French work with the drawing by Arthur Gaskin [61].

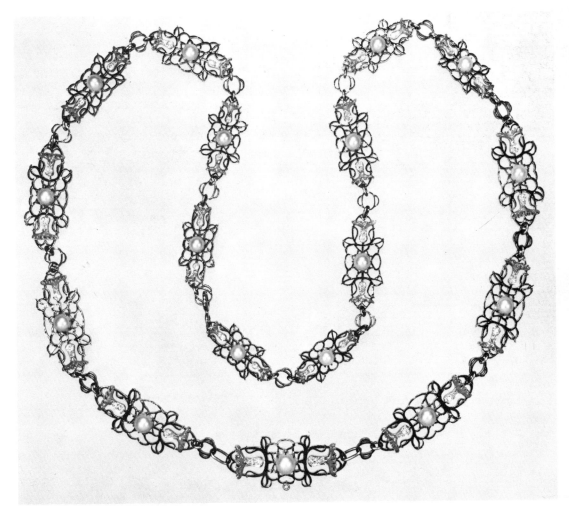

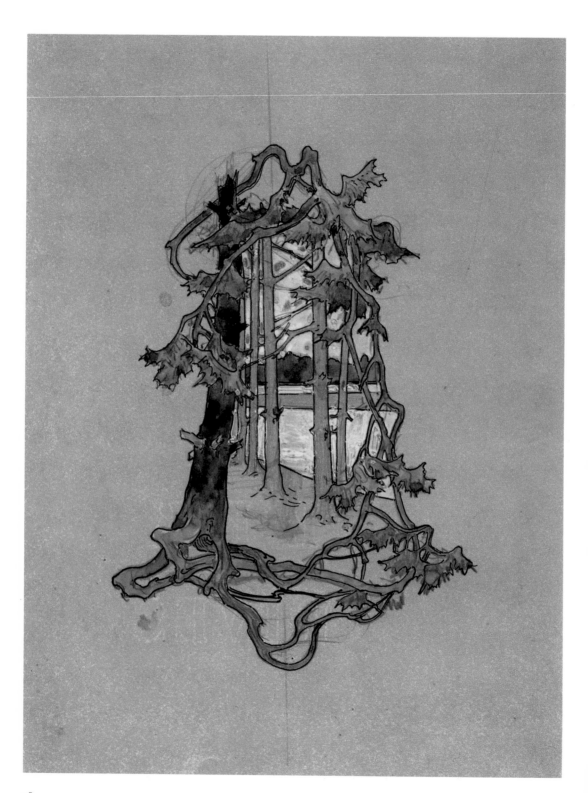

place to lock them up in since his workshop had no safe, or even a cupboard with a good lock. He had never felt the need of one.

The whole of the period covered in this book is very well documented; by exhibition catalogues, by the large number of illustrated periodicals which were published in the nineteenth century, and, in the case of French jewellery, by the publication between 1904 and 1908 of the standard work on the period, *La bijouterie française au XIXième siècle*, by Henri Vever, which was written when a large number of the important designers and craftsmen of the second half of the nineteenth century were still alive. Because of this mass of documentary material it is possible to attribute accurately a large number of surviving pieces to individual designers, or at least to particular firms or workshops. It becomes tempting to try and attribute the remaining unrecorded pieces, and a great cult of names has grown up, particularly around the work of the later period. A brief study of the volumes of the *Studio* or the *Art Journal* show how impractical this is, since they record a vast number of names about whom little or nothing is known, but who were obviously competent and prolific workers. A large amount of student work was produced every year in the many art schools which ran a metalworking course. There were also a number of small one-man workshops up and down the country, the names of whose owners are not even recorded and whose unidentifiable marks are to be found on small pieces of jewellery which turn up from time to time. These workshops were run on a poor financial basis and often closed after a relatively short time, like that of one immigrant Polish silversmith who made jewellery in silver and enamel, working in London in the period before the First World War, and who died of malnutrition in 1914. Under these circumstances, it is wise to be wary of either making or accepting attributions to particular artists without some reliable evidence, and to judge jewellery by the best standards of artistic quality and good workmanship.

72 opposite: René Lalique's drawing for the pendant illustrated below.

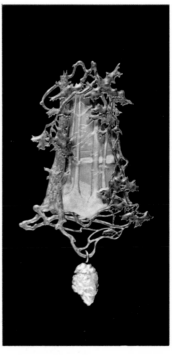

73 Enamelled gold pendant with baroque pearl, made by Lalique for Calouste Gulbenkian, c. 1900.

74 overleaf: Gold, coral and pearl necklace in the Etruscan style by Giacinto Melillo (1845–1915), a pupil and imitator of Castellani; c. 1880.

PART 2

Materials, Techniques and Marks

Materials

This was a time of enquiry and exploration, of improved communications, and the discovery of new resources; all of which affected jewellery of the period, not least in the use of materials. At a time of economic expansion, jewellery output increased to meet new demand, and the discovery of vast new sources of precious metals and stones was timely. Victorian women everywhere were gifted with amazing intellectual curiosity; this embraced geology, and explains the interest in stones of primarily geological, rather than necessarily great monetary, value. Mrs. John Sandford, writing of *Woman in her Social and Domestic Character* (*c.* 1837) says ' . . . her very boudoir breathes an academic air. Its decorations are sufficient to proclaim her character; its shelves are filled with books of every tongue; its tables are strewn with the apparatus of science; the casket of jewels is displaced for the cabinet of stones, the hammer and alembic occupy the stand allotted for the work-box.'

Stones are traditionally divided into 'precious' and 'semi-precious'; diamond, ruby, emerald, sapphire and pearl are generally regarded as 'precious', while amethyst, aquamarine, topaz, tourmaline, peridot, zircon, garnet, and all the other stones commanding a lower price than the precious stones, are all 'semi-precious' stones. This is usually regarded as a dubious distinction since absence of flaws and depth of colour are both important in determining price, and this

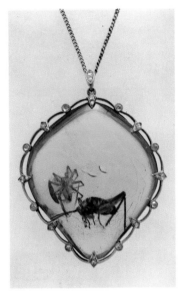

76 A piece of Baltic amber, containing a trapped spider and grasshopper, mounted as a pendant in the nineteenth century.

76 opposite: Pendant cross set with variously coloured sapphires, zircon, spinel, cairngorm and amethyst, within a border of small rose-cut diamonds.

77 A contemporary illustration of an English brooch by Ellis and Son of Exeter, who specialised in the use of local stones.

classification is now used as a guide to the status traditionally accorded to these materials. The precious metals most widely used in the nineteenth century were gold and silver, with various non-precious metals like aluminium, copper, bronze and steel being used mainly for ornamental pieces. Space does not permit here an exhaustive technical account; the aim is simply to indicate very briefly the range of materials available to the jeweller of this period, and the most typical uses to which they were put.

78 Brooch by Ellis and Son of Exeter set with possibly local agates. The pin includes a safety device which was patented by the firm.

Agate see Quartz

Alexandrite see Chrysoberyl

Amber

Amber is the fossilised resin of a prehistoric pine, pale-yellow or rust-coloured. It is found mainly in East Prussia — and occasionally on the sea-bed elsewhere. It was usually made into plain, polished, round or facet-cut beads and as a necklace was fashionable among the 'aesthetes' of the 1870s and 1880s. Inclusions trapped inside—such as a fly or lichen—were highly prized. Pieces containing them were mounted as polished pendants or brooches in their natural shape. Stresses produced artificially or by working the stone can produce a 'sun-spangled' effect. Reddish-brown Sicilian amber from the Simeto river was much prized in this period.

Amethyst see Quartz

Aquamarine see Beryl

Aventurine see Quartz

Beryl: Emerald and Aquamarine

Emerald and aquamarine are varieties of beryl. Emerald ranges from dark bluish-green to an almost colourless pallor; dark velvet-green emeralds are most prized. There are imitations—'Brazilian' emerald (green tourmaline), 'Oriental' emerald (green sapphire), or 'Ural' emerald (green demantoid garnet). Glass pastes are also used. Egypt, Colombia, Brazil and the Ural mountains (where emeralds were first found in 1830) are the main sources. Only the rare unflawed stones were used in expensive pieces (often combined with diamonds), except by 'archaeological' designers like Castellani and Giuliano, who used the flawed stones which were also used as beads at the turn of the century, for the interesting effects of colour and texture. Combined with gem-set and enamelled gold settings they were used, like rubies and sapphires, in the neo-Gothic jewellery (1850s) and Renaissance-revival jewellery (1870s and 1880s).

Aquamarine ranges from clear sky-blue (most prized) to an almost colourless slate. Unflawed aquamarine is more common than unflawed emerald. The large stones are most often found as the centre of a ring with a simple open-backed setting.

79 *Aquamarine pendant earrings, c. 1900, set in gold with pearls.*

Bog-oak see Jet

Cairngorm see Quartz

Chrysoberyl and Spinel

Chrysoberyls are green, greenish-yellow (most popular in this period), and pale brown. 'Alexandrite' (found on Alexander of Russia's birthday in 1830) is grass-green by daylight, pinkish red by artificial light. 'Cat's-eye', when cut *en cabochon*, shows a streak of light in the interior. This optical effect is known as 'chatoyancy'. Chrysoberyl cat's-eye is known simply as 'cat's-eye', and is not to be confused

with 'quartz cat's-eye', 'sapphire cat's-eye', etc. Spinels are ruby-red (occasionally known thus as 'Balas ruby'), or sapphire-blue, brownish-red, pinkish-red, violet-blue, purple and mauve. Except for the cat's eye, chrysoberyls and spinels were in the nineteenth century usually cut in a mixed cut, the top half like a brilliant, the lower half in a trap cut.

Chrysolite: Peridot and Olivine

Peridots are dark leek-green, and were fashionable in the late-nineteenth century. They were popular with the Arts and Crafts designers, and with firms such as Liberty's and Murrle, Bennett. The olive-green olivine was similarly used. They are varieties of chrysolite, known as such in its yellowish variety, also popular at the turn of the century.

Chrysophrase see Quartz

Citrine see Quartz

80 Brooch in highly chased gold set with a large sapphire and eight rubies.

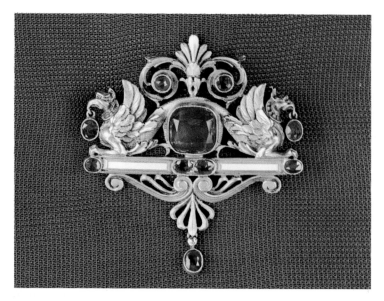

Coral

Coral is mainly found in the waters off Algiers, Tunisia, Sicily, Naples, Sardinia, Corsica, Japan and Malaysia. The nineteenth-century industry centred on Italy. The colours

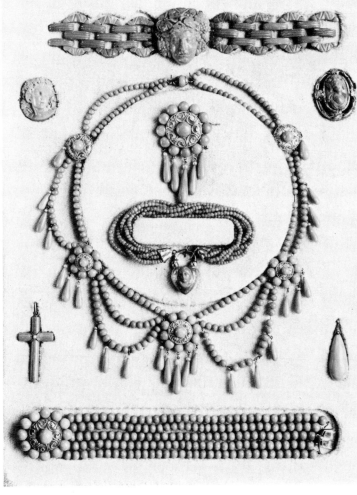

81 *Coral parure made in Paris in 1838.*

82 *Pendant in gold, decorated with* champlevé *enamels and set with a large oval carbuncle (garnet cut* en cabochon*), in the 'Holbeinesque' taste; English,* c. *1870.*

range from pure white (*bianco*) through shades of pink (*pelle d'angelo*, *rosa pallido* and *rosa vivo*) red (*rosso*, *rosso scuro* and *arciscuro*). Beads, cameos or small ornaments were made with primitive tools. The palest varieties were often used to make flower petals for gold and enamelled botanical jewellery. Branch coral (in its natural shape) tiaras were popular in the 1850s and 1860s. Coral was popular throughout the century in Europe, but most fashionable between 1830 and 1860; coral pieces were imported into America well into the 1880s. It was often combined with turquoises and half-pearls in simple gold brooches and bracelets. Coral was supposed to ward off evil spirits—all Italian children were given coral necklaces or amulets at birth—and a small piece of coral jewellery was the traditional present from a godparent.

Cornelian see Quartz

Corundum: Ruby and Sapphire

Ruby and sapphire are varieties of corundum, red and blue respectively. Purple, yellow and white sapphires are also known but less desirable. Both are found in Siam, sapphires also in Ceylon and Montana, U.S.A. (discovered there in 1895). They were popular throughout the century, less so in the 1860s and 1870s when coloured jewellery was unfashionable. They were usually facet-cut and combined with diamonds in expensive pieces, or cabochon-cut and set in gold with enamel in the neo-Gothic or 'Holbein'-style jewellery fashionable in England in the 1850s and 1860s. Both stones sometimes show 'asterism'—the optical effect of a six-pointed star—when cut *en cabochon*. Where there is only one ray of light (as distinct from three) a 'corundum cat's-eye' is the result.

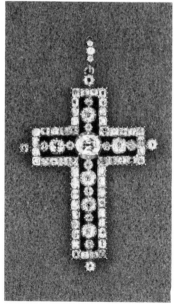

83 Pendant cross set with diamonds, c. 1850.

Diamond

Diamonds were fashionable everywhere throughout the whole of the nineteenth century and their popularity survived both the movement towards unostentatious jewellery in the 1830s and the views of the influential artistic coterie at the turn of the century, by whom they were regarded as vulgarly ostentatious. They are used for every kind of jewellery where the design is intended to give prominence to the stone rather than the setting.

Diamond is the hardest and most highly prized precious stone. By 1800 Indian deposits were virtually exhausted; but the Brazilian mines still produced stones throughout the nineteenth century. American and Russian finds were made, but without commercial significance, and work on all of them virtually ceased except in Arkansas. The year 1868 saw the discovery of the great South African deposits which produced spectacular stones—e.g. the Star of South Africa (1869), the Tiffany (1878), the Victoria, or Great White (1884), the Excelsior (1893) and the Jubilee (1895). The Cullinan, the largest ever recovered, was found in the Transvaal in 1905.

Diamond hardness is expressed as 10 on the Mohs scale, and other stones are related to it. Attempts to make artificial diamonds were made in this period; results are unsatisfactory even today. Ways of 'improving' diamonds were

tried—for example, backing with blue wax or varnish to simulate the best blue-white colour. There are elaborate tests for carat-weight, clarity and cut. Nineteenth-century imitations included white varieties of sapphire, zircon, topaz or beryl, alone, covered with a layer of diamonds (a 'doublet'), or sandwiched between two layers (a 'triplet'). Colourless crystal and glass paste were also used. Real and imitation stones were sometimes mixed. In practice an expert opinion is the only safe guide to the collector.

Emerald see Beryl

Feldspar: Moonstone, Sunstone and Labradorite

Moonstone, sunstone and labradorite are the varieties of feldspar commonly found in jewellery. Moonstone is nearly colourless with a slight milky sheen, and in some lights displays a bluish tinge. It is cut *en cabochon*, and was popular with the English and American craft jewellers. Sunstone, like aventurine quartz, appears spangled, due to haemetite

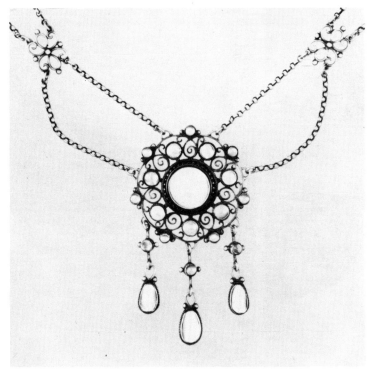

84 Arts and Crafts necklace set with moonstones and pearls, 1900–10.

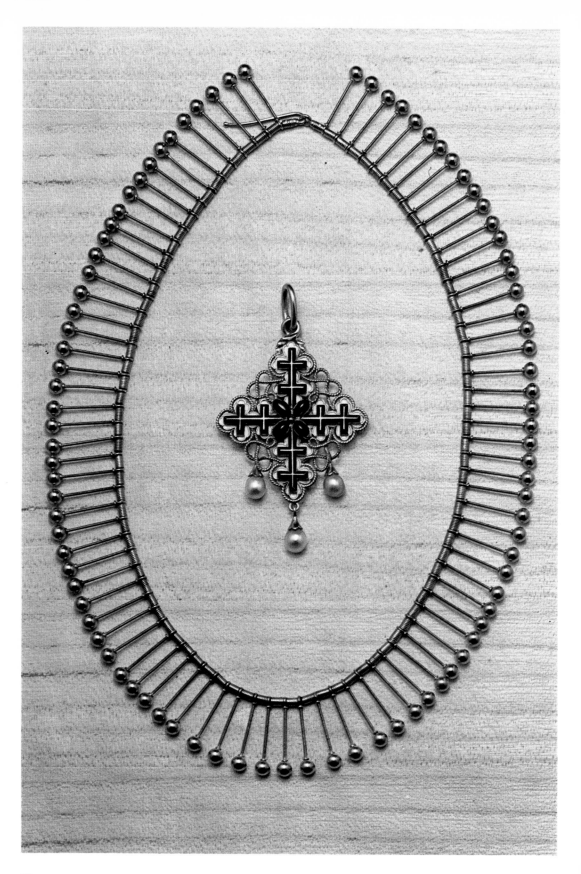

85 opposite: Fringe necklace in gold, by Robert Phillips, c. 1860; pendant in enamelled gold set with cabochon-cut sapphires with three pendant pearls, by Carlo Doria, c. 1870.

86 below: Gold jewellery in the 'archaeological' style; two fringe necklaces, one set with cabochon-cut sapphires, and a pendant decorated with enamels, made by Carlo Giuliano, c. 1870.

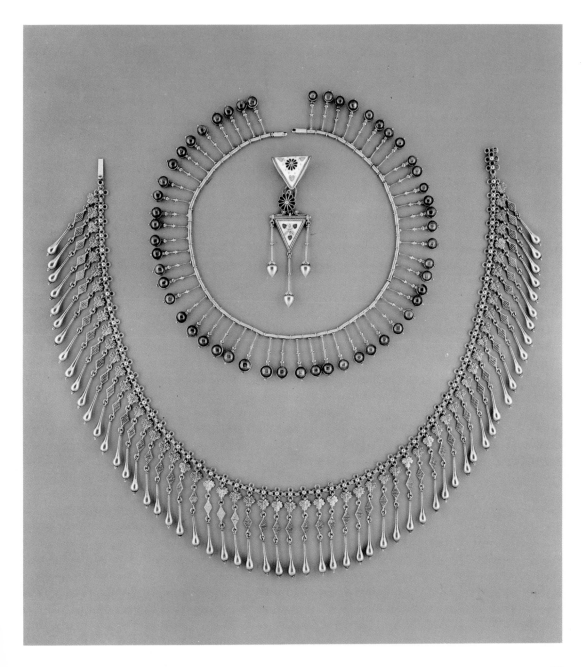

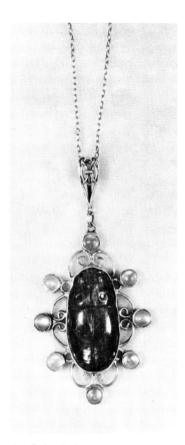

or other inclusions. Hence, sometimes, the term 'aventurine feldspar'. It was used like the quartz, and also for small carvings designed for rings. Labradorite, greyish by daylight, can show a fleeting display of colour, but was rarely used for jewellery.

Fluorspar ('Blue-John')

'Blue-John' (from a corruption of the French *bleu-jaune*) is purple fluorspar; found in Derbyshire, England, it was used to a limited extent in a similar way to Scottish agates and granites, and for inlaid work similar to 'Florentine' intarsia (see p. 126).

Garnet

The usable, clear stones prized in the nineteenth century came primarily from Ceylon, Brazil and Bohemia. The blood-red pyrope is the best-known variety; it is found in Bohemian-work, which used star- or flower-shaped clusters of the small Bohemian stones. The violet almandine garnet was widely used, usually as a 'carbuncle' (garnet cut *en cabochon*) in the centre of brooches or pendants [82], or cut in a heart shape for rings or the centre of a cross. The hessonite, or cinnamon-stone, is greenish-yellow (sometimes imitated in the East by polished fragments of Coca-Cola bottles!); the demantoid garnet ranges from deep emerald green to pale yellow (sometimes known as 'Uralian emerald'); spessartine is a red variety found also in the United States, and these stones are used as an inexpensive substitute for rubies and emeralds in neo-Gothic and Renaissance-revival pieces.

87 Labradorite scarab pendant, 1900–10.

Glass

Glass is best known in its use for paste imitations (see p. 101), but was also used as a jewellers' material in its own right. Venetian glass-bead jewellery was rich and varied, but little survives. The Venetian beads were often combined with gold in combs, earrings, brooches and necklaces. Major exponents of glass jewellery were Lalique, who finally took up glass-making exclusively, and Tiffany, whose 'Favrile' glass scarabs were often used for jewellery in the 'Etruscan' taste.

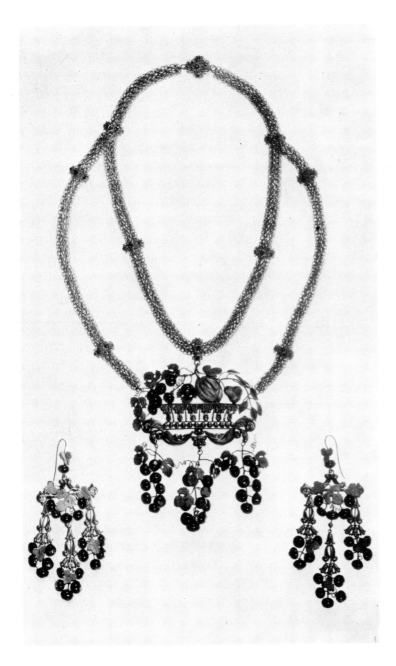

88 Garnet and coloured-gold grape necklace and earrings; French, 1830–40.

Gold

Apart from its function as a setting for precious stones, and a vehicle for enamel work, gold was used, alone or in combination, for some of the best nineteenth-century work,

89 *Three ivory brooches and a pair of earrings; French or Swiss, c. 1850.*

90 *Enamelled gold brooch set with lapis lazuli; Carlo Giuliano, c. 1880.*

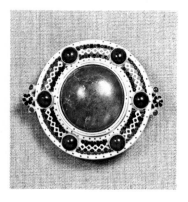

91 *opposite: Group of pearl jewellery set with pearls, half-pearls, and diamonds; English, 1880–90.*

e.g. Castellani's 'archaeological' jewellery, and Fabergé's revival of eighteenth-century *trois-* and *quatre-couleurs* work which was similarly technically demanding. There were various sources: as with diamonds the traditional sources were almost worked out by the early nineteenth century, but gold had been discovered in California and in Australia in the mid-century; and in 1884 it was discovered in the Transvaal. South Africa became the main producer. It is usually discovered in association with silver (and was in this combination thought to be a different metal, 'electrum'), or mercury; it does not oxidise, and is highly malleable. Pure gold is too ductile for use in jewellery; it is used in combination with other metals, and the gold content is expressed in carats. Pure gold is bright, pale yellow, and jewellery (particularly oriental) was often given a final pure gold wash to improve the colour. Copper added gives red or pink gold, but silver is usually also added to this for ease of working. Nickel or nickel and zinc added give white gold (today produced by the addition of 10% palladium, a form of platinum). The permissibility of 9-carat gold in England from 1854 rendered substitutes such as pinchbeck unnecessary thereafter, although filled-gold (rolled-gold) American jewellery was made throughout this period. English assay laws were in fact the most rigorous, but broadly the same standards of quality were applied elsewhere. The stamped imitation *repoussé* settings of cheap 'rococo-revival' jewellery fashionable in the 1860s were sometimes filled with a compound to give weight and appearance to pieces made with the thinnest possible metal. From the beginning of the period the French tried mechanical gold-working—stamped Empire links and settings are more successful than later attempts; French Empire and Restoration attempts at cheap 'Etruscan' granulation of 'Gothic' filigree lack the quality of the best Italian models of the same period, which were the result of much hard work and research.

Horn

Horn was used at the turn of the twentieth century as an alternative to tortoiseshell. Lalique's example was followed by Gaillard, who fully exploited the material's colouring. It became very fashionable in the early 1900s, much of the work being carried out by Japanese craftsmen in Paris.

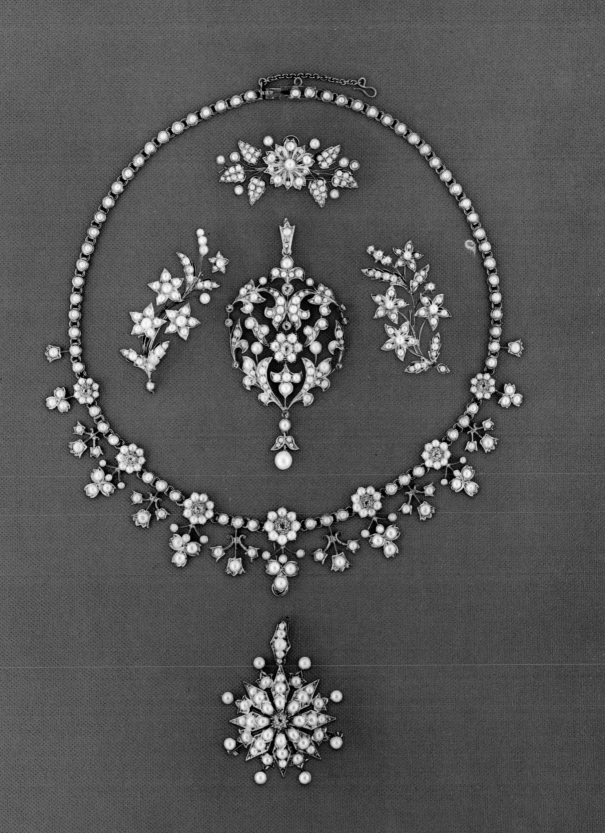

92 Horn hair-ornament by René Lalique.

Iron see Paste etc.

Ivory

Ivory is the material obtained from mammoth tusks or teeth. Like amber, it became a symbol of 'aesthetic' protest against extravagance in jewellery. Most ivory jewellery is in the form of miniature sculptures or carvings. In the early 1800s the traditional ivory-carving industry in Dieppe, France was revived, but died out by the mid-century. The Swiss too specialised in delicate carving—for example crosses elaborately wreathed in flowers or ivy, and hands holding bouquets. Lalique, Wolfers, and the English sculptor Richard Garbe were responsible for a revival in its use at the turn of the century. Much commercial Art Nouveau jewellery used ivory, usually carved in low relief with one of the motifs then fashionable, like the female head surrounded by flowing hair.

Jet and Bog-oak

Jet is a black fossilised variety of brown coal found mainly around Whitby, Yorkshire, England, and Galicia, Spain. It was used in this period mainly for mourning jewellery.

Bog-oak is a hard, black, fossilised wood, found mainly in Ireland buried in bogs. In jewellery it is found in much the same applications as jet, and in some specifically Irish celtic pieces as well. Much Irish jewellery was made on a 'cottage-industry' basis, hence perhaps the variable quality of much of the work.

Lapis lazuli

Lapis lazuli is an opaque blue stone ranging from greenish-blue to purple-blue, dark-blue being the most desirable. Iron pyrite inclusions usually appear as bright gold specks. Afghanistan is the principal and traditional source; a paler variety comes from the Chilean Andes. In this period it was frequently used in neo-classical and Egyptian revival jewellery, and in inlaid work and intarsia panels. It is most effective with gold, but craft-revival designers in England and America combined it with silver. Stained jasper served as an imitation, known as 'Swiss' or 'German' lapis. Some rather garish imitations were made from glass containing spangles of copper crystals.

Labradorite see Feldspar

Malachite

Malachite is a stalagmite copper ore with characteristic circular banding due to the crystal formation; it ranges from dark (*foncée*) green through *ordinaire* and *claire* to light (*pâle*) green, similar to 'Queen Anne' green. Pieces of malachite were most often used as low-relief cameos, *en cabochon*, or as beads. Although widely distributed, malachite was in fairly short supply since the principal sources are in the Ural mountains; the production of the famous Nizhnii-

93 Three-coloured gold bracelet set with malachite; French, 1830–40.

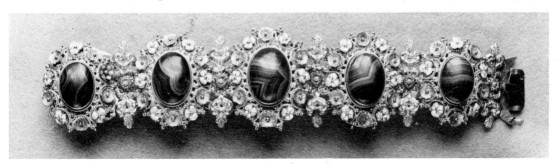

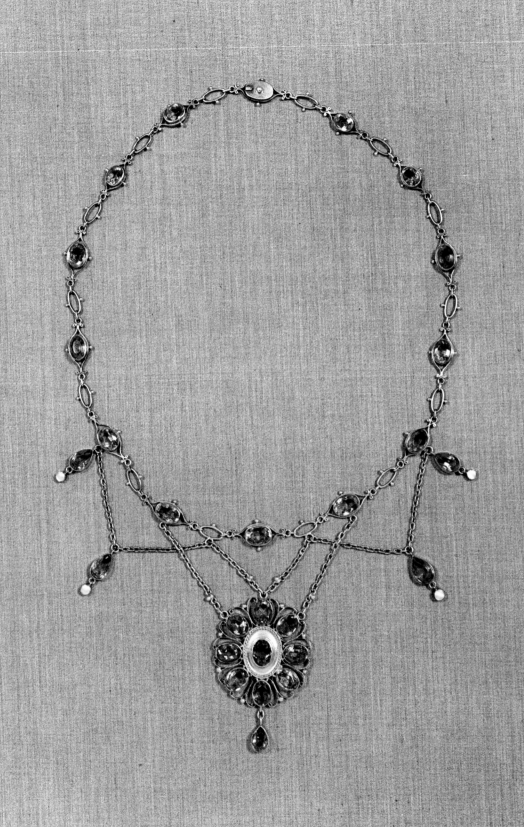

Tagilsk and Mednorndiansk mines were once the prerogative of the Russian Imperial family. It was discovered in Australia in about 1850, and thereafter became more plentiful. After 1850 some inexpensive pieces were produced from slightly convex pieces inlaid into silver or silver-gilt, or with long cylindrical, hexagonal, or octagonal beads. Unlike the earlier cameo work, the quality is rarely high. It was occasionally used as the surround of the delicate Italian mosaic fashionable from 1830 to 1860, and in round gold 'Etruscan' brooches. Before the great influence of Fabergé, the stone was best exploited by the Italians.

Marquisite see Paste etc.

Moonstone see Feldspar

Moss-agate see Quartz

Olivine see Chrysolite

Onyx see Quartz

94 opposite: Necklace and pendant, silver partly gilt and set with amethysts and mother-of-pearl; cf. the necklace by Bernard Cuzner [164]; English, c. *1900.*

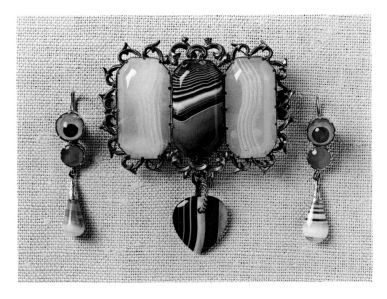

95 Brooch and earrings in gold set with artificially coloured chalcedony. Much of the cutting and colouring of agates was done during the nineteenth century at Idar-Oberstein in Germany.

Opals

The paler opals were often undervalued in the nineteenth century because they were held to be 'unlucky'. Until they were discovered in the mid-nineteenth century in Australia,

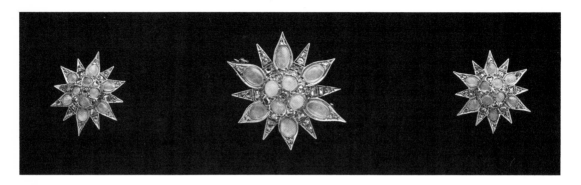

96 *Set of three brooches; the smaller pair has been converted to earrings. They are of gold set with opals and small diamonds; English, c. 1890.*

the main source of the stone was Hungary. Hungarian stones have a milky-white background to a display of red, blue and green fire. Yellow or pinky-red 'fire' opals were mined in Mexico from 1835. The stones were extensively used at the end of the nineteenth century particularly by French Art Nouveau and English craft jewellers. Cameos cut in opal became popular briefly at the turn of the century. Black opals (first discovered in Australia in the 1860s) used for cravat pins and lace pins are cut nearly flat to give a broad display of fire; these require special care as they are easily scratched, and constant repolishing wears away the stone.

97 *Two buckles and a chain with a pendant cross in the Gothic style; made of Berlin iron, c. 1850.*

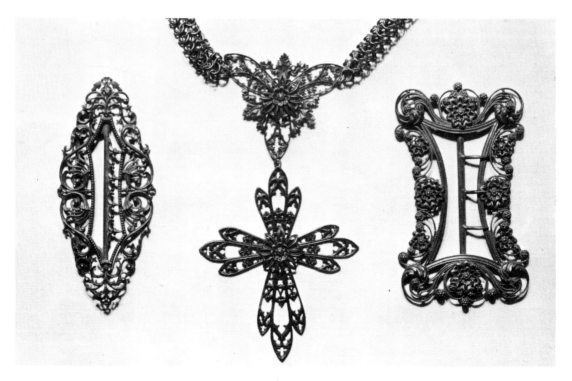

Paste, Steel, Iron, Pinchbeck and Marquisite

These were all essentially substitute materials, but except for pinchbeck, acquired their own styles and techniques. By 1830 interest in them had declined, although all were used until about 1850. Pastes were used throughout the century.

Paste (or sometimes 'strass') was developed in the early eighteenth century by G. F. Stras (*sic*), the French court jeweller. It could be faceted and polished, and enhanced by foil, or in the early nineteenth century mirror, backing.

Steel and *iron* jewellery had become unfashionable by 1830, although a large steel châtelaine appeared at the 1851 Great Exhibition (it is now in the Victoria and Albert

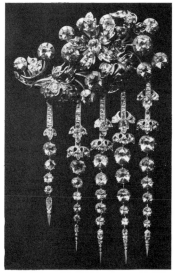

98 Silver brooch set with pastes; English, c. 1850.

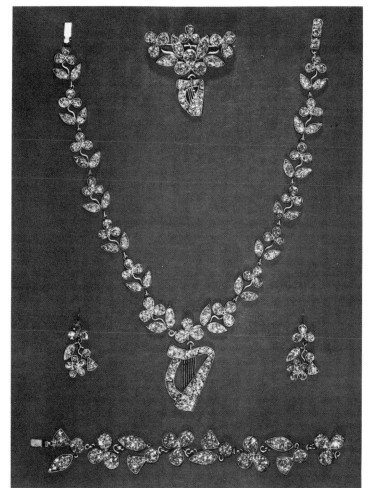

99 Marquisite necklace with links in the shape of shamrocks and a pendant Irish harp; a bracelet, brooch and earrings complete the set; made by Messrs. Goggin of Dublin.

Museum, London), and steel jewellery was manufactured throughout the century. Iron jewellery production in the early 1800s centred on Berlin—again, an example was shown in the Great Exhibition, but little was made after the 1840s.

Pinchbeck (known in Germany as similor), an untarnishable imitation gold developed by Christopher Pinchbeck in the eighteenth century, is an alloy of zinc and copper. It was widely used up to the 1850s, but was displaced with the development of other substitutes and the permissibility in England of an alloy with a lower gold content.

Marquisite jewellery, often confused with cut-steel work, is made from iron pyrites (often known as 'fool's gold'). Marquisite was widely used in the eighteenth century as a fashionable substitute for diamond; it was again popular from the mid-nineteenth century for inexpensive fashionable trinkets, the most delicate work being traditionally produced by the Swiss.

100 Bracelet in gold set with agates, smoky quartz and jasper found in Scotland; made by Mackay, Cunningham, of Edinburgh, 1848. There is a dated inscription on the back of the heart-shaped pendant which is made with a compartment to contain hair.

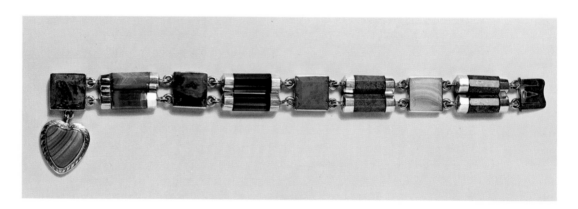

Pearl

Pearls are used unaltered in any way—the skill lies in matching them. They were among the most valuable stones until cultured pearls were introduced at the end of the nineteenth century. Like diamonds, pearls were never really out of favour during the whole of the century; unlike diamonds they never seem to have attracted a reputation for being vulgarly ostentatious. A foreign body causing irritation in the oyster shell is coated with nacreous substance to produce either a 'blister' or a spherical 'cyst' or 'mantle' pearl. Silvery-white and gunmetal-coloured 'black' pearls are the most valuable. The rare, irregularly-shaped examples are known as 'baroque' pearls; small examples are produced by mussels in Scottish rivers—known as 'Scotch' pearls,

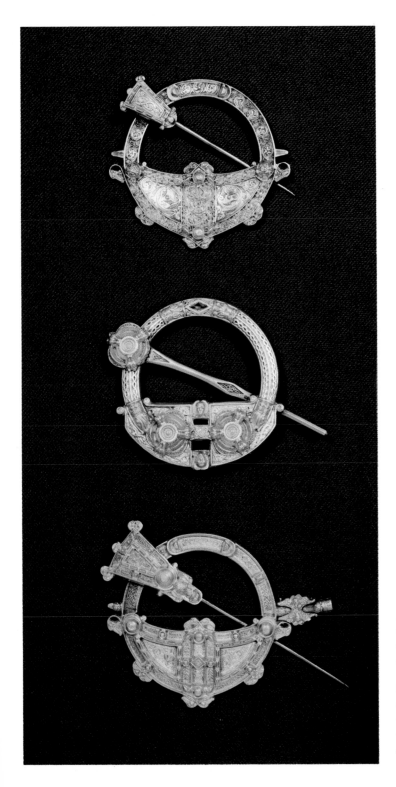

101 Three Celtic-revival ring brooches in silver, parcel gilt, chased and engraved. The top and bottom brooches made by Messrs. Waterhouse of Dublin, and the middle one by West of Dublin, all three are versions of the Celtic ring brooches shown at the 1851 Great Exhibition in London (see Art Journal Illustrated Catalogue, 1851).

popular in Scottish celtic revival jewellery, and in commercial Arts and Crafts-style pieces. Tiny pearls are known as 'seed' pearls; a continuous string threaded onto horsehair was sometimes worked into delicate flower and leaf shapes, or used to make hairwork pictures for 'sentimental' pieces.

France was the manufacturing centre of 'Roman' pearls, glass imitations coated with scales of the bleak, a fish. These were deceptive, if fragile. 'Venice' pearls were a more robust imitation, made of an igneous substance, not to be confused with 'perles de Venise', the glass beads made at Murano. In general, however, imitations were either unsatisfactory or too expensive.

Pearls are long-lasting if looked after; they crack and lose their lustre if kept in too dry an atmosphere; acid from human skin and some cosmetics can corrode them—a slightly barrel shape sometimes results. If often worn they should generally be cleaned and restrung every six months. They can also be damaged by some solvents intended for cleaning gold and silver.

Peridot see Chrysolite

Pinchbeck see Paste etc.

Platinum

Platinum is the most valuable of the precious metals. Unlike today, it was rarely used in the nineteenth century for jewellery. The few examples recorded include mourning jewellery advertised in 1827, a beautiful platinum and diamonds tiara in the form of a spray of blackberries made by Fontenay, and a number of diamond pieces of the 1890s.

Pottery and Porcelain

These materials were variously used, but fragile; little has survived, especially as the settings were usually of low value.

Jasper is a porcellanous stoneware coloured by staining, introduced by Wedgwood in 1774, often used in delicate blue, lilac, yellow and green as a ground for white cameo-like applied decoration in the neo-classical taste. Small plaques were designed to be set in cut-steel mounts as jewellery. Some existing cameos were mounted or re-mounted in lightly engraved gold settings or colourless

pastes in the 1840s and 1850s. Later jasper cameos show a lack of fine detail.

Parian was a hard white porcelain introduced in 1842, and mainly used for imitations of popular sculptures. Parian jewellery was mainly small brooches and bracelet clasps, cheaper (but fragile) imitations of popular ivory forms such as wreaths and bunches of flowers.

Belleek is a pearly porcelain with an irridescent glaze, capable of fine, detailed working. Wares were first shown at Dublin in 1865; the jewellery, like parian, was mainly in imitation of ivory forms.

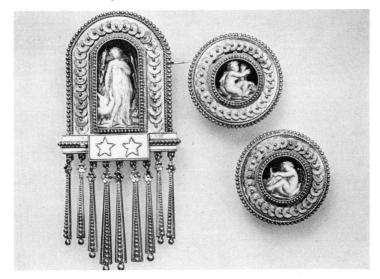

103 Brooch and earrings in gold set with porcelain enamel plaques; English, c. 1862.

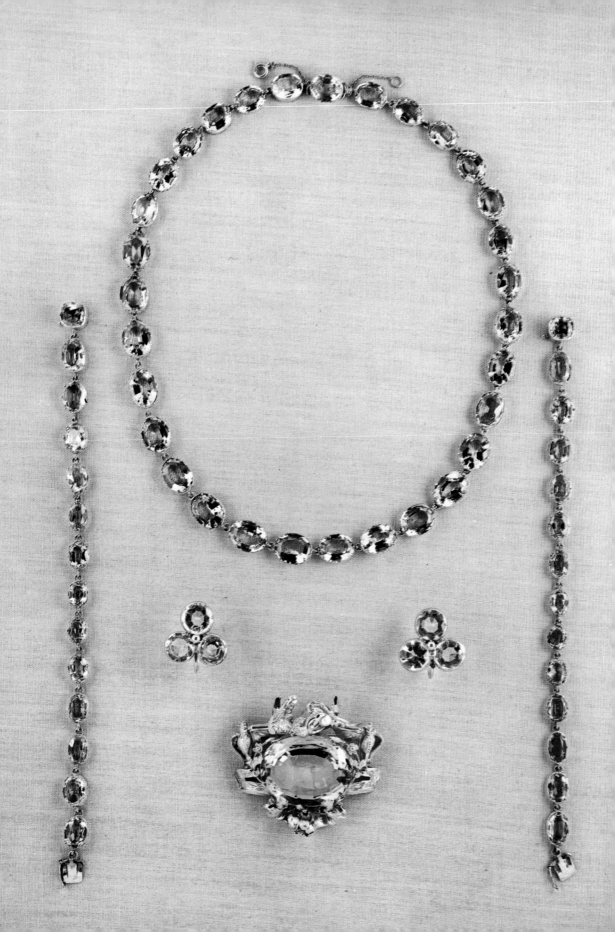

104 opposite: Necklace, bracelets and earrings set with topaz; English, c. 1840. The brooch is made of chased gold set with topaz and pearl; French, c. 1850.

Enamelled porcelain plaques, in the Limoges style (see p. 154), were produced in England by the Worcester factory; other plaques used in brooches, earrings and pendants were decorated with 'Etruscan' or 'Watteau' enamels. These were fashionable in the 1850s and 1860s.

Ruskin pottery (produced in West Smethwick, England), was primarily small circular or oval plaques with mottled or speckled glazes. It was set in silver or silver-gilt as brooches or buttons. It was produced from 1898 to 1933, bearing the impressed mark 'Ruskin' or 'Ruskin Pottery'.

105 Gold necklace in the form of a snake with ruby eyes; the body is set with turquoises.

Quartz

Quartz is commonly divided into 'crystalline' and 'crypto-crystalline' types, the latter known as 'chalcedony'. It is very widely distributed, and has since earliest times appeared almost throughout Europe in local and traditional jewellery. The types of crystalline quartz most widely used for nineteenth-century jewellery are amethyst, citrine, rose-quartz, rock-crystal, cat's eye and tiger's-eye, cairngorm and aventurine. The most commonly used chalcedony types are banded agates and onyx, sardonyx, cornelian, chryso-phrase, and moss agate.

Amethyst is the most prized quartz, ranging in colour from a faint mauve to the most valuable deep purple charac-terising the 'Siberian' amethyst, named after its early source, and used *en cabochon* in ecclesiastical and neo-Gothic jewellery. Large faceted stones are found set with a border

106 Gold cannetille *cross set with yellow agates; English,* c. *1840.*

of diamonds or pearls, or, in mid-Victorian rococo style brooches and pendants, lavishly engraved gold. Late in the century sources were found in Brazil and Uruguay, and the value of amethyst dropped. Pale amethysts were widely used by English craft jewellers in silver and silver-gilt jewellery.

Citrine ranges from a light golden to a rich brownish yellow. It is usually used in the form of round or oval faceted stones, in the mid-Victorian period in carved or engraved gold settings; in the 1880s in delicately enamelled brooches and bracelets; up to 1900 and later in elaborate festoon necklaces in the much-imitated Giuliano style [194]. True citrine is rare. A type of yellow-brown quartz is often sold as topaz, but is actually heat-treated amethyst.

Rose-quartz is rare and ranges in colour from strong rose-pink to nearly white. It is rarely very clear. Cloudy pink stones were polished for the heads of canes and parasols. Drop-shaped stones were mounted as pendants. Rose-quartz is prized for its beautiful colour.

Rock-crystal is colourless quartz, widely distributed in pieces of all sizes. In the eighteenth century particularly, but also in the period covered by this book, it was used, like glass pastes, in designs calling ideally for diamonds. Local deposits acquired names such as 'Bristol' or 'Bristow diamonds', 'Rhine diamonds' etc. They were rose-cut, and 'improved' by foil-backed closed settings until these became unfashionable. Cabochon-cut stones, carved and coloured from the back with realistic scenes, are known erroneously as 'Essex crystals'—the miniaturist William Essex seems to have had nothing to do with them. These reverse crystal intaglios became very popular in England and in the United States. Although first imported by American firms, it seems that this intaglio work was done in America fairly early, possibly by English migrants. With the fashion for colourless jewellery in the 1870s and 1880s, crystal beads became fashionable and they were also used to lighten the effect of necklaces of coloured stone beads.

Cat's-eye quartz is honey-yellow, brownish, or grey-green; *tiger's-eye quartz* is golden yellow. They were best cut *en cabochon*, usually for rings, larger stones sometimes being set in a plain gold collet in the form of an oval. *Tiger's-eye* is also, more rarely, cut flat and polished. As their names imply, they are both chatoyant forms of quartz.

Cairngorm is a reddish-brown, smoky quartz found in Scotland in the Cairngorm Mountains. It was often used in the traditional gold and silver Scottish jewellery popular from 1850 to the 1880s and 1890s, a fashion originating

107 Mourning watch, originally the property of President Lincoln's widow. It is set in black onyx and suspended from a black onyx fob.

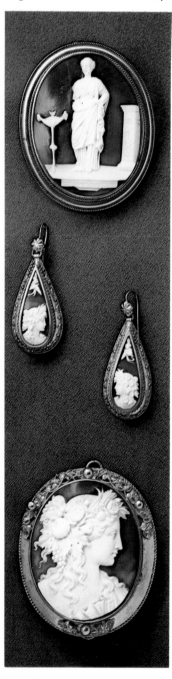

partly from the Queen's passion for Balmoral Castle, her Scottish retreat.

Aventurine quartz has plates of mica enclosed, which add a gold-spangled effect to its reddish-brown, yellow, or green colour. It was cut flat and polished, and used in brooches and bracelets, or to frame tiny mosaic pictures. It was often imitated with 'aventurine' glass.

Agate and *onyx* are banded stones and were popular for their geological interest. Heat-treated agates were used for cameos and intaglios, and were artificially stained and coloured for the brightly coloured jewellery popular in the mid-Victorian period [95]. Idar-Oberstein, Germany, was the main source, later Brazil, Uruguay and Paraguay. Some were also found in Scotland, and used for popular Scottish jewellery.

Sard is the yellowish or brownish-red variety of chalcedony. When the material is banded in layers of reddish-brown and white it is known as 'sardonyx'. These stones were used for cameos and for seals.

Cornelian (or *carnelian*) is a deep, clear red in colour, mainly used for beads. It was used plain or faceted, or carved to imitate ancient scarabs in 'archaeological' jewellery. Egypt was a chief source. Heat will impart the same colour to colourless chalcedony. Cornelian was also used for intaglios, seals, and signet rings.

Chrysophrase ranges from a clear apple-green to a dingy yellow-green; it is most frequently found in the deep-green slightly tinged with blue. It is used cut in a steep cabochon, and was much used for silver Arts and Crafts jewellery between 1900 and 1918, and as beads, simply polished or fluted.

Moss agate is agate with black, green, or red moss- or tree-like (dendritic) inclusions, sometimes resembling a distant rocky landscape—hence 'landscape' or 'scenic' agates. They were popular with the Victorians, but less so than with their predecessors.

Rock-crystal see Quartz

Rose-quartz see Quartz

Ruby see Corundum

Sapphire see Corundum

Sard see Quartz

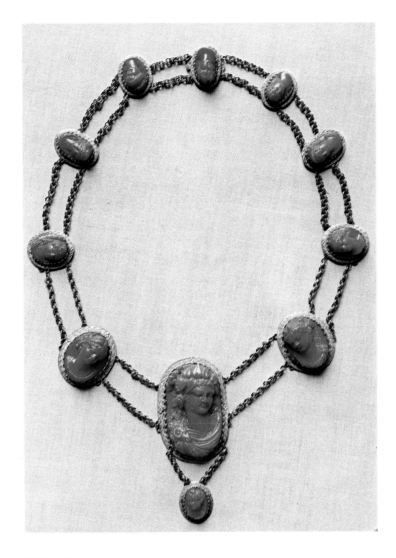

109 Gold necklace set with scarlet coral cameos from Naples or Genoa, c. 1850.

Shell

Many forms of shell were used in jewellery, mother-of-pearl from many sources being the most common. Palais Royale wares, the French mother-of-pearl ornaments made since the seventeenth century, were still being produced in the nineteenth. Craft jewellery, together with the jewellery of firms like Liberty's and Murrle, Bennett in England, Theodor Fahrner in Germany, and Gorham in the United States, brought a revival in the popularity of shell at the turn of the century.

The greeny-blue abalone shell which is found in Mexican traditional jewellery was popular with Arts and Crafts

jewellers; the helmet and giant (queen) conch were used mainly for cameo-cutting, especially in Italy and France. Shell cameos were generally gold-set; otherwise shell jewellery was generally silver-set, and popular in England in the second half of the nineteenth century, when coloured jewellery was out of favour.

110 Silver buckle set with pink shell surrounded by diamonds and translucent enamel; made by Peter Carl Fabergé, c. 1900.

Silver

Silver jewellery violently fluctuated in popularity. It was often a cheaper substitute for gold, and used on a large scale. In the 1830s it was popular for all kinds of fashionable pieces, less so in the 1850s, but from the 1860s until the 1890s it remained in demand. Sometimes its colour and texture were particularly suitable to a design, for example the very sculptural designs of French Gothic-style jewellery, or the hand-wrought shapes of the craft revival, for which it was much used at the turn of the century. Mexico and Peru were and are the principal sources, followed by Sweden and Russia. The great Comstock Lode in Nevada, U.S.A., was discovered in 1860.

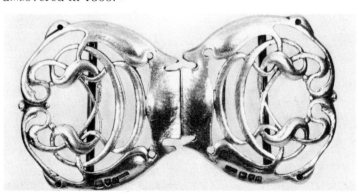

111 Silver buckle by Liberty, 1900.

Usually found in association with other metals, silver is used in its pure state (fine, or solid silver) alloyed with copper (sterling silver), or, more rarely in jewellery, plated onto a base metal. Silver tarnishes very quickly on atmospheric contact; cleaning is easiest by dipping in solvent, but the surface quality of old silver is produced by rubbing clean. In this period artificial 'antique' finishes were tried: 'oxidising' (a misnomer) by immersion in a near-boiling potassium sulphide solution; or patination, the artificial surface texture and colour imitating the patina of time. The neo-Gothic 'antique' finish was achieved by brushing potassium sulphide solution into the corners and round the edges of the design. Some silver pieces are partly or completely gilded which produces the characteristic silver-gilt colour which is much more subtle than pure gold [101]. The fashion for Japanese styles in the 1870s boosted the popularity of silver, which was inlaid with other metals. In France and the United States, unlike Britain, assay laws permitted the making of gold Japanese-style jewellery with applied or damascened silver and copper; in England only coloured-gold decoration could be used.

Silver's popularity with the craft revival was partly economic, but partly ideological. True handcraftsmanship was to be combined with inexpensive materials to produce worthwhile replacements for mass-produced, shoddy trinkets. But the working classes were not induced to buy, and the Birmingham manufacturers undercut the craft-revival jewellers with machine-made copies of their work, produced at lower prices.

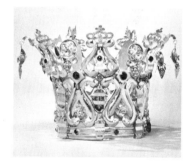

112 Traditional silver bridal crown; by Desingthun, Norwegian, c. 1830.

Spinel see Chrysoberyl

Steel see Paste etc.

Sunstone see Feldspar

Topaz

The topaz in its natural state ranges in colour from a sherry-brown to a pale clear yellow; it can be pale blue, and, most common of all, colourless 'white'. Yellow stones can be heat-treated to produce the clear, pale pink rarely occurring naturally. Almost all yellow stones found in jewellery tend to be called 'topaz', but many of these are probably yellow quartz. Topaz crystals form easily into pendeloque (or drop-

shaped) stones, and were often cut in this way. In spite of their hardness, they break easily and should be treated with great care.

Tortoiseshell

The semi-transparent, mottled-brown sea-turtle shell was specially popular in the first half of the nineteenth century, after which the quality of the gold- and silverwork used to decorate it declined. However, tortoiseshell was widely used, especially in the United States, until almost 1900. Delicate heat makes the material malleable, ready to receive the gold- and silverwork known as *piqué*. Small rods or stars are used to make *piqué point;* plain or scalloped strips are used to make *piqué posé*. By the 1840s much *piqué* was being enriched with materials like mother-of-pearl and other shells. Much late American work bore formal designs in gold, steel, or gilt-metal 'nail-heads', which stand up slightly from the surface. The best American work is in the form of pendants or crosses, or fine-link chains, all worked from the shell without any metal decoration. In the United States in the 1860s a fashionable evening head-dress was a large tortoiseshell comb decorated with a network of gold filigree and tortoise-

113 Group of tortoiseshell brooches and earrings decorated with gold and silver piqué posé; English, late nineteenth century.

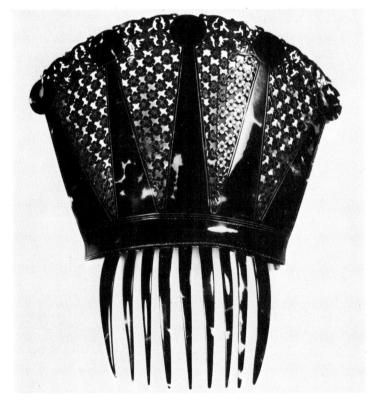

114 A comb made of finely carved tortoiseshell; Spanish, nineteenth century.

shell beads, terminating in gold amphora-shaped drops falling from the head of the comb in a 'waterfall'. Tortoiseshell combs were widely used—for example the Spanish mantilla comb, briefly fashionable in the 1870s. By 1875, tortoiseshell ornaments other than the comb were unfashionable, and the introduction of mass-produced *piqué posé* work in 1875 (in Birmingham, England) led to the gradual disappearance of true *piqué*.

Tourmaline

Tourmalines are striped or parti-coloured shading from pink to green, or chatoyant, cut *en cabochon* as 'tourmaline cat's-eyes'. Heat treatment tends to lighten the colour. The stones were normally cut with a brilliant upper part, and trap-cut or step-cut below the girdle. Large flawed stones were used for small carvings, a Chinese speciality, and these became fashionable as pendants after 1900.

Turquoise

Turquoise is opaque. The value lies in the colour, which ranges from intense, clear, sky-blue to a greyish green, the most common and least desirable. Ammonia immersion or heat treatment are used to 'improve' the colour, but these methods are easily detected, and impermanent. There are large Mexican deposits; the Navajo Indians' traditional jewellery is of silver set with turquoises, but the main source is the East, particularly Persia. Eastern influences are apparent in Victorian turquoise jewellery, especially when Indian jewellery was fashionable in the 1870s. Naturalistic, 'Romantic' jewellery of the 1840s in the form of flowers and insects, was often gold pavé-set with turquoises, as were the round, gold 'Etruscan' brooches of the 1850s and 1860s.

Zircon

Zircon ranges in colour from red and reddish-brown (these stones were respectively known in the nineteenth century as hyacinths and jacynths), to pale yellow and colourless (sometimes known as jargoons). Brown stones can be heated to produce blue—indeed, almost all zircons used in jewellery are thus treated, including the colourless variety which is one of the most common diamond substitutes. Zircon was usually cut into a modified brilliant.

Techniques

Cameos and Intaglios

The ancient art of gem-cutting—of which the great Gemma Augustea, from the first century B.C. (now in the Kunsthistorisches Museum in Vienna) is a remarkable example—fascinated both collectors and artists in the nineteenth century. Twice since the classical age, a revival of interest has produced a modern school of gem engraving. In the late mediaeval and Renaissance period, due to the patronage of collectors like Lorenzo de' Medici and François I, some fine cameos and intaglios were produced. Almost completely neglected during the seventeenth and early eighteenth centuries, the art of cameo-cutting was again revived during the age of neo-classicism (as the period from the late 1760s up to about 1820 has been termed). It was a fashionable complement to the classical motifs decorating every item of furniture and the high-waisted Grecian-inspired dresses of the Empire and Regency period. The popularity of this archaeologically orientated neo-classicism lessened towards the end of the 1830s, giving way to Romantic Gothic style, but the popularity of the cameo as a piece of jewellery remained undiminished for nearly half a century longer. During the Gothic revival period some 'romantic' subject matter found its way into the design of the cameo. The large sardonyx cameo by Saulini [117] is after a painting by the German 'Nazarene' painter, K.A.H. Mücke, entitled *Angels Bearing the Body of St. Catherine to Mt. Sinai,* and a large mid-nineteenth-century English shell cameo now in the City Museum and Art Gallery in Plymouth is obviously inspired by mediaeval sculpture. From 1800 until about 1880 the demand for cameos was so great that every material remotely suitable for the purpose was used to make them, ranging from the laboriously carved and engraved precious stones, which were both scarce and expensive, to mass-produced cast or moulded imitation stones in glass or pottery.

Many coloured precious stones, often flawed, were carved as cameos or intaglios, but they are not very effective as they lack the definition produced by the colour contrast in stratified stones. The majority of precious cameos—both antique and modern—were made from onyx (i.e. the black-and-white variety of chalcedony) or agate, both of which

115 A reconstruction of Bernard Cuzner's workshop at the Museum of Science and Industry in Birmingham, England.

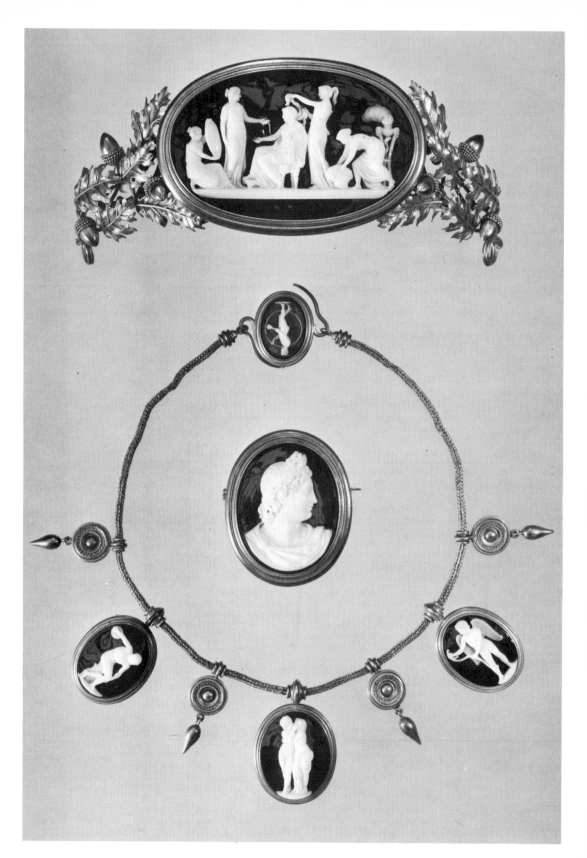

have colours against a contrasting background. The colours found naturally in these stones are pale grey or brown, banded with white. The white layer is impermeable, whereas the coloured layer is porous; the grey or brown can be darkened or coloured. It is possible, by boiling the stone in honey or a solution of sugar and water, and then steeping it in sulphuric acid, to cause carbon to be deposited in the porous layer, making it very dark or even black. Other colours can be produced by using different solutions for soaking the stone (see p. 110) and some cameos and intaglios were cut in these artificially produced red, green or blue stones, to simulate antique gems, as well as from the much more popular black or brown and white.

The tools used to carve the design in relief above the surface for the cameo, or to engrave the incised design of the intaglio, are burrs of various sizes very similar to a dentist's drill. The heads are made of carborundum or hardened steel and charged with diamond dust and olive oil. The carving of a large and complex hardstone cameo could take several years, which explains the popularity of substitutes.

Shell cameos are perhaps the most successful substitute. They were made in the same way as hardstone cameos, utilising the strata found in two varieties of shell—the large helmet shell (*Cassis madagascariensis*) which has white and brown layers, and the giant or queen conch (*Strombus gigas*) which is white and rose-pink. Shell is very easy to work; shell-cameo cutting is said to have been practised since the fifteenth or early sixteenth century and a few

116 opposite: Brooch, necklace and tiara set with cameos cut by L. Saulini; the goldsmith was Castellani. The goldwork and the cameo of the tiara were designed by Sir John Gibson R.A., a neighbour of the Saulinis, father and son, in the Via Babuino, Rome; c. 1860.

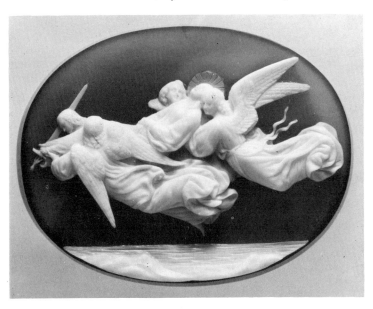

117 Cameo cut by L. Saulini depicting angels bearing the body of St. Catherine to Mt. Sinai; c. 1850.

118 *Onyx cameo by Georges Bissinger depicting George Washington after the bust by Houdon.*

examples said to date from the late eighteenth century appear on the market from time to time. The Italian trade in shell cameos, which assumed great importance in the nineteenth century, originated in about 1805 in Sicily; but the vast majority of antique shell cameos date from the mid-nineteenth century. A number of the most elaborate were produced in France in the 1860s [108]. Many other materials were used to produce small cameo-like reliefs to be set as jewellery: coral, ivory, jet, rock-crystal, lava and meerschaum. Fake cameos are made of a cameo-doublet, consisting of a base of coloured stone with the relief in a contrasting colour, cemented on to it. Wedgwood's jasper-ware cameos were made in this way, and were still fashionable during the early years of the Victorian period; indeed a type of jasper cameo of appallingly low quality is still made today.

In the 1830s cameo-set jewellery differed very little in style from that of the Empire period, the cameos in low relief set in simple filigree, gold ropework or pearl mounts. Towards the middle of the century the cameos were cut in much higher relief and set in much heavier gold mounts, often enriched with diamonds or coloured precious stones and elaborate enamel decoration. This later work was sometimes set with precious stones to form a cameo *habillé*. In 1855 Hancocks and Co. were commissioned to remount as a large set of wearable jewellery part of the famous collection

119 *'Filled gold' bracelet set with a meerschaum cameo, of American manufacture.*

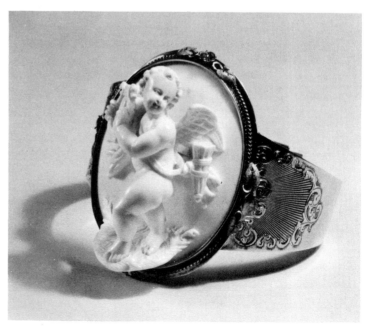

of antique cameos made during the first half of the eighteenth century by the third Duke of Devonshire. At the 1867 Paris exhibition John Brogden showed a necklace and earrings in elaborately worked gold decorated with enamel and set with chalcedony and onyx cameos (now in the Victoria and Albert Museum) and the cameos cut by Saulini and designed by Gibson, the English neo-classical sculptor [116] date from about the same period. Cameo-set jewellery remained reasonably popular, though no longer in the height of fashion, for some years longer. The neo-Renaissance style jewellery of the 1870s was sometimes set with high-quality cameos or intaglios, but increasingly these came to be replaced by miniatures or medals and by the eighties they had become completely passé.

Enamelling Techniques

Although fashionable previously, enamelling was neglected by jewellers in the eighteenth century, but it was widely used for watches and boxes. Enamelling on jewellery was not common again until near the mid-nineteenth century, although some attempt to revive enamel enrichment of settings had been made, without popular success, in the early 1800's.

There are a number of different enamelling techniques, all of which were used during the period covered by this book. A variety are often combined in one piece; but once the processes used are understood it is not difficult to recognise the different types.

Basically the process is concerned with fusing vitreous substances in various colours, translucent or opaque, onto a surface—in jewellery almost always of metal or very much more rarely, porcelain—by heating in a kiln. The enamel colour, in the form of a paste of powdered glass mixed with metallic oxides to provide the different colours and bound with oil, is spread on the metal in the required patterns, and then baked for a carefully calculated amount of time. All the different techniques described below are really variants of this process.

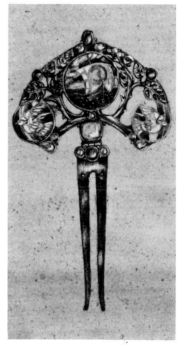

120 Design for a comb by Henry Wilson, incorporating three enamel discs; c. 1900.

The two chief difficulties are the changes in the colours resulting from the heat of the kiln, and the tendency of metals to distort with the successive firings usually necessary for any but the simplest decoration. Silver distorts badly, and this can cause cracking in the finished enamel. Despite the many problems, successful examples of almost every imaginable enamelling technique were produced during this period.

121 Design for an enamel brooch by Alfred Gilbert; c. 1890.

122 Badge, in painted enamel on gold, of the President of the Royal Society of Painters in Water-colours, by Hubert von Herkomer.

Painted enamel miniatures: Throughout the nineteenth century, these were very fashionable. They were sometimes portraits—imaginary or real, copies of famous pictures, or landscapes or views of well-known picturesque locations. Imitation cameos (usually in *grisaille*, a complex technique in which the image appears in monochrome, usually tones of grey on a white ground, which could be used for imitating cameos, or engravings) or neo-rococo designs of flowers, fruit and insects in the Battersea and Bilston style were other variations. There was also a revival of a type of 'Limoges' enamelling, very unlike the fourteenth-century work from which it takes its name, as it used far too great a range of colours.

The sophisticated and delicate type of enamel painting used in eighteenth-century France was still used for jewellery during the nineteenth century. It is carried out on a smooth undercoat of white enamel fired onto a slightly convex thin metal ground, either of copper or gold, which was usually also counter-enamelled to reduce the tendency of the metal to warp in the kiln. The colours, mixed with a little oil or water, were then painted onto the white surface in successive layers, each layer in turn necessarily being fired at a lower temperature so as not to disturb the work that had already been carried out. Some of these miniatures were carried out in delicate colours, like water-colours, or a form of *grisaille* lightly touched with pale colours, called 'tinted *grisaille*', and some of the nineteenth-century portrait miniatures were done in deep jewel-like colours, often in a mixture of opaque and translucent colours enriched with gold paint and with *paillons* (little mica-like flecks of gold foil included in the enamel or laid on to the ground which flash from the depths of the coloured layers).

Portrait miniatures were fashionable throughout the nineteenth century. The early nineteenth-century examples are characterised by a certain doll-like appearance, and the turn-of-the-century work by experimental enamellists like Alexander Fisher by a stylised appearance which had much more the quality of a painting, achieved through a greatly increased number of firings. To attain a delicate brush-stroke effect called for great skill and the quality of nineteenth-century enamel work is extremely variable. Enamel painting had been a speciality of the Swiss since the seventeenth century, and much of the great demand for enamelled jewellery at this time was supplied by them. This Swiss work has a highly professional finish, often absent from English work; but much of it was designed to supply the tourist trade. As a result, it is rather lacking in both

charm and originality. However, the enamel work offered by Bautte of Geneva, who sold jewellery of this kind known as 'Geneva ornaments', was greatly admired by John Ruskin (see *Praeterita*, pt. II, chap. V). Many sets survive, as evidence of their popularity.

Cloisonné and champlevé enamels: *Cloisonné* and *champlevé look* rather similar since both use a thin ridge or wall of metal to separate the colours. In the *cloisonné* technique the walls are made by applying thin strip metal or wire in the required design to the surface of the area to be enamelled. The interstices are then filled with the powdered enamel colour and the piece is fired. The form of *cloisonné* enamelling traditionally used in Russia, Hungary and Norway—sometimes called *skan*—is made in this way, with delicate filigree patterns applied to the surface of the piece, the interstices then being filled with a mixture of opaque and trans-

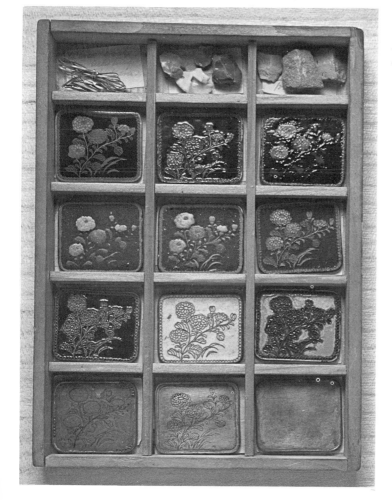

123 Fitted box used to demonstrate the stages of cloisonné *enamelling, from the blank copper plaque to the finished enamel.*

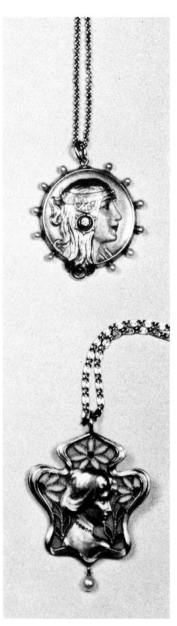

124 *Two gold Art Nouveau-style pendants: the upper piece is decorated in translucent enamels, the lower in* plique-à-jour *enamel; American, c. 1900.*

lucent enamels. In some cases, part of the gold surface is left uncovered and then burnished giving a very rich effect. This technique was revived in Russia and Norway at the end of the nineteenth century and became very popular. *Cloisonné* was revived for use in jewellery in the mid-nineteenth century when Japanese decoration and craftwork became fashionable [42].

In the *champlevé* method the walls of metal are obtained by hollowing out the areas to receive the colour. The hollows are filled with colour as in *cloisonné* and the piece is then fired. The *champlevé* technique was used to give an antique-looking effect, for example for neo-Byzantine work or Gothic-revival ecclesiastical ornaments; it was much less popular for jewellery than *cloisonné*.

Basse-taille enamelling: In *basse-taille*, the surface is worked in low relief, the design being engraved in varying depths, parts of which are then filled with translucent enamel colour and fired. The different thicknesses of the enamel produce colours of greater and lesser intensity, and the engraved design can be seen through the thin parts of the enamel. The uncovered metal surfaces are usually worked as well, either engraved or with a pattern of alternating burnished and 'bloomed', or dead, gold.

Taille d'épargne enamelling: A similar form of enamelling over an engraved design using much the same method, but with opaque colours, is *taille d'épargne*. Here the enamel usually simply fills a deeper line in the engraved decoration, without the subtle variations of depth used in *basse-taille*. *Taille d'épargne* was widely used to decorate the settings of mourning jewellery with foliate designs in black or blue and white enamel. Mourning rings were made in this way with the lettering (usually 'In Memory' with a name or initials and a date) above the surface in gold and the rest of the surface enamelled, or vice versa. From about 1830 this technique was used to decorate the surfaces of the fashionable wide, hinged bangles; this type of decoration remained popular through the mid-century, being produced in a modified form in large quantities by the more expensive Birmingham firms.

This Birmingham jewellery was almost certainly exported to the United States and was enthusiastically copied there by a firm of New York jewellers from the 1860s onwards. The American work is almost always carried out in black enamel combined with bloomed and burnished gold sometimes enriched with engraving on the burnished surfaces. Bracelets of this type were very popular and are usually decorated with a continuous strip of pattern in either a

faintly rococo floral design or a modified version of popular neo-classical motifs. Brooches and earrings were either made simply of gold with similar enamel decoration, or set with pearls following the lines of the enamelling and with drop-shaped onyx pendants. American commercial firms fully understood the need to be smart and this black and gold colour scheme was used for other types of fashionable but not valuable middle-class jewellery, such as the widely popular tortoiseshell and goldwork (see p. 45), and the jet and gold jewellery (p. 59).

The use of *basse-taille* and *taille d'épargne* was more or less abandoned in the 1870s when settings became much lighter, but the use of translucent enamel over an engine-turned pattern, called '*tour à guillocher*', was popularised by Fabergé, who used it for his miniature jewelled eggs, and for the elegant little round or oblong brooches with asymmetrically-set precious stones which were considered the height of *chic* at the turn of the century.

Plique à jour enamelling : Plique à jour is sometimes graphically called window enamel (*Fensterémail*). In essence the technique is similar to *cloisonné*, but the spaces are open-backed, allowing the light through the translucent enamel. The metal *cloisons*, made either of strips of gold or of saw-pierced sheet gold, are laid onto a surface to which the enamel will not adhere once fired, and the interstices are filled with powdered colour. Experiments were made with this technique at the turn of the century in building up the enamel in layers with repeated firings to produce an effect like cabochon-cut stones, but it was unsatisfactory and not widely used. The great popularity of this technique, particularly with the French Art Nouveau designers, is not easy to understand since it is uniquely unsuited to any piece of jewellery except the tiara, as the effect of the light passing through the coloured enamel is lost when the piece is worn. These French pieces are, nonetheless, fascinating *objets d'art*—miracles of accomplished technique—and this may well have been their main purpose. *Plique à jour* was hardly ever used by the craft revival jewellers in England and the United States, nor by the *Jugendstil* designers in Germany and Austria.

Niello

The use of the ancient technique of niello for decorating silver was revived in the early 1800s by the German jeweller, Wagner, working in Paris. He was a friend of Fauconnier

who is usually credited with starting the taste for neo-Renaissance silverwork, and master of F.-D. Froment-Meurice, who used this technique for a number of pieces [125]. The design is engraved and then filled with a deep black, metal alloy compound consisting of one part silver, two parts copper and three parts lead, mixed with sulphur to a grainy consistency. The piece is then heated in the furnace until the compound has melted; when it is cool the surface is filed smooth and burnished. This technique was used by a London firm, S.H. and D. Gass of 166 Regent Street, for two very elaborate bracelets on show at the Great Exhibition in 1851. This type of decoration was usually carried out in black—or black with white enamel heightening—on silver, though some French pieces dating from the 1860s are enriched with gold inlay. Once the technique had proved popular for the decoration of silver jewellery it was used sporadically, usually for pieces in a quasi-mediaeval or Renaissance style, from the late 1840s until the end of the century.

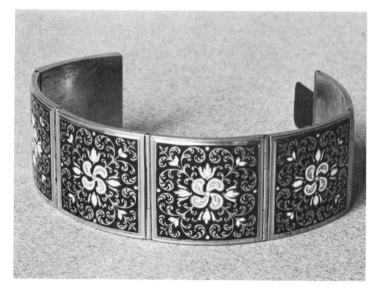

125 Niello bracelet by Emile Froment-Meurice working in the technique revived by his father, François-Désiré.

Roman Mosaic and Florentine Intarsia

In both Roman mosaic and Florentine intarsia or *pietra dura* work the design or image is formed by fitting together very small fragments of coloured hardstone or glass. The so-called Roman mosaic is formed from rods or *tesserae* of

coloured glass, arranged in masses to form a picture and cemented upright into a recess or frame of marble or some other hardstone, glass, gold or gilt metal. The images produced by this method range from whole floors, through table tops, medium-sized decorative plaques and boxlids, down to delicately wrought miniature pictures. The frames for these little images when used for jewellery are often of lapis-lazuli, malachite, aventurine quartz or glass, or black glass. Sometimes the mosaics are set directly into the gold setting without a frame. They vary greatly in quality, from the most delicate, which look almost like enamels, to the very crude, made with coarse, large *tesserae*, roughly set. The best work seems to date mainly from before the middle of the nineteenth century, but small souvenir brooches or earrings can still be bought today, usually of a rather indifferent quality.

The subject matter of these little pictures shows little variety—mainly views of the ruins of ancient Rome, or subjects taken from the wall-paintings at Herculaneum and Pompeii. King Charles's spaniels feature frequently for some reason, as does Dante, more predictably, since the repertoire of subject matter is, at least during the first half of

126 Necklace composed of oval mosaic views of Rome set in gold; Italian, c. 1840.

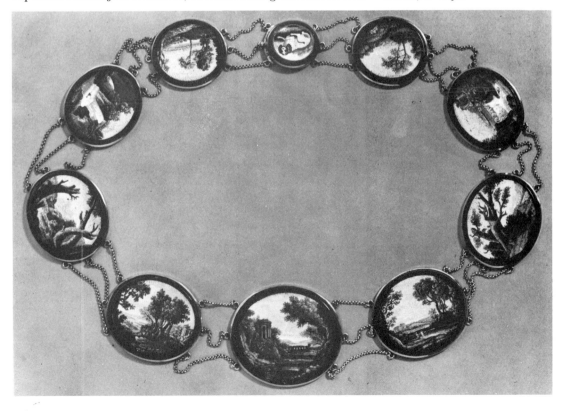

the century, consciously Italianate in inspiration. The Roman firm of Castellani specialised in this work, mounting incredibly fine mosaic work in gold frames decorated with Etruscan-style filigree and granulation. Castellani liked to include Latin inscriptions in the mosaic plaques, the letters in bold Roman capitals with formal geometric decoration surrounding them. With the great revival of interest in Egypt in the late 1860s, mosaics began to appear decorated with Egyptian motifs [47], but this period already shows a decline in quality and the popularity of mosaic jewellery waned along with the 'archaeological' style at the end of the century.

'Florentine' intarsia is inlaid work of a rather different kind. Here the specially shaped fragments of hardstone and coloured gems are cemented into shallow depressions cut into a base of black marble to form a picture on the same principle as marquetry in coloured woods. The choice of stones is very important since the markings on the stone will provide gradations of tone necessary to make the image more realistic. In the most delicate work flowers and butter-flies or other insects are depicted with the greatest realism, petals and wings being achieved with lightly veined stones. Fine-quality work was produced in Italy throughout the nineteenth century, and this Italian *pietra dura* was imitated in Derbyshire, under the direction of the sixth Duke of Devonshire, in black Derbyshire marble inlaid with feldspar from the mines rediscovered at the end of the eighteenth century. In local cottages small ornaments were made in the form of crosses or oval brooches and pendants decorated with insects and flowers, and were sold to sightseers, among them the young Princess Victoria, who visited the area in 1826.

By the 1860s, the quality declined, the stones were chosen with less attention to their particular qualities, and a number of other materials were used to achieve an im-mediately striking but less demanding effect. Coral, tur-quoise, mother-of-pearl and even coloured glass were all used, in some cases combined with passages of painted decoration, and the resulting pieces lack all the delicate realism and subtlety of the best of the earlier work.

Both mosaic and intarsia jewellery were often made in large sets or parures [20]. Although this type of jewellery was very fashionable in the period from 1820 to about 1840–50, and popular for a long period after that, it is rarely discussed or even mentioned in contemporary reports on jewellery design, and it was clearly not regarded as 'artistic' in the way of 'archaeological' or Japanese-style pieces.

The Cutting of Gemstones

In order best to display the beautiful optical properties of precious stones they are cut or polished according to their character. Transparent stones are usually faceted, while translucent or opaque stones are cut *en cabochon*, or polished to make beads.

127 Model of the Cullinan diamond before it was cut.

 There are four main styles of cutting in which the arrangement of the facets varies with the shape of the stone. The most widely used cut for the diamond is the *brilliant*. The brilliant cut consists of fifty-eight facets, of which thirty-three, including the flat 'table' at the top, are on the 'crown' of the stone, and twenty-five, including the 'culet' (or small cut off the point of the base), are below the girdle (i.e. the

The brilliant: left, the upper part, or crown; centre, a view of the side; right, the lower part, or pavilion.

128 *A series of models showing the nine stages in cutting a brilliant.*

widest circumference of the stone and the point which separates the 'crown' from the 'pavilion' or lower surface). The thirty-three cuts on the crown are made up of one table, eight star-facets, four templets or bezels, four quoins or lozenges, eight cross-facets and eight skill-facets. The twenty-five cuts on the pavilion consist of one culet, four pavilion facets, four quoins, eight cross-facets and eight skill-facets.

The step cut: left, the upper part; centre, a view of the side; right, the lower part.

The cut most frequently used for large coloured stones as well as for very large diamonds is the *trap* or *step cut*, which has a large oblong table with cut corners surrounded by square-cut facets sloping down to the girdle on the upper surface, and a larger number of rows of similar facets sloping in towards the culet on the base. The number of rows of facets on both surfaces varies with the size of the stone. This cut is frequently used for emeralds and is sometimes known as the emerald cut. The emerald cut was evolved in the nineteenth century but rarely used until the early years of the twentieth, and it is now associated with the style of jewellery developed by firms like Cartier and Van Cleef and Arpels in the 1920s.

The *mixed cut* is, as the name suggests, a combination of the brilliant cut on the crown and the step cut on the lower surface, and is used for certain coloured stones when either a deeper or shallower base than that allowed by the true brilliant will show the colour to greater advantage.

The *rose cut*, a development of the earliest form of facet-cutting, consists of a flat base, and twenty-four facets on the upper surface, divided into six star-facets and eighteen cross-facets. Where this same arrangement is repeated on the base in place of the flat face the stone is known as a *double rose*. The earliest record of facet-cutting dates from about 1640, in the form of a modified rose with only sixteen facets. The twenty-four-faceted stone, or Dutch rose, followed, and later the thirty-six-facet *rose recoupée* was evolved. The rose

The rose cut: above, the upper part; below, a view of the side.

129 Models of the nine principal stones into which the Cullinan diamond was cut.

cut remained in constant use for all but the most expensive diamond jewellery until the early nineteenth century; it was revived at the end of the century for the then fashionable small pins and pendants in the eighteenth-century taste. This cut involves the least wastage of stone and can be used on much smaller stones than the brilliant.

Oval or drop-shaped stones are cut in a modified version of the rose or brilliant cut. The most common shapes are those known as the *briolette*, the *marquise*, and the *pendeloque*.

The briolette.

The marquise.

The pendeloque.

The simple cabochon.

The *cabochon cut* which is used for most translucent and all opaque stones is a round or oval dome shape which may have a flat base, when it is known as a *simple cabochon*, or a hollow base; the latter is used with the few transparent stones cut in this way to increase the flow of light through the stone. When the base is dome-shaped like the upper surface, it is called a *double cabochon*.

Calibré cut stones are small oblong or *bateau*-shaped stones cut specially for jewellery in which the main stones are surrounded by a mass of small stones in an elaborate ribbon design. *Calibré* can be roughly translated as 'cut to fit'. Cartier and Chaumet excelled at this style, which was fashionable from the turn of the century until the outbreak of the Second World War.

The cutting of gemstones is the most highly skilled work in the manufacture of jewellery, and even the most dedicated advocate of handcraftsmanship did not envisage it as part of the equipment of the craft jeweller. The two great centres of diamond cutting are Amsterdam and Antwerp, and great diamond dealing firms all over the world travel to these cities and to Tel Aviv and Johannesburg. As sometimes

eighty per cent of a stone's value can lie in the way it is cut, it is hardly surprising that this process is only carried out by the most expert and highly trained craftsmen.

Gold- and Silverworking Techniques

Both gold and silver are used in various degrees of purity from a very high precious metal content with only a small amount of alloying metal added to give strength, to a heavily alloyed mixture which may not legally be called 'gold' or 'silver'. The standard proportions used in Europe and America for these alloys are given on p. 140. It is usual nowadays and was standard practice in most commercial workshops throughout the greater part of the nineteenth century for the raw material needed to make up a piece of jewellery to be bought already partly worked into the various standard components, in the form of gold and silver sheet, fine wire in various grades, ready-formed tube, and some ready made chain, though this was one of the most revealing short-cuts which the commercial firms on the way to mass-production could take. Most jewellers would also supply themselves with a variety of ready made pins and catches, and a number of suppliers in the mid-nineteenth century found it worth their while to patent any particularly ingenious type of catch or safety-pin.

The basic shape of a piece is first formed in one of a number of ways. One is by hand-cutting with a jeweller's saw and then shaping up with a hammer and punch in a specially shaped depression, like a mould. Another way is to cast the main shapes in carved moulds by the *cire-perdu* or lost-wax process as described by Cellini in his notebooks. The cheapest and quickest method of shaping a number of identical pieces is by stamping, either by hand or by machine, but the loss of definition which results from this method makes the final result very disappointing when compared to the hand finished cast or hand-cut work.

Once the basic shape has been achieved, the surface decoration is carried out with the traditional tools which have remained virtually unaltered since the classical period. Raised or three-dimensional designs are either punched or hammered up from the back of the piece in the method known as *repoussé*, or tooled up from the upper surface of the piece in the method known as chased-work, or *ciselure*. These two methods produce very similar results, but *ciselure* has a somewhat more sharply defined and tooled appearance. Two-dimensional decoration can be achieved by engraving

either with a graver or with a multi-pointed tool which produces the regular linear designs of machine-engraving or engine-turning. The faceted decoration known as diamond engraving is a form of deeply cut engraving. Much of the faceted decoration of settings in cheap gold and silver jewellery was, in fact produced by stamping or moulding, and the loss of definition is particularly noticeable in this type of geometric design.

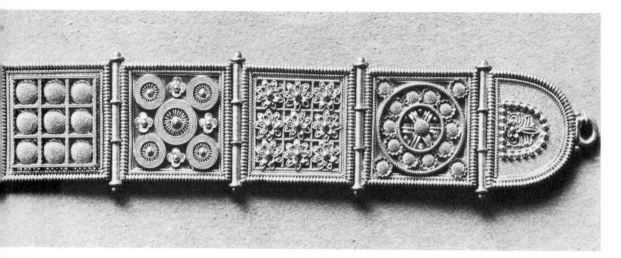

130 Enlarged detail of a gold bracelet decorated with elaborate granulation by Castellani; c. 1860.

131 opposite: Two silver Arts and Crafts necklaces, both incorporating mother-of-pearl; the upper necklace with the fashionable hammered finish was made by Murrle, Bennett in the early years of this century.

The surface of the piece could also be decorated with applied filigree of granulated work carried out in fine wire and minute grains of metal. The enlarged detail [130] of the bracelet in the Etruscan taste made by Castellani in the 1860s shows this type of work at its most elaborate. Surface texture was achieved by either hammering the metal to produce a hand-crafted appearance, or by 'blooming' (i.e. lightly pitting the surface of the metal by immersion in acid), which was used mostly in contrast with areas of highly burnished metal to provide interest on otherwise undecorated parts of the surface.

Openwork designs were produced either by saw-piercing the basic shape of the piece, or by building up the design with wire in a form of heavy filigree known as *cannetille* work [106].

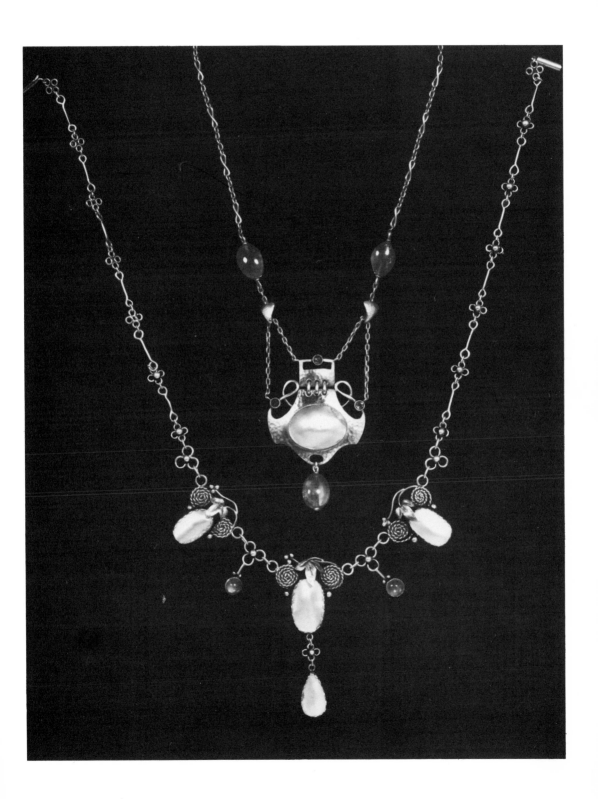

JEWELS

BY ARTISTS OF THE MODERN SCHOOL

NECK CHAIN AND PENDANT SET WITH MATRIX OPAL OR TURQUOISE, smartly modelled in solid 15 carat Gold

BROOCH
Elegantly modelled

GEM SET
in 15 carat Gold

MOTIVE "HONESTY"

MOTIVE "THE WAVE"

BROOCH
carved in solid 15 carat Gold
Gem-set Centre

BROOCH
executed in 15 carat Gold
set with 2 Gems

BROOCH

BROOCH AND SLIDE
clever arrangement at Back for keeping Long Watch Guards and Muffchains in position while worn. The contrivance not being visible from the front, the article serves a double purpose.
Mounted in 15 carat Gold and Gem-set

Charming Design, mounted in 15 carat Gold and set with 3 Turquoises or Opals

BROOCH

Obtainable through high-class Jewellers

These Designs are the Property of and made up by
MURRLE, BENNETT & Co.
13 CHARTERHOUSE STREET
LONDON, E.C.

Very quaint design with a slab of Matrix Turquoise in centre
Mounted in 15 carat Gold

Marks

Too little attention has been paid in the past to the meaning of the various marks which appear on some pieces of jewellery. These extend to hallmarks on gold and silver, patent marks, design registry marks and trademarks.

The assay laws of the various European countries are very complicated and, for one reason or another, it was often possible for jewellers to avoid having their wares marked; they sometimes did so since there was, and still is, a real danger of a delicate piece being damaged or distorted in the punching process. Therefore, many makers' marks, often the only mark on a small piece of jewellery, are engraved rather than stamped. The jewellery designed for the Wiener Werkstätte and carried out by trained craftsmen in the workshop is a welcome exception to the general rule of inadequate or non-existent marking. For example, the buckle illustrated [193] bears the mark of the workshop (the 'WW' monogram), that of the designer Josef Hoffmann, that of Karl Ponocny, the goldsmith employed by the workshop, and the Vienna silver mark. The present day collector can only regret the many evasions of the assay laws and consequent examples of inadequate marking.

The precise dating of nineteenth-century jewellery is very difficult owing to the long period of years during which any particular style might remain in fashion. The only way to approach the problem is by having a large body of documentary and other evidence among which similar pieces may be found, and it is for the purpose of building up this body of reference material that marked pieces are so valuable.

A certain amount of British silver jewellery, particularly the pieces produced in the large provincial firms towards the end of the nineteenth century, was fully hallmarked. This entailed, depending on the date, four or five marks, which were: (*i*) The sovereign's head in profile which served to show that the duty payable on the silver had been paid. This was used from the time when the duty was first imposed in 1784 until the repeal of the duty in 1890. (*ii*) The mark used by the office at which the piece was assayed. (*iii*) The date letter for the year in which the piece was made. It is best to use a reference book for the deciphering of date letters since hardly any of the assay offices use the whole alphabet when marking the date letter, and they are not even con-

Maker's mark of Murrle, Bennett.

132 opposite: An advertisement for Murrle, Bennett from Modern Design in Jewellery and Fans, *published in 1902.*

Holmström's initials.

ФАБЕРЖЕ

Fabergé's signature in Cyrillic script.

sistent in choosing which letters to leave out. (*iv*) The quality, or standard mark, which indicates that the piece is entirely made of silver of the required standard of purity; this is a lion standing with one paw raised, the lion passant guardant of heraldry. The Scottish offices use their own standard marks, Edinburgh has the thistle and Glasgow a lion rampant. (*v*) Last but not least the makers' own mark in the form of initials, which was the type of makers' mark used since 1720 and which is still used today.

Two silver standards are permitted in England: Sterling, which is 925 parts of silver to 1000, and Britannia, which must be at least 95.84% pure. These standards are indicated by either the lion guardant or the Britannia mark. Foreign gold and silver wares imported into England have to be assayed and marked before they are put on sale, in order to comply with a Customs Act dating from 1842. From 1883 until 1904, the letter 'F', for foreign, in an oval was added to the standard mark; from 1904, following the passing of the Foreign Plate Act, the various offices used their own town mark instead. In 1908 Peter Carl Fabergé brought an unsuccessful test case against the Goldsmiths' Company in an attempt to get his delicate, enamelled gold and silver boxes, which were to be imported for sale in England, exempted from the assaying law, as it was quite certain that they would be damaged by the application of the import marks. The Goldsmiths' Company pointed out to Fabergé that the practice in England was to assay enamelled goods 'in the rough', in other words before the enamel decoration was applied, and he was advised to send his boxes from Russia in an undecorated state and return them to his workshops for enamelling after they had been assayed! The standard marks applied to imported wares differ from the standard marks used in Britain, being in the form of figures, the form of marking used in most other European countries and in the United States.

In the United States at the beginning of the nineteenth century it was customary for the silversmith to sign his work with his initials, or with the first letter of his given name and the full surname, and with the name of the city where he worked or some other form of address as well. A variety of standard marks were used to indicate the grade of silver used, such as 'COIN', 'PURE COIN', 'STANDARD', 'DOLLAR', etc., but in 1852 Tiffany's introduced the English Sterling standard (925 parts silver to 1000) to America, marking their goods accordingly with the words 'English Sterling, 925–1000' in addition to the firm's usual marks. The English Sterling standard was adopted a few years later by the U.S.

Federal Government who passed a law determining that this should be the minimum silver content in any goods marked with the 'Sterling' mark.

'Pseudo-hallmarks' in imitation of the English marks (see above) had been used by some American silversmiths in the mid- and late eighteenth century, but American nineteenth-century silver is generally very difficult to date since no system of date latters in the English style was adopted, and sometimes the only indications which can help with some idea of dating are alterations in marks which occurred with the formation of new partnerships, or changes of address, where these are given. Accurate dating from changing marks or different addresses is not possible, as the same mark was often retained for some time after the location of a firm had changed, even in some cases after the ownership had changed, the manufacturers being reluctant to drop a trademark that might, after some years in use, be becoming quite well-known.

The Gorham Company adopted a system of marking some pieces of their silverware with date letters in the English manner in 1868. The letters A-Q were used in the years 1878–1884, but after this symbols were used instead, changing every year from 1885 until they were discontinued in 1933. The symbol for 1900, for instance, was a bell, for 1905 a horseshoe, for 1912 a fish, and so on. The trademark 'Martelé' was used on some of their silverware and silver jewellery produced by the design group under the direction of William Codman from about 1900 until 1910 (see p. 188).

Tiffany's address changed at fairly frequent intervals from the time when they first opened in New York up until 1902, giving a rough indication of the date of any piece which is fully marked; in addition to this, from 1858 onwards the first letter of the surname of the current President of the company was used. During a number of years in the period covered by this book this was the black letter 'M' for their chief designer, Edward C. Moore. Tiffany's also used special marks for the pieces exhibited in Chicago in 1893, in Paris in 1900 and at the Pan-American Exhibition in Buffalo in 1901.

It is simply not possible to carry the mass of information needed to place and date American silver around in one's head, and a valuable record of the marks and hallmarks of manufacturing silversmiths and jewellers working in America during the nineteenth century, along with records of the various changes of address and brief histories of each firm, will be found in *American Silver Manufacturers, their Marks,*

The Moscow town mark, showing 1894, the date when it was last used.

134 Design for the grande châtelaine Bianca Capello by Alphonse Fouquet.

135 *Drawing submitted to the Design Registry for the buckle illustrated below.*

136 *Silver buckle by William Comyns; the Design Registry number is on the reverse.*

Trademarks and History, by Dorothy T. Rainwater, published in Hanover, Pennsylvania, in 1966.

Gold jewellery is quite often marked only with a standard mark. This provides no help in the matter of dating, but may be helpful in determining the country of origin of any particular piece, often surprisingly difficult in a period when the progressive Europeanisation of taste had more or less wiped out any regional difference in style which in an earlier period would have been a means of telling the nationality. Various different standards are permitted in Europe and America, and the ways of indicating the standard quality of metal used differed from one country to another. In England before 1854 the only standards permitted were 22 carat (that is twenty-two parts of gold to twenty-four) and 18 carat. After 1854 with the enormous increase in demand for gold wares three new standards were permitted, 15, 12 and 9, and these were later reduced to two when 14 carat replaced 15 and 12, in 1932.

Hallmarking systems in France, Germany, Holland and Italy were all as complicated and confusing as those used in England and the United States. A rough-and-ready system of identifying the country of origin of antique or second-hand pieces has, of necessity, been evolved by any dealer seriously interested in helping those among his customers who are collectors. For instance, the eagle's head is a French quality mark for gold, the gold standards permitted in France being 900/1000, 840/1000, and 750/1000. All goldwares imported from other countries bear the mark of an owl in an oval (in use since 1893) and those intended for export bear the stamp of the head of Mercury and a number indicating the quality. The French standards for silver are 950/1000 (equivalent to the Britannia standard) indicated by the head of Minerva in an octagonal shield, and 800/1000 indicated by a crab-mark. In addition to the quality and export/import marks, all the French assay offices have their own mark. Facsimiles of a number of French marks and the quality marks of other European countries are given in *The Retail Jeweller's Guide*, second edition, by Kenneth Blakemore, published in 1973, which also explains in considerable detail the English hallmarking system. The French marks are recorded in far greater detail in the books edited by Tardy, *Les Poinçons d'Or*, and *Les Poinçons d'Argent*.

In Russia the quality marks used are quite different and can be confusing to convert into more comprehensible terms. At some time during the first half of the nineteenth century laws were passed by the Tsarist regime requiring all gold and silver articles to comply with certain minimum stan-

dards and to be marked accordingly. The standards for gold are given in figures accompanying the town mark (see below); they are 56, 72 and 92, which indicate that there are either 56 of zlotniks of gold to 96 of alloy, or 72 zlotniks of gold to 96 alloy, 96 zlotniks being the equivalent of a Russian pound. To convert this into English carats, which are numbered in 24ths (see above) it is necessary to divide the Russian figures by four, thus arriving at: 56 equals 14 cts., 72 equals 18 cts., and 92 equals 23 cts. Silver standards are represented by the numerals 84, 88 and 91, which when converted into parts of silver per thousand will be 875, 916·6 and 947·9. Thus it can be seen that the 88 standard is slightly below Sterling, and the 91 rather above Sterling and very slightly below the Britannia standard.

The Russian town marks used in conjunction with these standard marks were abandoned at the end of the nineteenth century in favour of the 'kokoshnik' mark, the female profile head being shown wearing the Russian national head-dress. The St. Petersburg town mark used from the mid-eighteenth century until 1896 was two crossed swords intersected by a sceptre; the Moscow town mark used until *c.* 1894 was a St. George and the Dragon. Many of the pieces made in the Fabergé workshops are very fully marked and can be accurately dated when both the peculiarities of the Russian system are mastered and the history of the workshops is known. For instance, only the pieces made in the Moscow workshops were marked with the Imperial eagle which Fabergé was entitled to use after he had received the Royal Warrant from Alexander III in 1884. The marks used by Fabergé, as well as facsimiles of the kokoshnik mark and the Moscow and St. Petersburg town marks, are all given in *Peter Carl Fabergé, His Life and Work*, by H. C. Bainbridge. published in 1949.

Apart from these official marks a number of manufacturing jewellers and craftsmen with their own workshop had more fanciful trade or makers' marks which were often put on to pieces of jewellery which are not fully hallmarked. In the section of biographical notes, this mark, where it is known, is recorded. They range from the extremely simple, like Arthur Gaskin's plain capital 'G', to the more elaborate decorated monograms of Carlo Doria and the Kensington firm of Child and Child. A number of French *fin-de-siècle* pieces are marked with facsimile signatures; for instance Lalique used one or two different versions of his signature and so did Georges Fouquet. Facsimiles of marks found on some of the pieces exhibited at Duke University Museum of Art in 1971 are given in a hallmarks supplement to Dora

Castellani monogram.

FROMENT MEURICE

Engraved signature used by François-Desiré Froment-Meurice and his son Emile.

CG C.&A.G.

Carlo Giuliano's initials.

AJG

G

Engraved or pricked initials of Arthur Gaskin.

R. LALIQUE

LALIQUE

R.L.

Signatures and initials of René Lalique.

Jane Janson's catalogue, *From Slave to Siren*.

The large-scale manufacture of jewellery and silverware only began in America in the early 1840s. Previously all business had been transacted directly between the customer and the craftsman, each customer specifying what he wanted and having it specially made, and it is only from the middle of the nineteenth century that trademarks become common in jewellery; even at this period a great mass of material, as in England and on the continent, is entirely unmarked. At the very end of the century a first attempt was made to collect and record all the trademarks used by American jewellers and silversmiths, and in 1896 the *Jewelers' Circular* published *Trademarks of the Jewelry and Kindred Trades*. A number of further editions appeared recording additional marks and removing the names of those firms which had gone out of business between the appearance of one edition and the next, thus providing a valuable record of the demise of various nineteenth-century manufacturers.

Although hallmarks have been faked all too frequently by the most ingenious methods this is not very easy to do, and it is fairly safe to say that where a piece of jewellery is fully marked it can be taken to be perfectly genuine. This is certainly not true of signatures, particularly the plain stamped lettering or engraving used by many designers of the Art Nouveau period (*cf.* particularly Lalique and Fouquet) and not too much reliance should be placed on the genuineness of a piece marked with a signature alone if the quality of the work, or some peculiarity of style or in the use of material, make it in any way suspect.

The full hallmark theoretically demanded by the English assay laws on jewellery of any precious metal gives the exact date, to the year, by means of a date letter which can be looked up in any list of English hallmarks. The patent date is less useful since a patent was valid for fourteen years, but the design registry marks narrow the field down to three years, which was the period after which the registration of the design had to be renewed. A number of pieces of English nineteenth-century jewellery, mostly those made by firms in fairly large-scale commercial production, are marked with a patent mark or a design registration mark. Patents are concerned with actual inventions which can usually be taken to involve a new mechanical or chemical process. As far as jewellery was concerned this would be something in the nature of a new kind of chain made with patented machinery, a new gilding or enamelling process, or the invention of a special spring catch or safety device. A number of pieces were advertised as having a 'patent' safety-chain,

or as being made of a recently patented type of flexible chain. Although designs were often also said to be 'patented', in fact the patent office was not concerned with the external appearance of an object, this being catered for from the time it was opened in 1839 by the Index of Registered Designs. There was no legislation to prevent the use of the words 'patented design' until 1875 and a number of these claims on earlier pieces must be regarded with some scepticism. The design registry marks provide very full information on the date of registration and all registered designs are kept in the Public Records Office. Explanations of the numbering system and significance of the symbols used by the design registry during the nineteenth century are given in a number of books on collecting, among them *Victorian Porcelain*, by Geoffrey Godden, published in 1961, Appendix I, pp. 212–3, and in an article, 'Patents, Registered Designs and Trademarks', which appeared in the magazine *Antique Finder*, vol. 12, no. 11, November 1973.

Some of the pieces illustrated in this book bear marks whose significance is explained in this chapter; for instance the silver buckle made by William Comyns [136] has, in addition to the maker's initials, the leopard's-head mark for London, the date letter 'g' for 1902, and the design registry number, 352623. Illustration 135 shows the form in which the design would have been presented to the Design Registry Office for registration. The diamond and ivory rose brooch in illustration 137 is marked with the maker's initials in monogram, 'T.F.', and the St. Petersburg town mark of crossed swords and a sceptre, dating it, rather surprisingly in view of its very post-1910 Cartier-like appearance, before 1896. The drawing illustrated [134], a design by Alphonse Fouquet for a châtelaine has the *'marque déposé'* stamp of the French patent office, showing that Fouquet made some attempt to keep this very striking design exclusive to his own firm. Unger Brothers of Newark patented a number of the Art Nouveau designs for silver which were developed by the firm's chief designer. P. O. Dickinson, under the influence of work seen at the Centennial Exposition in Paris in 1900.

Small pieces of information, even when they are not particularly useful, are very interesting, often indicating trends and showing popularity of designs that one might now think either too bizarre or too trivial to need the protection of a patent or registration mark.

Impressed mark of Tiffany and Co.

137 Brooch in the form of a rose in enamel and diamonds; Russian, c. 1890.

138 overleaf: An advertisement for Liberty from Modern Design in Jewellery and Fans *published in 1902.*

143

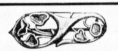
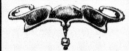

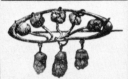

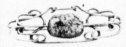
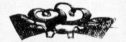

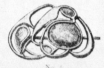

PART 3

Jewellers and Designers

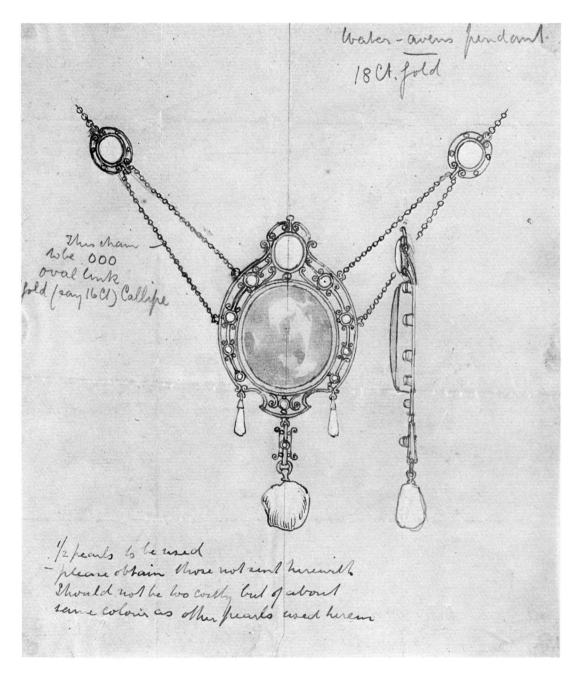

water-avens pendant.
18 Ct. gold

This chain
to be 000
oval link
gold (say 16 Ct) Callipe

½ pearls to be used
— please obtain those not sent herewith
Should not be too costly but of about
same colour as other pearls used herein

139 *Design in pen and water-colour for a necklace and pendant; by Nelson Dawson, c. 1900. There are detailed technical instructions to enable much of the work to be carried out by assistants.*

Albert of Saxe-Coburg (1819–1861)

married Victoria, Queen of England in 1840 to become Prince Consort

Prince Albert was chief inspiration and, with Sir Henry Cole, one of the chief planners of the Great Exhibition in 1851. Collector, patron of the arts, amateur architect and composer, he also designed jewellery for his wife, as well as the turquoise eagle brooch, which was given to the bridesmaids at their wedding. He also designed the Florence Nightingale jewel made by Garrard's and the collar and badge of the Order of the Star of India shown in the International Exhibition of 1862.

Artificers' Guild

firm of craft metalworkers, London

This firm was founded in 1901 by Nelson Dawson, who bound himself to work exclusively for the Guild for five years, but by 1903 the Guild was in dire financial difficulties. It was acquired by Montague Fordham, who had been a director of the Birmingham Guild of Handicraft, and its activities were transferred to the Montague Fordham Gallery in Maddox Street. Montague Fordham had bought the premises at 9 Maddox Street in 1900, and until 1906 the gallery was known as 'Montague Fordham, House furnisher, Jeweller and Metalworker'. From 1903 the address of the Artificers' Guild was given as '9 Maddox Street' as well. In 1906 the gallery was renamed, and until 1911 the business was known as 'The Artificers' Guild (late Montague Fordham) Art Metalworkers'. The firm continued to operate until the First World War at this address, re-opening later at 4 Conduit Street. J. Paul Cooper did a certain amount of work for the Guild, but the chief designer from the time when Montague Fordham acquired the Guild was Edward Spencer, a former assistant of Dawson.

Mark: AS . GD . LD. (device enclosed in a shield)

Ashbee, Charles Robert (1863–1942)

English architect, designer, and writer

On leaving Cambridge, Ashbee was articled to G. F. Bodley. He lived at Toynbee Hall, the settlement in the East End of London, and he founded the School and Guild of Handicraft there in 1887–8. The Guildsmen who worked with Ashbee, making up the designs which he provided, were almost all amateurs who learnt their craft by a process of

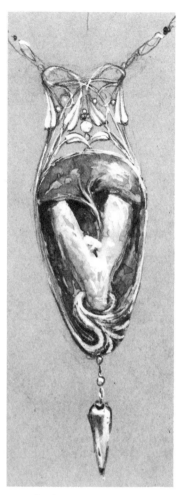

140 Design for an enamelled pendant, by Ashbee.

trial and error. Ashbee's own knowledge of metalworking seems to have come largely from Cellini's *Treatises* which he translated, and which were published in 1898. In 1890 the Guild moved to Essex House, and in 1895 the school was closed. In 1898 the Guild of Handicraft became a limited liability company and the Guild mark (see below) was registered with the assay office. In 1902 the workshops of the Guild were moved down to Chipping Camden in Gloucestershire, but the two retail premises which had been acquired in London, 16A Brook Street (1890) and 67A Bond Street (1902), were retained, imposing an impossible financial strain on the resources of the Guild. In 1907 a catalogue was issued, announcing the disposal at very cheap prices of a number of pieces of silverwork and jewellery, and in 1908 the Guild went into voluntary liquidation, though some of the craftsmen continued to work independently, sometimes using the old designs made by Ashbee in the past.

Ashbee provided most of the Guild's designs though a number of the Guild pieces illustrated by Margaret Flower (see bibl.) were designed by Hugh Seebohm. Ashbee had set his face against what he described as 'the unspeakable rubbish of fancy goods', but he was to echo Morris's disillusioned remarks about the wealthy patrons who made up the bulk of his customers, a source of disappointment to both men, who had hoped to cater for, and reform, the taste of the working classes. Ashbee was a key figure in the Arts and Crafts movement, a formative influence on the design of Liberty's jewellery and silverwork, and an inspiration to the Secessionists in Vienna whose own Wiener Werkstätte were based on the Guild of Handicraft. His success in interesting the general public in the work of the Arts and Crafts movement was to be of great benefit to his contemporaries, among them the Gaskins, the Dawsons and Edgar Simpson, whose designs are so close to Ashbee's as to amount almost to blatant plagiarism. He exhibited with the Arts and Crafts Society from 1888, and in the Vienna Secession Exhibitions, nos. VIII, XV, XVII and XXIV.

Marks: C R A (scratched or pricked, in use from 1896); G O H ltd. (registered in 1898)

Attenborough, Richard
firm of goldsmiths and jewellers, London
Founded in 1796, the firm was listed in 1846 at 68 Oxford Street and from that address sent jewellery to the Great

Exhibition in 1851. By 1852 there was a branch at 19 Piccadilly. The firm also exhibited at the International Exhibition in London in 1862.

Aucoc, André
firm of goldsmiths, silversmiths and jewellers, Paris
The firm was founded by Casimir Aucoc in 1821 at 154 rue St Honoré and moved to 6 rue de la Paix in 1835, specialising at that date in silversmithing. Casimir was succeeded in 1854 by his son Louis who was soon to add the manufacture and sale of jewellery to the silversmithing business. In 1876 René Lalique joined the firm as an apprentice. The firm continued to make jewellery until after 1900, but this branch of the business was always regarded as a sideline. When André Aucoc took over the firm, he concentrated on the silversmithing and his main production was the recreation of the work of famous silversmiths of the eighteenth and early nineteenth centuries.

Bailey, Banks and Biddle Co.
firm of jewellers and silversmiths, Philadelphia, Pennsylvania
The firm was founded in 1832 by Joseph T. Bailey. From 1878, it was under the management of Joseph T. Bailey Jnr., with his partners George Banks and Samuel Biddle. The firm is still in business in Philadelphia, though most of the old records have been lost with the passage of time.

Bapst, Maison
firm of court goldsmiths and jewellers, Paris
Georges-Michel Bapst (1718-1770) became *Orfèvre-joaillier du Roi* in 1752, succeeding his father-in-law, Georges-Frédéric Stras (the inventor of 'strass'—the colourless glass paste used extensively for jewellery throughout the eighteenth and nineteenth centuries) who retired that year. Bapst was in turn succeeded by his own son, Georges-Michel *fils*, who had been apprenticed to another royal jeweller, Pierre-André Jacquemin from 1761 to 1770.

In 1797, Jacques Bapst (son of Georges-Michel *fils*) married the daughter of Paul Nicholas Menière, a member of the great family of eighteenth century silversmiths. At the end of 1788 Menière had acquired the business of Boehmer and Bassange, who had been jewellers to Marie-Antoinette but were ruined by the notorious *affaire du collier*.

141 *A diamond flower spray in the revived eighteenth-century style, made by Bapst for the Empress Eugénie. The piece was photographed in 1887 at the time of the sale of the French crown jewels. All Eugénie's jewels were dispersed at the fall of the Empire and it is not known how many, if any, survive.*

Jacques Bapst's two sons, Constant and Charles-Frédéric, succeeded to the business. One of their first tasks was the remaking of some of the Napoleonic regalia for Louis XVIII. The firm, now known as Bapst *frères*, also made the coronation regalia for Charles X. Charles-Frédéric, who was joined in the firm by his nephew Alfred, remained the director of the workshops for fifty years. During this time the magnificent diamond parures, many of them designed by Alfred, which were shown at the Exposition in 1867, were made from the reassembled *diamantes de la Couronne* for the Empress Eugénie. After the death of Charles-Frédéric, in 1871, he was succeeded by his nephew Alfred, and his two sons Jules and Paul. At the time of his father's death in 1880, Alfred's son Germain left the firm to go into partnership with Lucien Falize leaving the family business to his uncles, who renamed the firm 'Jules et Paul Bapst et fils'.

Bapst et Falize

firm of goldsmiths and jewellers, Paris
This was a partnership between Germain Bapst, son of Alfred Bapst (director of Bapst *frères* from 1871 until 1880), and Lucien Falize from 1880, which was dissolved in 1892 when Germain Bapst withdrew from the firm.

Bautte et Moynier

firm of watchmakers, jewellers and enamellists, Geneva
The firm was established in the late eighteenth century by Jean-François Bautte (1772–1832), a watchmaker specialising in very thin watches. It concentrated on enamelling and fine goldwork rather than on jewellery made of valuable precious stones, and was well known in the nineteenth century for the fine quality 'Geneva' ornaments which it sold.

The stock carried by the firm in the 1840s is lovingly described by John Ruskin in *Praeterita*, published 1885–9 (Vol. XXXV of the Library edition of Ruskin's complete *Works*, ed. Cook and Wedderburn, p. 325). Ruskin writes 'Virtually there was no other jeweller in the great times. There were some respectable, uncompetitive shops, not dazzling in the main street; and smaller ones, with an average supply of miniature watches, that would go well for ten years; and uncostly, but honest, trinketry. But one went to Mr. Bautte's with awe, and of necessity as one did to one's bankers.' He paid Bautte's the supreme compliment, very rarely extended to the more famous Paris and London

142 Bracelet in gold, decorated on both sides with cloisonné *enamels in the Japanese taste, made by Bapst et Falize in 1883 (marked with makers' monogram and date). It was owned by Mrs. H. F. Makins, daughter of John Hunt of Hunt and Roskell, and was worn with the set of enamelled jewellery made by Alexis Falize.*

jewellery firms of whom he often spoke scathingly, of buying some pieces of enamelled jewellery for his wife.

Murray's *Handbook* for 1846 states that in Geneva 'The largest and most celebrated establishment for jewellery and watches was that of Bautte and Company.' Their name is not included in the next edition which appeared in 1852.

Benson, J. W.
firm of retail jewellers, London
Founded in 1874, the firm was located at 25 Old Bond Street, and merged in about 1897 with Alfred Benson and Henry Webb who had acquired Hunt and Roskell (of 156 New Bond Street—see below), the well-known royal jewellers and goldsmiths. The firm still exists at the same address.

Bindesbøll, Thorvald (1846–1908)
Danish architect and designer
Son of a prominent Danish neo-classical architect, Bindesbøll himself became an architect in 1876. However, his most outstanding work was in decorative art. He developed an individual style which owed little to fashionable Art Nouveau ideas but anticipated to a remarkable extent the experimental work of twenty years later. His work shows the combined influence of William Morris and eastern art; the jewellery designs, which are not dissimilar to the work of Mogens Ballin (founder of the Copenhagen silver workshops where Jensen worked as a young man), use a range of imagery quite outside the current fashionable vocabulary, often appearing almost grotesque, and without any of the richness of the contemporary French Art Nouveau pieces.

143 *A silver buckle designed by Thorvald Bindesbøll and executed by P. Hertz early in the twentieth century.*

Birks, Henry, and Sons
firm of goldsmiths and jewellers, Montreal
The firm was founded by Henry Birks (1840–1928), son of a Sheffield-born pharmacist, in Montreal in 1879. Members of the Birks family had been connected with the cutlery trade in Sheffield, and Henry Birks claimed that the names of forty-seven of his ancestors were inscribed in the Court Rolls of the Ancient Company of Cutlers in Sheffield. His trademark, a churchwarden's pipe, which is used on his best silver, was once that of a Birks ancestor, William, who made silver for Charles II. Henry Birks was apprenticed

to the Montreal Jewellery firm of Savage and Lyman. In 1868 he married Harriet Phillips and eleven years later opened his own business, after the failure of Savage and Lyman in the seventies, with three thousand dollars and a staff consisting of two men and a boy. By 1900 the number of employees had risen to over two hundred, and by a number of extensions and profitable amalgamations with rival businesses, the firm had become (and still is) one of the largest jewellers in Canada. Henry Birks' three sons, Gerald W., John Henry and William Massey, were all admitted into equal partnership with their father during the last years of the nineteenth century, and William became president of the whole concern at the time of his father's death in 1928. After the deaths of the three sons of Henry Birks, which all took place within a few months in 1949-50, Henry Gifford Birks, son of William, succeeded to the presidency. A fuller account of the firm and its present-day operation is given in 'The House that Henry Birks built', by Mackenzie Porter, published in *Maclean's Magazine*, 15 December 1954.

Marks: Churchwarden's pipe; lion rampant with twin letters в

Birmingham Guild of Handicraft
firm of craft jewellers, Birmingham
The Guild was founded in 1890 with Montague Fordham, a solicitor and later owner of the Montague Fordham Gallery and The Artificers' Guild, as one of the first directors. He was joined by a number of other directors in 1895 when the Guild became a limited company. C. Napier Clavering and Arthur Dixon were the chief designers. In 1910 the Guild amalgamated with the Birmingham firm of Gittins Crafts-

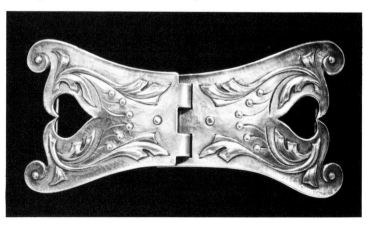

144 Birmingham Guild chased silver buckle; c. 1910.

men Ltd., who specialised in the production of good quality hand-made jewellery and other metalwork. E. R. Gittin's chief jewellery designer was H. R. Fowler. There is evidence to suggest that the production of jewellery by the Guild dates from after the amalgamation with Gittins.

Mark: B G O H (in a square)

Blackband, William Thomas (1885–1949)
English goldsmith and jeweller

Blackband was apprenticed to a Birmingham goldsmith in the late 1890s and at the same time attended evening classes at the Vittoria Street school. After a scholarship course at the Central School of Art he returned, in 1909, to Vittoria Street to teach part-time, joining the full-time staff two years later. He worked in close collaboration with Arthur Gaskin, the head of the school at this time. Blackband did some of the work on the elaborate commissions received by Gaskin from public bodies, notably the filigree work which Blackband made his particular speciality. He succeeded Gaskin as Head of the Vittoria Street School in 1924 and remained there until retiring in 1946.

Black, Starr and Frost
firm of goldsmiths and jewellers, New York

The firm of Marquand and Paulding was founded in 1801 by Isaac Marquand in Savannah, Georgia. From the time of its establishment in New York in 1810, the firm was called 'Marquand and Co.'; then in 1839, 'Ball, Thomkins and Black'; in 1851, 'Ball, Black and Co.', and in 1876, 'Black, Starr and Frost'. From the time of their arrival in New York in 1810 they occupied premises which became known as the 'Diamond Palace of Broadway'.

The Prince of Wales visited the firm in 1861 and bought some pearls. Around the same date, various issues of Mme Demorest's *Quarterly Mirror of Fashion* illustrate fashionable pieces from the stock of Ball, Black and Co. Much of their stock was made up of imported jewellery and the bulk of the business was always in more substantial and useful goods than the 'Gold, enamelled and Etruscan Jewellery; Stone, Cameo, Coral, Jewelry, Jet and tortoise-shell Goods' which they advertised in 1864; their merchandise even included a 'camp chest and Ball's American Camp Cooking Range and Boiler'. In 1929, Black, Starr and Frost merged with the Gorham Corporation, an arrangement which lasted until 1966.

LADIES' LOCKET.

This locket has the face of a Skye terrier, cut "intaglio" back of the crystal, and colored. They are fashionably worn suspended from velvet necklets. From Ball, Black & Co.

145 Illustration from Mme. Demorest's Quarterly Mirror of Fashions, *May 1867.*

Bolin, W. A.

firm of court jewellers, Stockholm

In the eighteenth century, the Bolins were shipowners near Gothenburg but the shipping business was sold in 1836 by the widow of John Bolin who was drowned with his eldest son. Another of John Bolin's sons, Charles, settled in St. Petersburg where he married the daughter of a prominent jeweller of the period and thus entered the jewellery business.

His firm was founded in St. Petersburg in 1845, with his brother Henrik as a partner. Later, a branch was opened in Moscow. The firm exhibited jewellery valued at £40,000 at the Great Exhibition of 1851 in London; some was illustrated in the Official Catalogue. The Bolins became goldsmiths and jewellers to the Russian Imperial Court although no member of the family ever took out Russian citizenship. At the beginning of the First World War, William Bolin took the stock from the German branch which had been opened in Bad Homburg an der Höhe and went to Sweden to set up a branch in Stockholm, requested to do so by King Gustav V. The king opened the new showrooms in 1916 and later the firm moved to their present premises in Sturegatan. The whole stock and all the documents belonging to the Russian organisation were lost in the Revolution in 1917.

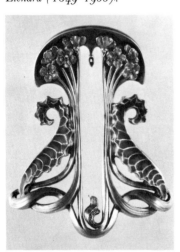

146 Clasp made by K. S. Bolin, Moscow, stamped 'Bolin 1903', from a published design by Paul Lienard (1849–1900).

Bott, Thomas (1829–1870)

English ceramic artist

Employed by the Worcester Porcelain Company, Bott pioneered the use of the Limoges technique for enamelling on porcelain, based on the French enamelwork of the sixteenth century, usually in the form of brilliant white figures and ornament on a dark blue or black ground. Bott painted a series of small cameo-like ceramic plaques for Robert Phillips and incorporated them into a gold neo-classical style necklace which he showed at the International Exhibition held in London în 1862.

Boucheron

firm of court jewellers, Paris

The firm was founded in 1858 by Frédéric Boucheron (1830–1902) who had been apprenticed at the age of fourteen to the famous *ciseleur* Jules Chaise (1807–1870) in the Palais Royale, at one time the jewellers' quarter of Paris. By the mid-1860s, his reputation as a jeweller was

sufficiently well established to justify the move to more lavish quarters in the Place Vendôme; he was particularly noted for his elegant and lavish diamond jewellery. He won a gold medal for his exhibit at the Exposition Universelle in Paris in 1867.

The Maison Boucheron employed, among others, Octave Lœuillard (*chef d'atelier* 1865–1875), whose delicate botanical jewellery in the form of ferns and single long-stemmed flowers seems strikingly original in comparison with the Louis XVI-style bouquets which were so fashionable throughout the nineteenth century. Louis Rault (1847–1903) sculptor-engraver, silversmith and jeweller, worked in the Boucheron workshop from 1868 to 1875. He set up on his own at the end of the nineteenth century making designs for silverwork and jewellery in the Art Nouveau style. A number of small *maquettes*, in wax on plaquettes of slate, of his designs are preserved in the museum at the Hotel Lambinet in Versailles. (Rault's mark is an elaborate and stylised monogram of his initials, L. R.) Jules Brateau (*b.* 1844) and Lucien Hirtz (noted for his easily recognisable, highly chased gold jewellery), also worked for the Maison Boucheron, and Jules Debût (1838–1900) designed most of the jewellery shown by the firm in 1878 and some of that made for Sarah Bernhardt. Debût remained with the firm until 1879. The Musée du Luxembourg bought some of the most spectacular Art Nouveau pieces made by Boucheron for the Exposition in Paris in 1900. The name of Boucheron is still as well known today as it was in the nineteenth century.

Mark: BOUCHERON

147 Diamond, gold and enamel bracelet by Boucheron; it is thought to have been made for the 1878 Exposition Universelle.

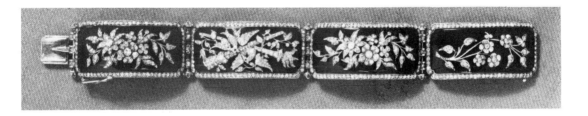

Boutet de Monvel, Charles (*b.* 1855)
French painter, engraver, medallist, jeweller and enamellist
Born in Paris, Boutet de Monvel studied at the Ecole des Beaux Arts from 1874 under Gérôme and Ponscarmé. He studied medal engraving at the school but did not start

making jewellery until about 1898. He worked in Paris, from 1898 to about 1910, apparently at his private address, using the yearly exhibitions at the Paris Salon as his shop window.

In the *Studio Yearbook of Decorative Design* for 1909, Boutet de Monvel's address is given as 8 rue Tronchet, Paris. He appears to have been exhibiting his remarkably original jewellery, usually made of silver, textured and oxidized and in designs based on unusual natural forms, since the turn of the century; much of his work is illustrated in the early volumes of *Der moderne Stil*, and in various other publications from 1901 onwards.

Like that of many of the younger designers working in Paris at this period—Charles Rivaud and Paul E. Mangeant for instance—his work has a greater affinity with the Arts and Crafts jewellery being made in England, or the work of the *Jugendstil* designers, than with the more elaborate and expensive pieces produced by the great Art Nouveau designers like Lalique and Georges Fouquet.
Mark: CH DE MONVEL

148 Jewellery shown by Messrs. T. and J. Bragg at the 1872 International Exhibition.

Bragg, T. and J.

firm of goldsmiths and jewellers, Birmingham, England

The firm of T. and J. Bragg was founded by Thomas Perry Bragg in the early nineteenth century, and was taken over by his two sons, Thomas and John, in 1844. They exhibited work at the International Exhibitions in 1862, 1867, and 1872. Examples of typical brooches and bracelets in engraved gold decorated in enamel, which were shown in 1862, are now in the Victoria and Albert Museum. This type of work was widely copied in the United States in the mid-nineteenth century, probably originally from one of the great number of pieces imported from Birmingham. Most of the American work is carried out in black enamel on gold, whereas the English work, except in the case of mourning jewellery, is often in blue, or blue and white, enamel. Pieces of 'Egyptian' jewellery were shown by the firm in 1872. The work of this firm is typical of the better-quality Birmingham work of the period.

Brogden, John (working 1842–1885)

English goldsmith and jeweller

From 1842 to 1864 Brogden was a partner in the firm of Watherston and Brogden of 16 Henrietta Street, Covent Garden (the firm is listed in 1826 as Brogden and Garland, but from 1835 to 1841 the firm's name had been Garland

and Watherston: both at the same address, 16 Bridgewater Square, Barbican). In 1864 Brogden took over the premises in Henrietta Street and continued to operate here as a wholesale jeweller under his own name until 1880. From 1881 until 1885 he is listed as an 'art goldsmith' at Grand Hotel Buildings, Charing Cross.

He showed jewellery at the exhibitions in London and Paris in 1851, 1862, 1867 (when he won a gold medal), and 1878. Two of his most remarkable 'archaeological' pieces are in the Victoria and Albert Museum; one is a bracelet made in about 1860 and decorated with a scene depicting Ashur-bani-pal, King of Assyria, making a sacrifice on his return from a lion hunt (after one of the recently discovered sculptures from Nineveh); the other is a set of necklace and earrings in gold decorated with coloured enamels and hung with cameos of chalcedony and onyx in a range of pale colours. His gold work shows outstanding technical ability, particularly in the delicacy of the granulation and the filigree used in both his 'archaeological' and his Gothic-style jewellery. His work in the Italian archaeological style was particularly commended by Alessandro Castellani in his report on the British jewellery shown at the Paris Exposition in 1878.

Marks: J B; BROGDEN (both in rectangular shield with chamfered corners)

149 Enamelled gold necklace and earrings set with chalcedony cameos, made by John Brogden and shown at the Paris Exposition of 1867.

150 Gold pendant cross designed by Brogden after the cross in a picture in the National Gallery, London, attributed to Quintin Metsys; made c. 1870.

Bromsgrove Guild of Applied Art
guild of craft jewellers, Bromsgrove, nr. Birmingham, England
The Guild was founded in *c.* 1890 by Walter Gilbert, the sculptor, metalworker and designer, whose work was strongly influenced by that of his more celebrated cousin, Alfred Gilbert. A number of the designers connected with the Arts and Crafts movement worked for the Guild, among them Mr. and Mrs. Arthur Gaskin and Professor Joseph A. Hodel, instructor in metalwork at the Liverpool School of Art and a distinguished jewellery designer. The Bromsgrove Guild was, by some administrative oversight, one of the only organisations showing English Arts and Crafts work at the centennial exhibition in Paris in 1900. A fuller account of the Guild will be found in *Saga of the Guild of Decorative Art*, by Barbara J. Morrison, privately printed in 1969.

Marks: B G; B G A A

Bulgari, Gioielleria

firm of goldsmiths, silversmiths and jewellers, Rome

The firm was founded in 1881 by Sotirio Bulgari (1857–1932), descendant of an ancient Greek family of goldsmiths from Kallartris; he left his country of origin as a young man and went to Naples. After some years of hard struggle and having failed to establish himself successfully there, he left for Rome in 1881 and set up as a goldsmith, opening first a shop in Trinita dei Monti, which was shortly followed by a number of other branches including one in the via Condotti, which is still open, having been considerably enlarged in 1934. He had begun to specialise in jewellery, before coming to Rome, in 1880, and he was joined in his now successful business by his two sons, Constantine in 1889, and Giorgio in 1890. In the present century the firm has become renowned for the large and exotic jewels in strange or savage forms, often of animals, made of a mixture of precious and semi-precious stones and gold enamelled in vivid colours.

Burges, William (1827–1881)

English architect, antiquary and designer

Burges was the son of a marine engineer who provided him with sufficient means to create a mediaeval fantasy without the need to build up a flourishing architectural practice. His wide interests—in Gothic and French Renaissance architecture, antique metalwork and jewellery, archaeology and Indian and Japanese art—combined to produce the eclectic decorative style used in the house he designed for himself in Melbury Road, in the design for St. Finn Barre's Cathedral in Cork, and in his two great schemes for Lord Bute—the restoration of Cardiff Castle and the building of Castell Koch. He also designed for Lord Bute a set of neo-Gothic marriage jewellery.

His jewellery designs are almost all Gothic in inspiration, with the exception of a necklace and earrings in the Etruscan style which was presumably influenced by the work of Castellani. That Burges was greatly interested in Castellani's work is evident from his article 'Antique Jewellery and its Revival', a long account of Fortunato Pio Castellani's research into antique methods which appeared in the *Gentleman's Magazine* in 1862. From a later period there exist a number of watercolour drawings for less elaborate Gothic-style pieces, several of which were designed as marriage jewels like the Bute brooch; these designs bear indications in the form of names and code numbers of having been commercial commissions, possibly for Hardman and

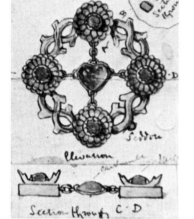

151 Design in pencil and water-colour for a Gothic-style brooch by William Burges.

152 Brooch made by Hardman, possibly based on the design by Burges, illustrated above.

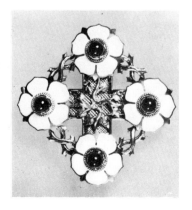

Co., for whom he made other metalwork designs. These are now in the drawings collection at the Victoria and Albert Museum.

The badge and chain designed by Burges for the Exeter Corporation is illustrated in the *Building News* of 5 September 1885. Early and roughly sketched ideas for the jewellery for Lord Bute, as well as an album of ecclesiastical metalwork designs (much less elaborate than the Bute pieces) are all in the drawings collection of the library of the Royal Institute of British Architects.

Burne-Jones, Sir Edward (1833–1898)
English artist and designer

Close friend and associate of William Morris and the pre-Raphaelite painters, Burne-Jones was commissioned by John Ruskin in 1883 to make designs for the 'Whitelands' cross (the prize offered annually by Ruskin to the most popular girl, to be chosen by her fellow pupils, at Whitelands College in Chelsea). Three sketch-books begun by Burne-Jones in 1882 contain further designs for jewellery. One, entitled *Thoughts of Designs for a Flower Book* (in the Victoria and Albert Museum) and another, called *Secret Book of Designs* (British Museum), both contain a number of delicate finished designs, many with birds and leaves, which are in the same style as the brooch made after his design for his wife Georgiana, and described by her in the *Memorials* (pub. 1904); this is one of the few surviving pieces designed by him. The third sketchbook in the collection at Wightwick Manor, Wolverhampton, contains a number of jewellery designs which are bolder and more antiquarian in inspiration. The designs for the 'Whitelands' cross (or rather, the few designs which survive out of the fifty which Burne-Jones claimed to have made) are in the Sharp Collection in the library of Queen's College in New York with a number of other jewellery designs which appear to be rough ideas for pieces in the Wightwick Manor sketchbook.

The pieces designed by Burne-Jones and made for his wife and daughter (which seem to have disappeared—with the exception of the brooch described in the *Memorials*, a pendant, a pair of cuff-links, and two rings) were made either by the Kensington jewellers Child and Child, whose enamel-work at the turn of the century betrays a strongly pre-Raphaelite influence which might be supposed to come from their contact with Burne-Jones, or by Giuliano.

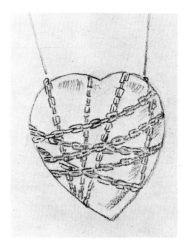

153 Design for a chained-heart pendant necklace by Burne-Jones; c. 1885.

Caetani, Michelangelo – Duke of Sermoneta (1804–1883)

Italian antiquarian and painter

The Duke was patron, friend and collaborator of the Castellanis—father and sons—from 1828 until his death. He gained access for Fortunato Pio Castellani to the archaeological excavations being carried out for the State and he continued to help the Castellani firm with encouragement, money and ideas for experimental work with jewellery design and techniques throughout their long association. He was awarded a medal for his share in the presentation of the Castellani exhibit at the 1873 Vienna Exhibition. The Duke's antiquarian interests led him to design in antique styles other than the strictly classical, and the neo-Gothic and Italian mediaeval jewellery produced by the Castellanis was probably designed, or at least inspired, by him.

Mark: as Castellani

Caldwell, J. E. and Co.

firm of jewellers, silversmiths and antiquarians, Philadelphia, Pennsylvania

James E. Caldwell, who was born in New York in 1805, was trained as a watchmaker and jeweller. He is said to have started his business in Philadelphia in 1835, but there is no documentary evidence to support this; the first advertisement issued by the firm appeared in 1839 in the June 20th issue of the *United States Gazette*.

From 1840 to 1859, the business operated from 140 Chestnut Street and gradually moved westward during the following years—to 822 Chestnut Street in 1859 and to 902 in 1868, where it remained until 1916. In 1843, Caldwell took a partner, and for a time the firm was known as Bennett and Caldwell, but in 1848 a notice appeared in the *United States Gazette* to the effect that James M. Bennett was leaving the business. From that time, the firm operated under the name of J. E. Caldwell and Co. and is still known by that name.

The range and type of jewellery stocked by Caldwell's in the mid-nineteenth century can be guessed from the fact that they were used by the fashion editor of *Godey's Ladies' Book* to fulfil customers' commissions. The goods stocked by the firm were described at some length in the April 1869 issue of *Godey's* and some idea of the style and quality of the jewellery can be obtained from the illustrations in Mme Demorest's *Quarterly Mirror*. Unfortunately two serious fires, in 1869

and 1914, destroyed most of the records of the work of the early years.

James Caldwell died in 1881 and was succeeded by his son, J. Albert Caldwell, who ran the business until his death in 1914. The founder's grandson, J. Emott Caldwell, then ran the business until his own death in 1919. A fuller account of the firm's history can be found in Joseph Hugh Green's *Jewelers to Philadelphia and the World, 125 Years on Chestnut Street*, a pamphlet published by the Newcomer Society of North America in 1965.

Carr, Alwyn (1872–1940)
English silversmith and enamellist
In 1898 Carr became a partner of the designer and silversmith Omar Ramsden, with whom he had studied at the Sheffield School of Art. He had won a Sheffield Corporation Scholarship to the School of Art (tenable for four years) in 1893, one year before Ramsden won a similar award.

They went to London in 1898 to set up their workshop. Their mark (see below) was registered in February of that year, and from then until 1918, they continued in a partnership which was in the early years mainly financed by Carr.

At the beginning of the war in 1914, Carr enlisted in the Artists' Rifles; he was invalided out in 1918 and after his recovery from some months of illness, returned to take up his work with Ramsden again. However, the intervening years had changed the character of the workshop and the partnership proved to be unworkable: it was formally dissolved in 1919. Carr continued throughout the 1920s as a silversmith and designer of wrought ironwork.
Mark: RN & CR. (in a rectangular shield with chamfered corners)

Cartier
firm of court jewellers, Paris
The business was founded in 1859 by Louis François Cartier who had started making jewellery in a garret workshop in about 1847. He had the great good fortune to attract the favourable notice of the Princesse Mathilde Bonaparte, cousin of Napoléon III, who was a valuable and influential patron, and was able to open a modest retail shop in the boulevard des Italiens by 1859.

In 1874 he was succeeded by his son, Alfred, who had been working in the business since 1864. At the turn of the century, the shop, under the management of L. F. Cartier's three

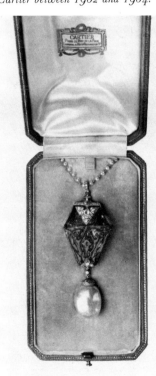

154 Jade and baroque pearl pendant set with diamonds and hung on a pearl and platinum chain; made by Cartier between 1902 and 1904.

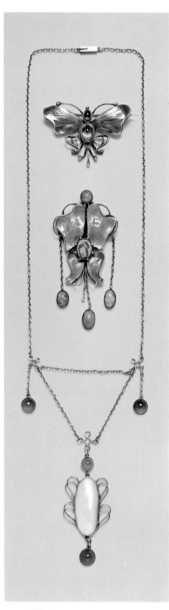

155 Necklace, pendant and brooch; the necklace is in silver and gold set with mother-of-pearl and chryso-phrases, the pendant is enamelled and set with turquoises, and the brooch is made of silver set with a pale olivine; designed by C. R. Ashbee for the Guild of Handi-craft, c. 1900.

grandsons, Louis, Pierre and Jacques, moved to 13 rue de la Paix, joining the other most fashionable and successful jewellery shops in Paris at that time. In 1902 the London branch was opened in New Burlington Street (moving in 1904 to its present location at 175 New Bond Street) and the branch in New York was opened in 1912. The name of the firm has become identified with stylish jewellery in original combinations of precious and semi-precious stones made during the 1920s in the Art Deco style.

Marks: LFC (in a diamond-shaped shield); AC (with a hatchet)

Castellani, Alessandro (1824–1883) and Augusto (1829–1914)

Italian goldsmiths, silversmiths, and antiquarians

Sons of the Roman goldsmith and jeweller, Fortunato Pio Castellani, they jointly managed the family firm after their father's retirement in 1851. They were experts in the field of antique and classical jewellery and were instrumental in popularising the archaeological style which their father had pioneered in the first half of the nineteenth century. Augusto Castellani formed the famous *collezione Castellani* of antique jewellery, part of which forms the basis of the collection at the Villa Giulia in Rome.

The activities of the firm of Castellani span a period of over sixty years: a great deal of the work survives, perhaps mainly because expensive precious stones were rarely used. The technical quality of the surviving marked pieces—though generally high—is somewhat variable, the artistic quality even more so. Presumably, the 'Etruscan'-style gold brooches and the mosaic-work set in gold—of fine but not outstanding quality—formed the stock of the shop, whereas the more spectacular pieces were special commissions.

Very few pieces can be dated by external evidence, though drawings exist by Augusto Castellani in the Cooper-Hewitt Museum in New York, dating from about 1870. The set of jewellery designed for the Countess of Crawford by Michel-angelo Caetani dates from about 1875 (though the diadem seems to be nearly identical with one shown by the firm in Paris in 1867) and the drawings made by Caetani for the Castellani firm appear to date from the period 1860–70. The gold mounts for a set of cameos by Saulini were made by the Castellanis in the 1860s [116]. A few indications can be gleaned from these documents: for instance, it seems most likely that the pieces of jewellery in antique styles other than

classical were inspired by the designs of Caetani, and the period from the reopening of the firm in 1858 until well into the 1860s and 1870s appears to have been the most prolific for jewellery of exceptionally high quality.

No work was done in the Rome workshop between 1848 and 1858, and both Alessandro and Augusto seem to have been virtually in exile during that period. Vever claims that Alessandro was in Paris, and there is also some evidence to suggest that one or both of the brothers spent some time in London. The growth of their reputation in England dates from 1861, when jewellery in the archaeological style made by the firm was shown in Jermyn Street, and Augusto Castellani read a paper on the revival of classical style and technique

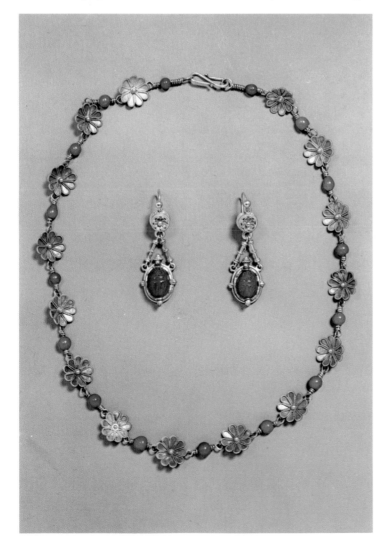

156 Gold and amber necklace by Castellani, and gold earrings set with carnelian scarabs in the style of Castellani; all c. 1870.

to the Archaeological Association. This was extensively reported by Burges in *The Gentleman's Magazine and Historical Review*. They also showed their work at the 1862 International Exhibition in London, where the gold jewellery decorated with granulation in the Etruscan style created a sensation; for that reason, it must be assumed that the rather dull and uninspiring brooches illustrated by the *Art Journal* in the catalogue of the exhibition give absolutely no idea of the quality of the work shown by the firm. Their jewellery in the archaeological style was widely imitated in France, America and England, as well as in Italy, and it is probably safer to assume that work which is not marked with the firm's crossed capital Cs was done by someone else.

Mark: c c (in monogram)

157 Gold and enamel tiara in the Greek style by Castellani; 1867 (?).

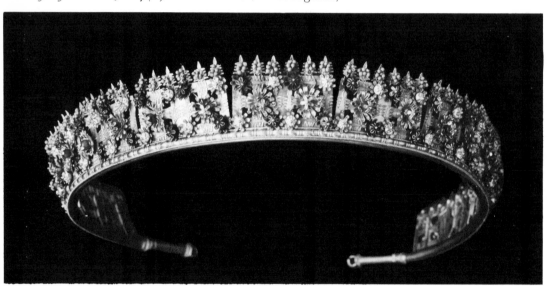

Castellani, Fortunato Pio (1793–1865)
Italian goldsmith and silversmith

Son of a jeweller, Castellani entered his father's Rome workshop in 1814, at a time when the firm was concentrating on making fashionable jewellery in imitation of contemporary French work. It was in about 1826 that he began making jewellery in gold and filigree, copied from the early Roman jewellery unearthed in the extensive archaeological excavations then being undertaken. In 1836, through his friend and patron Michelangelo Caetani, Duke of Sermoneta, he was present in an advisory capacity at the excavation of the great Regulini Galassi tomb which yielded the most sophisticated and perfect collection of Etruscan metalwork ever found.

Castellani determined to learn the technical secrets of the ancient goldsmiths, in order to copy their jewellery with its granulated decoration. After much research, he succeeded in finding craftsmen—in the small town of St Angelo in Vado in the Marches—who were working with techniques similar to those used by the Etruscans; he took both men and women from the town to work for him in Rome.

In 1848, the political situation in Italy forced the workshop to close, and no business was done in Rome for ten years. Fortunato Pio Castellani retired in 1851, leaving the business to his two sons, Alessandro and Augusto, who opened the workshop again in 1858.
Mark: C C (in monogram)

Chaumet, J.
firm of retail jewellers, Paris and London
Chaumet were successors to the firm of Etienne Nitot, jeweller and silversmith to Napoléon I. The Nitot firm, which was run by Etienne and his son François Regnault, was handed over to Fossin *père*, their *chef d'atelier*, when Napoléon fell from power in 1815. Fossin established himself first at 75 rue de Richelieu, later moving to 62 where the firm remained until 1905. Jean-Baptiste Fossin (1786–1848) was a fashionable jeweller throughout the restoration period, he was given the *Brevet du Roi* in 1830, and was joined by his

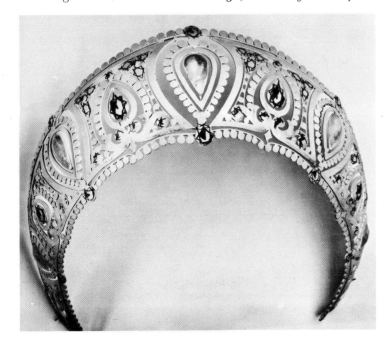

158 A cardboard maquette for a tiara designed by the firm of Chaumet in Paris; late nineteenth century.

son Jules in the same year. Jules Fossin (1808–1869) carried on the business until 1862. In that year, the firm was handed over to Prosper Morel, the son of the celebrated silversmith, J. V. Morel, who had worked as *chef d'atelier* for Fossin *père* in the past. He remained as the director of the firm until 1889. Joseph Chaumet (1854–1928), partner and son-in-law of Prosper Morel, who joined the firm in 1874, opened the London branch in 1875, becoming the official director of the whole firm in 1889. He was succeeded by Marcel Chaumet, and the firm is still in business in London and Paris.

The firm is renowned for the delicate form and outstanding craftsmanship of immensely valuable jewellery made with large, beautifully matched stones in a framework of smaller, specially shaped (or calibré) pavé-set stones in nearly invisible settings. For a fuller account, see *Une pléiiade de maîtres-joailliers, 1780–1930*, privately printed in Paris for the Maison Chaumet in 1930.

Child and Child
firm of silversmiths and jewellers, London

Established in 1880 at Seville Street, Child and Child moved in 1891 to 35 Alfred Place West (now Thurloe Street), Kensington. In this year they became manufacturing jewellers, and began to produce the easily recognisable enamelwork of high quality for which they are best known, as well as more conventional pieces in the revived eighteenth-century style. Soon after the move to Kensington, they became jewellers by appointment to the Princess of Wales (later Queen Alexandra) and Princess Christian. They made up some of the jewellery designs of the painter, Edward Burne-Jones, and their enamelwork seems to have been

159 Cloak clasp in silver with plique à jour *enamels in the form of fantastic insects; made by Child and Child,* c. *1900.*

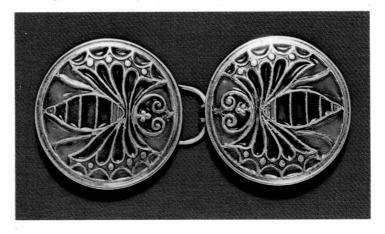

strongly influenced by contact with him, both in colour and in form. The firm continued at the Kensington address until 1915–16 when it closed down, presumably a victim of the wartime depression in the jewellery trade.

Mark: a stylised sunflower, the stalk flanked by the initials
C & C

Collingwood Limited
firm of court jewellers, London
The firm was established in 1817 by Joseph Kitching, who enjoyed the valuable patronage of Princess Charlotte, the Duke and Duchess of York, and the Duke of Gloucester. He moved to 46 Conduit Street in 1834 and in 1837, the year of Queen Victoria's accession, his firm was awarded the warrant of appointment as jewellers to the Queen. Kitching retired in 1853 and was succeeded by Henry Collingwood, who was followed in turn by his son, Robert Nelson Collingwood. The firm held the Royal Warrant continuously for 126 years.

Colonna, Edward (*b.* 1862)
German-born decorative designer
Born in Cologne, Germany, Colonna went to Brussels to train as an architect. In 1882, however, he left for America, where he worked as an interior designer with Associated Artists, the firm founded by L.C. Tiffany in 1879. He then went to live in Dayton, Ohio, where he produced his revolutionary booklet of Art Nouveau designs, entitled *Essay on Broom Corn*. Strongly reminiscent of the work of Louis Sullivan, the Chicago architect, the booklet pre-dates very similar experimental work in design by Belgian artists such as Horta and Van de Velde. The designs in Colonna's book are inspired by the wavy, interlaced lines of the stalks of corn which were used to make a corn-broom (the besom or rustic broom).

In 1898, Colonna returned to Europe to work for Samuel Bing; he produced jewellery and furniture designs for the Maison de l'Art Nouveau which were a great success at the Exposition in Paris in 1900, and his jewellery was widely commended for being more wearable and commercial than that of most other Art Nouveau designers.

Colonna went back to America in 1905, after Bing's shop had closed, and there continued designing in the style he had developed from the *Essay*. His designs were to prove highly influential in America where traces of his ideas can

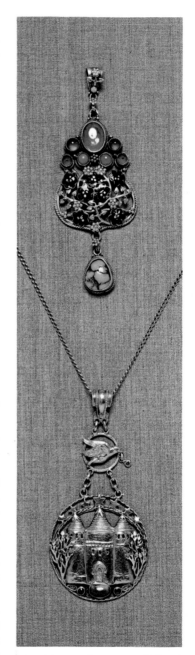

160 *Two pendants enamelled and set with semi-precious stones, designed and made by John Paul Cooper.*

be found in the work of many designers connected with the craft revival [67]. In the 1920s he developed a modified geometric manner not unlike the currently fashionable French Art Deco work, but these later designs lack the striking originality of his work at the turn of the century.

Marks: COLONNA (stamped); S.A.N.B. (in a diamond, the mark of the Maison de l'Art Nouveau)

161 Designs for jewellery in water-colours, by Colonna.

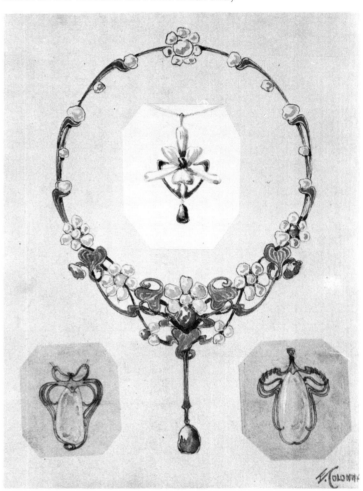

Cooper, J. Paul (1869–1933)

English architect, silversmith and jeweller

In 1887, Cooper was articled to the architect, J.D. Sedding. On Sedding's death in 1891, he went to complete his articles under Henry Wilson. Wilson aroused his interest in metalworking, which Cooper took up in 1897, specialising in the use of unusual materials, notably shagreen which he began

using in 1903, long before it became so fashionable in the 1920s and 1930s. His work is frequently illustrated in the *Studio* and the *Art Journal* from the turn of the century, mainly in the long critical reports of the Arts and Crafts Society's exhibitions.

Cooper taught at the Birmingham School of Art, where he was head of the metalwork department from 1904 to 1907. He was always strongly influenced by Wilson, particularly in the Gothic-style work [60] and to a lesser extent, by his contacts with Birmingham artists like Gaskin and Cuzner. He moved to Kent and finally set up his workshop in his house (which he designed himself) at Westerham. From 1906 he used a Japanese metalworking technique, combining silver and copper, called 'Mokumé', probably after having discussed the additions (relating to Japanese techniques) to *Silverwork and Jewellery* with his friend and teacher, Henry Wilson.

Mark: J P C (in a rectangular shield with chamfered corners or in a circular monogram)

Cranach, Wilhelm Lucas von (1861–1918)

German painter, jeweller, interior decorator and creator of objets d'art W.L. von Cranach claimed descent from the painter Lucas Cranach. He studied in Weimar and Paris, and in 1893 settled in Berlin working as a landscape and portrait painter. His jewellery designs include many elements typical of the continental Art Nouveau style, closer to French and Belgian taste than to German, but they have an air of real decadence

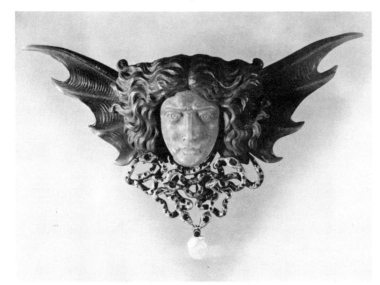

162 Medusa-head brooch designed by W. L. von Cranach in 1902.

which is absent (*pace* contemporary commentators) from the work of Lalique, Fouquet or Philippe Wolfers. He exhibited in Paris in 1900 where he won a gold medal, and at the Berlin Exhibition in 1906. For a fuller account (including illustrations) of his work, see *Werke moderner Goldschmeidekunst von W. Lucas von Cranach*, ed. W. Bode, published in Leipzig in 1905.

Mark: W L C (in monogram)

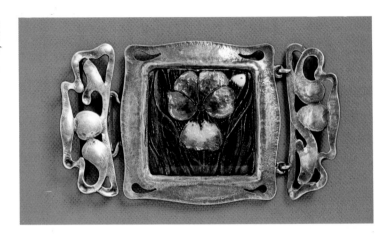

163 Silver waist clasp by Nelson Dawson set with an enamelled plaque of a pansy in a frame of leaves by Edith Dawson; c. 1900.

Cuzner, Bernard (1877–1956)
English silversmith and jeweller

Cuzner was born in Warwickshire, the son of a watchmaker to whom he was apprenticed on leaving school. During his apprenticeship he attended evening classes at Redditch School of Art where he early showed an exceptional aptitude

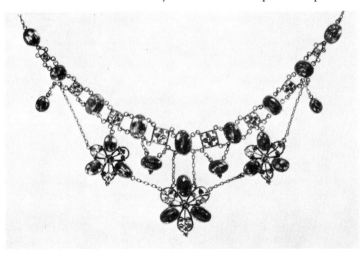

164 Silver necklace set with amethysts, designed by Bernard Cuzner; c. 1905.

for silversmithing. He abandoned watchmaking after two years and went to work for a Birmingham silver firm attending evening classes at the recently opened Vittoria Street School for Jewellers and Silversmiths under Robert Catterson Smith, who with Arthur Gaskin influenced his work during the early years. He began designing for Liberty's in about 1900, and various Liberty designs are attributed to him, but without sufficient documentary evidence to substantiate these claims. He may also have been employed at some time by the Birmingham Guild of Handicrafts; indeed the silversmith's work made by the Guild is closer to the designs used by Cuzner to illustrate his book, *A Silversmith's Manual* (1935), than any of the Liberty pieces usually assigned to him. A collection of drawings by Cuzner for silver work and jewellery is now in the Birmingham Museum of Science and Industry with his workshop [115]. In the year 1910 he was appointed head of the Metalwork Department at the Birmingham School of Art in Margaret Street; he retired from this position in 1942, but continued to work at silversmithing until his death in 1956.

Mark: B C

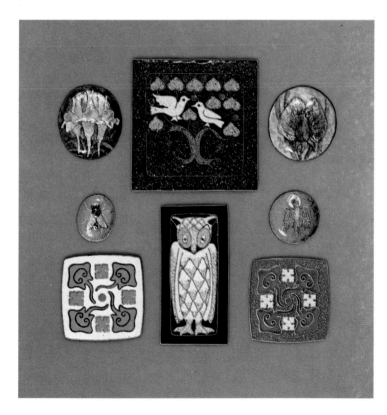

165 *Group of painted and* cloisonné *enamels for setting in jewellery and silverwork, made by Edith Dawson;* c. *1900.*

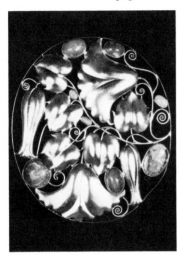

Czeschka, Carl Otto (1878–1960)

Austrian painter, graphic designer and artist-craftsman

A member of the Vienna Secession Movement (formed in 1897–8) Czeschka joined Hoffmann in the Wiener Werkstätte soon after they were founded in 1903. In 1907, he went to Hamburg to teach at the Kunstgewerbeschule there, but continued to provide designs which were made in the Werkstätte.

Marks: w w (monogram in a square shield, for Wiener Werkstätte); c o c (monogram in a square)

Dawson, Nelson (1859–1942) and Edith (*née* Robinson, married Nelson 1893)

English designers, metalworkers, and enamellists

Nelson Dawson studied architecture in the office of his uncle and painting at the South Kensington Schools. He met his wife while working in an art shop in Scarborough, where she exhibited watercolours for sale. In 1891, he came to London where he took up metalworking and attended a series of lectures on enamelling given by Alexander Fisher. He taught his wife enamelling and she carried out the enamelling work for his jewellery and silver, eventually ruining her health as a result of inhaling the noxious fumes from the enamelling kiln.

In 1900, the Dawsons had an exhibition at the Fine Art Society in Bond Street where they showed 125 pieces of jewellery, many of them decorated with enamel. The following year, Nelson Dawson founded the Artificers' Guild, binding himself to work exclusively for the Guild for five years. However, he left in 1903 when the Guild was taken over by Montague Fordham. The Dawsons' works, which they exhibited in London and on the Continent, are frequently illustrated in contemporary journals like the *Studio* and the *Art Journal*. Their style of rather architectural silverwork decorated with delicate enamels, often of flowers or birds, was developed early and retained—more or less unaltered—throughout the early years of the twentieth century. Quantities of jewellery and silverwork were produced in the workshop where up to twenty craftsmen might be employed at one time, preparing work for exhibitions and fulfilling commissions. The strain of organising the finances of the business was very great and it was with some relief that the metalworking was entirely abandoned in 1914.

Marks: n d (in an ivy leaf); the enamels sometimes signed with d

Doria, Carlo (working *c*. 1860–1880)

Italian-born goldsmith and jeweller

Doria came to England from Italy in about 1860 and worked for the firm owned by Robert Phillips, who was renowned in the 1860s and 1870s for his 'archaeological' jewellery in the Italian manner. Doria's work in gold, lightly decorated with enamel and set with stones chosen more for their colour than their value, is of a quality equal to that of Castellani or Giuliano, but it seems to be much more rare.

Mark: C D (monogram with a stylised fleur-de-lis)

Emanuel, Harry, F.R.G.S.

English goldsmith and jeweller; jeweller by appointment to the Prince of Wales (later Edward VII)

In 1860, Emanuel was operating from the address at 5 Hanover Square which had been occupied since 1846 by Emanuel Bros., who were previously (from about 1826) at 7 Bevis Marks. He moved in about 1880 to 27 Old Bond Street and in 1890 to 40 Albemarle Street.

It seems possible that Carlo Giuliano worked for this firm when he first came to England: the gold and enamel pendant shown by Harry Emanuel at the Paris exhibition in 1867, and illustrated in the *Art Journal* catalogue, is nearly identical with one made by Giuliano and now in the jewellery collection at the Victoria and Albert Museum, London.

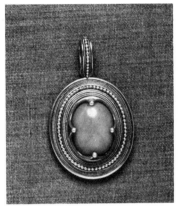

167 Gold and enamel pendant set with coral, made by Carlo Doria; c. 1870.

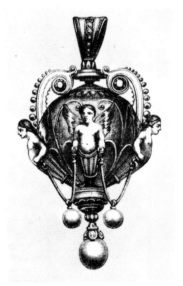

168 Page from the Art Journal Illustrated Catalogue *of the 1867 exhibition in London showing the pendant exhibited by Harry Emanuel.*

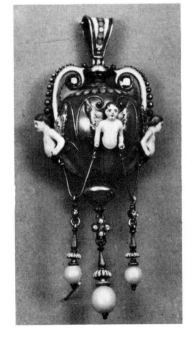

169 Enamelled pendant exhibited by Harry Emanuel in 1867, designed and made by Carlo Giuliano.

173

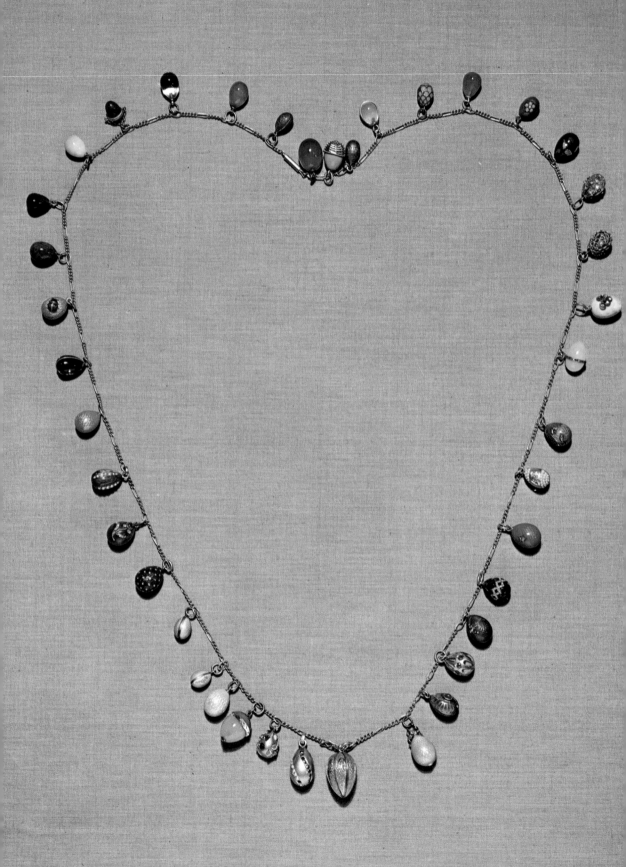

Fabergé, Gustav (1814–1881)

Russian goldsmith and jeweller

The Fabergé family was said, traditionally, to be of Huguenot origin; Gustav was born at Pernay on the gulf of Riga. After serving his apprenticeship with a St. Petersburg jeweller, he opened his own business in the fashionable Morskaya Bolshaya Street. He retired in 1860, leaving the family business in the care of his chief silversmith Zaiontchkovsky, until his son, Peter Carl, was old enough to take over.

Fabergé, Peter Carl (1846–1920)

Russian goldsmith and jeweller

The eldest son of Gustav Fabergé, Peter Carl took over the running of the family firm in 1870, once his education was complete. He had trained in the jewellery business in Frankfurt and had also learned the trade in St. Petersburg from Peter Heskias Pendin, goldsmith and chief assistant to his father.

Between 1870 and 1881, the firm specialised in making fashionable jewellery. In 1881, the younger Fabergé received the Imperial warrant from Czar Alexander III and in the following year, he made the first of the jewelled Easter eggs which both Czar Alexander and his son, Nicholas II, would give each year thereafter as gifts to their wives.

In 1883, Peter Carl Fabergé's younger brother, Agathon, joined the firm and from then on, they concentrated on production of the small, jewelled *objets de fantaisie* and hard-stone sculptures, for which they were later to be renowned in both Europe and America. In 1887, a branch was opened in Moscow to specialise in jewellery—a trade by then somewhat neglected by the firm in St. Petersburg—and particularly in the fashionable 'Old Russian' style, which used a form of *cloisonné* enamel technique called *skan* to decorate small pieces of metalwork and jewellery in traditional Russian shapes. In 1890 the St. Petersburg branch of the firm moved to larger premises; in the following years branches were opened in Odessa, Kiev, and finally, London in 1906; in 1898 an even larger building was completed in St. Petersburg.

The pieces for sale in St. Petersburg were made by Fabergé's work-masters who operated separate workshops which he supplied to them rent-free; he also supplied the designs and the materials and supervised the production of each piece. The workmasters themselves were responsible for the recruitment and the wages of their assistants. Fabergé's two chief jewellers were the workmasters A.W.

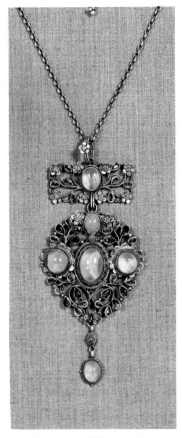

170 Pendant and chain in silver, set with fire opals, amethysts, and green pastes designed and made by Mr. and Mrs. Arthur Gaskin; c. 1905.

171 opposite: Necklace consisting of forty miniature jewelled and enamelled Easter eggs; many of the eggs were made in the Fabergé workshop in the late nineteenth century.

172 *Art Nouveau pendant, set with an amethyst by Peter Carl Fabergé; c. 1900.*

173 *Red topaz, diamond and seed-pearl necklace by Peter Carl Fabergé; c. 1910.*

Holmström and A. Thielemann. After the completion of the larger Fabergé building in 1898, most of the workshops were situated there. The Moscow workshops did not operate on this system and were managed by the jeweller, Oskar Piehl.

Fabergé first exhibited his work at the Pan-Russian Exhibition in Moscow in 1882, winning a gold medal. This success was repeated in 1885 at the International Gold-smiths' Exhibition in Nuremburg, where he exhibited copies in gold of the fourth-century B.C. ornaments that had been found in the Crimea, and added to the collection of the Hermitage in St. Petersburg. These copies were made at the suggestion of Count Stroganoff and with the Czar's permission, by the goldsmith Edward Kollin, one of the Fabergé workmasters who had been with the firm since the 1860s. In 1896, Fabergé received another gold medal at the Pan-Russian Exhibition in Nijny Novgorod, but his greatest triumph came five years later, when he exhibited (*hors de concours*, as he was a member of the jury) at the Exposition Universelle in Paris and was awarded the Légion d'Honneur.

In 1906, a branch was opened in London for the sale of Fabergé objects; it existed until just after the outbreak of the First World War. In 1918, the firm was 'nationalised' by the Bolsheviks who seized as much as possible of the remaining stock of precious stones and metals and completed pieces. Fabergé escaped to Switzerland and died in Lausanne in 1920.

Marks: FABERGE; also *Fabergé* in Cyrillic, or the initials in Cyrillic

Fahrner, Theodor (1868–1928)
jewellery manufacturer, Pforzheim, Germany
Fahrner made very inexpensive jewellery using cheap mass production methods and low-carat gold or silver set with semi-precious stones, opaque hardstones or *perles de coq* in the *Jugendstil* style. He often used designers from the artists' colony in Darmstadt, much like the Liberty venture in London, among them Patriz Huber and J.M. Olbrich. Some pieces designed by Henri van de Velde were made by the firm in about 1900; the firm exhibited in Paris in the same year.
Mark: T F

Falize, Alexis (1811–1898)
French goldsmith and jeweller
Alexis Falize was apprenticed to the Maison Mellerio in

1833; he left to become manager of the workshops of the Maison Janisset, well known Parisian jewellery firm of the *Restauration* period, from 1835 to 1838. He set up on his own in the Galerie des Valois, Palais Royale, in 1838, but continued to supply his old employers. He worked for a period at the Maison Carré, 167 Palais Royale, and appears to have taken over the business in about 1850.

Falize was chiefly notable for his work on the revival of the *cloisonné* enamel technique for use in jewellery in the mid-sixties. He exhibited jewellery decorated with *cloisonné* enamels in the Japanese taste at the Paris Exposition in 1867 [42]. He also produced ambitious neo-Renaissance pieces in the manner of Alphonse Fouquet. He retired in 1876 handing over the firm to his son, Lucien, who was to exhibit under his own name in 1878, thus ending the long period of anonymity which the firm had maintained under his father's management.

Mark: A.F. (in a lozenge with a flail)

Falize, André (1872–1936)

French goldsmith and jeweller

Eldest son of Lucien Falize he succeeded his father, with whom he had been working since 1894, at his death in 1897, working in the Art Nouveau style fashionable at the time. He ran the firm with the help of his two brothers. Jean and Pierre, under the name of Falize *frères*.

Falize, Lucien (1838–1897)

French goldsmith and jeweller

Trained by his father, Alexis, he took over the running of the firm at the time of the elder Falize's retirement in 1876. Lucien expanded the firm, exhibiting at the 1878 Exposition and, in 1880, going into partnership with Germain Bapst. Bapst withdrew from the firm in 1892, and Lucien's son, André, took over at the time of his father's death in 1897. Lucien continued to experiment with enamels, reviving the neglected technique of *basse-taille* (i.e. painting in translucent enamels over engraved decoration); he used this as well as the *cloisonné* techniques revived by his father for the very distinctive jewellery of fine goldwork decorated with enamels in a mannered *Japonaiserie* style that the firm of Bapst et Falize produced from about 1880 until the turn of the century. He exhibited neo-Renaissance jewellery in the manner of Hans Collaert in 1889. Lucien Hirtz, who worked for Boucheron, became an associate of Falize in the 1890s.

Mark: as Alexis Falize

174 Design for watch châtelaine by Alexis Falize; c. 1875.

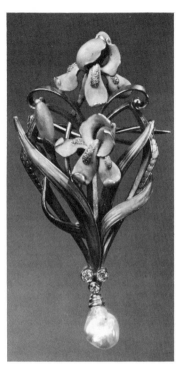

Feuillâtre, Eugène (1870–1916)

French sculptor, enamellist, silversmith and jeweller

An enamellist of remarkable ability, Feuillâtre worked for Lalique at the end of the nineteenth century. He made numerous experiments with the complex technique of enamelling on silver; he also perfected a technique for enamelling on platinum.

He set up on his own in 1899, specialising in objects decorated with *plique-à-jour* enamel—pieces which are some of the technically most sophisticated examples of Art Nouveau metalwork. He exhibited in the Paris Salon in 1899, at the exhibition in 1900, and at Turin in 1902. The elegant quality of his work in jewellery can be seen in a piece illustrated in *Studio*, in the form of two dragonflies settling upon a branch of umbels, made of enamel, platinum and diamonds.

Mark: Feuillâtre (in italic script, engraved)

175 Iris brooch designed by André Falize and made in Paris in 1900.

Fisher, Alexander (1864–1936)

English metalworker, painter and sculptor

From 1884 to 1886, Fisher was a pupil at the South Kensington Schools and there, his interest in enamelling—which was to be his predominant artistic interest—was roused when he attended a series of lectures given by L. Dalpeyrat of Sèvres. Fisher was awarded a scholarship to study enamelling in Paris where he experimented with the layered effects in translucent enamels, sometimes with metal or foil inclusions like the eighteenth century *paillons*, which were to be widely influential when they were exhibited in England.

Soon after his return from Paris, he set up his own workshop and he taught from 1896 to 1898 at the Central School of Arts and Crafts. In 1904, he set up his own school in Kensington. From 1893 until 1898 he lived at 139 Oxford Street; he moved to 4 Warwick Studios in Kensington and remained there until 1901; from that date until 1911 he lived in 17 Warwick Gardens. He wrote a number of articles on the history and technique of enamelling (see, for instance, 'The Art of Enamelling on Metals' which appeared in the *Studio* in several parts in vols. XXII, XXIII, XXV, XXVIII, 1901–1905) and exhibited regularly with the Arts and Crafts Exhibition Society.

Many of the illustrated pieces in the *Studio* and elsewhere are large caskets or framed enamels in silver or bronze; the jewellery is more rare. One of his most ambitious pieces of jewellery (if it can be so called) was the famous girdle of painted enamel plaques with a buckle over four inches high;

each plaque was decorated with a scene from a Wagner opera and they were made between 1893 and 1896. The girdle was exhibited, still unfinished, at the Royal Academy in 1895, and at the Arts and Crafts exhibition in the following year; it is now in the Victoria and Albert Museum.

Marks: A F (painted on the enamels); *Alex. Fisher fecit* (inscribed)

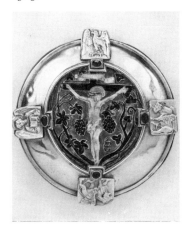

176 Gold and translucent enamel morse set with emeralds, designed and made by Alexander Fisher; c. *1905.*

Fontana et Cie

firm of goldsmiths and jewellers, Paris

The firm was founded in 1840 by Thomas Fontana as a modest business located in the Palais Royale in the Galerie Beaujolais—still a fashionable jewellery quarter at that date. At the time of his death in 1861, his son Charles was still too young to succeed to the management of the business and so it was carried on by two of his nephews, Joseph Fontana and Auguste Templier. Charles Fontana took over the direction of the firm in 1871 and Joseph Fontana left ten years later to found another *Maison* with his brother Giacomo, who had already been established for some time in the Galerie des Valois.

In 1893, the firm moved from the Palais Royale to 6 rue de la Paix. Pierre Fontana, son of Joseph, took over the business after the deaths of his father and uncle in 1897 and 1899 respectively.

Fontenay, Eugène (1823–1887)

French goldsmith, jeweller and antiquarian

Son and grandson of jewellers, Fontenay was chiefly renowned for his fantastic and delicate *bijoux étrusques*, decorated in the ancient Etruscan technique with minute grains of gold. Fontenay was apprenticed to the fashionable jeweller Edouard Marchand and worked for a time with the French goldsmith and jeweller, Dutreih, whose work he praised in almost hysterically lavish terms in his book on antique and modern jewellery. He set up his own workshop at 2 rue Favart in 1847. In 1858 he made a diadem of diamonds, emeralds and pearls for the Empress Eugénie. In 1867 he exhibited jewellery made from jade taken from the Summer Palace in Pekin, as well as the *bijoux étrusques*, inspired by the antique jewellery in the collection formed by the Cavaliere Campana which was acquired by Napoléon III for the Louvre in 1860. He wrote his book, *Les bijoux anciens et modernes* (pub. 1887), after he retired in 1882.

Fouquet, Alphonse (1828–1911)

French goldsmith and jeweller

Alphonse Fouquet worked from the age of eleven with various manufacturers of cheap jewellery in Paris. In his *Histoire de ma vie industrielle*, he recounts that in 1854 he went to work as a designer with Jules Chaise (see p. 65) and a year later to Carre et Christofle to work with Léon Rouvenat. The Fouquet firm was founded in about 1860 at 176 rue du Temple. Its early production consisted mostly of the elaborate and heavy jewellery fashionable at the time: in fact, it is indistinguishable from the work of other contemporary Parisian firms of similar standing, like Mellerio, Morel, Fossin and Vever. In the 1870s, Fouquet started to produce

177 Design for 'Diane' bracelet in engraved gold and enamel by Alphonse Fouquet; 1878.

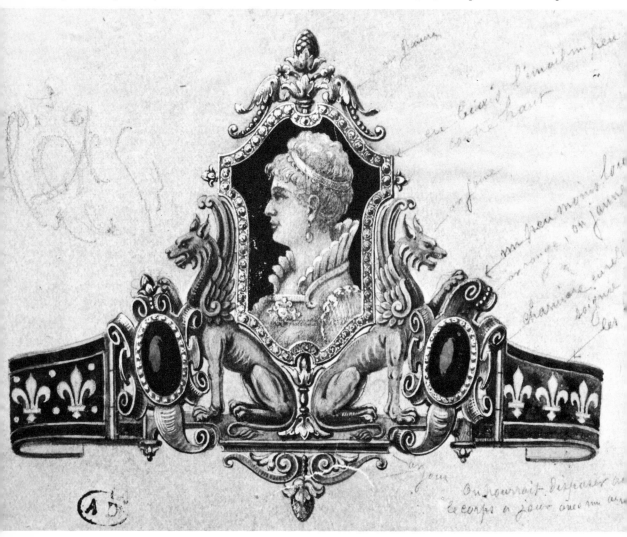

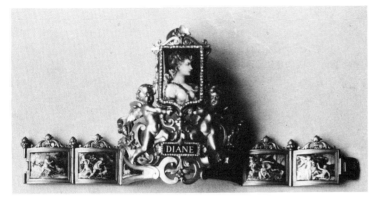

the complex neo-Renaissance pieces for which he was famous, made in heavily worked and chiselled gold, decorated with painted enamels. The designs for many of these pieces are in the library of the Musée des Arts Décoratifs, part of a collection of over ten thousand drawings, which cover the whole of the firm's activities from the first period in 1858 until well into the twentieth century; these were given to the museum by M. Georges Fouquet. Alphonse Fouquet moved the firm twice between 1860 and 1879, moving in that year to 35 Avenue de l'Opéra. He was awarded the Légion d'Honneur in 1888, and retired in 1895, leaving the business to his son, Georges Fouquet, who had joined the firm with his brother-in-law in 1891.

Mark: FOUQUET

Fouquet, Georges (1862–1957)

French goldsmith and jeweller

Eldest son of Alphonse Fouquet, he joined his father in 1891, and took over the running of the family firm in 1895. He immediately set about modernising production, calling on designers like Tourrette and Desrosiers: Tourrette, like Feuillâtre, was an enamellist who worked for Lalique and

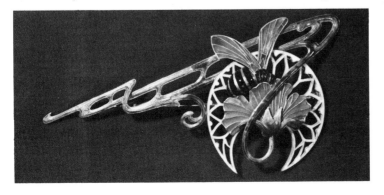

179 Flower and bee pin designed by Desrosiers for Georges Fouquet; c. 1900.

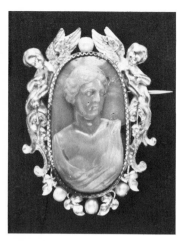

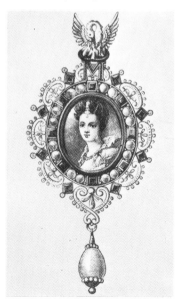

their work is remarkably similar; Desrosiers designed for Fouquet some of his best-known and most reproduced pieces, like the *Chataigne* (chestnut) pendant and the *Murier* (mulberry) necklace, both in the Musée des Arts Décoratifs.

Fouquet is probably best known as the maker of Alphonse Mucha's celebrated jewels designed for Sarah Bernhardt (see p. 209) and both the exterior and the interior of his shop in the rue Royale were designed for him by Mucha in 1901. Fouquet was joined in 1919 by his son Jean, the well-known modern designer.

Marks: G. Fouquet; Gges Fouquet (facsimile signatures, inscribed)

180 One of a pair of brooches in gold set with high-relief coral cameos and pearls, part of one of the last sets of jewellery made by F.-D. Froment-Meurice and similar to one of his exhibits in the Paris Exposition of 1855.

181 Jewelled pendant in the Renaissance style by Froment-Meurice, as illustrated in the Art Journal *catalogue of the Paris Exposition Universelle of 1867.*

Froment-Meurice, Emile (1837–1913)

French goldsmith and jeweller

The son of François-Désiré Froment-Meurice, he succeeded his father in the family business a number of years after his father's early death, since when the workshop had been under the management of his mother. He exhibited jewellery in the Exposition Universelle in Paris in 1867 and continued to work in the traditional style of the firm, established by his father. His work remained resolutely neo-Renaissance and Romantic in taste until the turn of the century, at which point he made some experimental designs in a very modified Art Nouveau manner; though even these bear the traces of Romantic inspiration in the details of the settings (see particularly the pendant, now in the Victoria and Albert Museum, London).

Mark: FROMENT MEURICE

Froment-Meurice, Francois-Désiré (1802-1855)

French goldsmith, silversmith and jeweller

Son of the goldsmith François Froment, who founded the family business in 1774, François-Désiré took the name of his stepfather, Pierre Meurice, whom his widowed mother had married. Meurice was also a goldsmith, and his stepson entered his workshop as a boy, leaving in 1818 to complete his training with a *ciseleur*, at which time he is also said to have studied sculpture and drawing.

Froment-Meurice worked with the silversmith Jacques-Henri Fauconnier, one of the first to work in the neo-Renaissance style (apparently at the instigation of the Duchesse de Berri) and the German, Karl Wagner, notable for his work on the reviving of the mediaeval technique of

niello for jewellery, which became very popular in the mid-nineteenth century. In 1839, Froment-Meurice exhibited for the first time under his own name, showing his first pieces in the Gothic taste, which had been made that same year. His work was an immediate success and from then until his early death, his reputation grew rapidly: he was frequently referred to as the Cellini of the nineteenth century. His enamelled jewels in the Renaissance style were much admired in England and had a great influence on English taste in the 1850s and 1860s; a group of his jewellery in this style and technique which was exhibited in London in 1851 is illustrated in Matthew Digby Wyatt's *Metalwork and its Artistic Design*. He died in 1855, at the height of his success.

Mark: FROMENT MEURICE

Gaillard, Lucien (*b*. 1861)

French silversmith and jeweller

Son and grandson of well-known Parisian jewellers, Amedée (who founded the family firm in 1840) and Ernest (who was born in 1836 and succeeded his father in 1860), Lucien Gaillard was apprenticed as a silversmith in his father's workshop in 1878 and he also studied in a number of other workshops. Ernest Gaillard retired in 1892 and was succeeded in his turn by Lucien. Lucien was interested in Japanese mixed-metal techniques and he made a series of experiments with colouring and patinating silver. His work as a silversmith was greeted with acclaim at the Paris Exposition in 1889 but his contemporary and friend René Lalique persuaded him to turn to jewellery design which he took up seriously in about 1900, when he moved from the rue du Temple to a spacious workshop at 107 rue de la Boëtie. He worked in enamels and unusual materials such as ivory and horn, presumably under the influence of Lalique, who had been working with horn and ivory mixed with precious and semi-precious stones since the 1890s. He won the first prize for jewellery at the Paris Salon in 1904 and

182 Diamond-set floral gold panel bracelet, with plique à jour enamels in the Art Nouveau style; by Lucien Gaillard; c. 1900.

from this date, his work was very favourably reviewed, it even being suggested that his designs surpassed those of Lalique. From 1900 onwards, he employed Japanese crafts-men in his workshop, realising his long held ambition to perfect the Japanese techniques which he had studied for so many years.

Mark: L GAILLARD (engraved)

Garrard, R. and S.

firm of goldsmiths and jewellers, London, 1802–1952; afterwards amalgamated with the Goldsmiths' and Silversmiths' Company

The firm succeeded that founded by the jeweller and silver-smith, George Wickes, who received his first Royal Appoint-ment (to Frederick, Prince of Wales) in 1735. Wickes was joined by a partner, Edward Wakelin, in 1747. The firm founded by Wickes became Wakelin and Tayler, and Robert Garrard the elder was taken into partnership by Edward Wakelin's son, John, in 1792; he took control of the firm in 1802. Robert Garrard the elder died in 1818 and the business was inherited by his three sons, Robert, James and Sebastian. Robert Garrard the younger, who was born in 1793, controlled the firm throughout almost all of the Victorian period until his death in 1881, and the business continued to be run by his father's descendants until its amalgamation with another firm, the Goldsmiths' and Silversmiths' Company in 1952.

Garrard's succeeded Rundell and Bridge as Crown Jewellers in 1843 and thereafter carried out a number of commissions for the Queen and Prince Albert. A scrapbook kept by G. Whitford, an employee of the firm from 1857 to 1899, contains details of a number of these royal orders, including carefully preserved letters from the Queen, designs for various pieces of jewellery with pencilled altera-tions by Princess Alice, and even an envelope containing a lock of Princess Alexandra's hair; this scrapbook is in the collection of the Royal Library at Windsor Castle.

The firm showed jewellery at the Great Exhibition in 1851, including a 'bracelet in polished gold with ruby and brilliant circular centre—from the Nineveh sculptures', and at the International Exhibition in 1862, where the technical quality of the work was much admired. The son of J.B.C. Odiot, jeweller to Napoléon I, was sent to study English workmanship at Garrard's, and Vever points out in his history of nineteenth-century French jewellery that English work was considered 'très soigné' by the French (English artistic taste was less admired, both on the Continent and by

the English themselves, who regarded Parisian as the most refined taste in the world).

Garrard's continued throughout the century to execute expensive and valuable commissions for members of the royal families of Europe, and are best known for work in fine precious stones. For a fuller account of the firm's history, see *Garrards, 1721–1911*, privately printed for the firm in 1911.

Gaskin, Arthur (1862–1928)
painter, illustrator, silversmith and jeweller;
and Georgina (1868–1934)
illustrator, silversmith, jeweller and enamellist

Arthur Gaskin studied and later taught at the Birmingham School of Art, where he became involved with the group of staff and students at the school who were known as the Birmingham Group of Painters and Craftsmen. It was at the school that he met his future wife, Georgina, who was an accomplished illustrator and silversmith. They were married in 1894 and their joint metalworking enterprise was begun in 1899. In that same year, they showed several simple pieces of jewellery in gold and silver at the Arts and Crafts Exhibition Society's show in London. At the International Studio exhibition in 1901, they showed twenty-six pieces and they continued to exhibit at Arts and Crafts shows and with the Birmingham Group for the next fifteen or sixteen years.

Gaskin soon established his characteristic style: from the earliest years, the designs are based on curling tendrils of gold or silver wire, embellished with leaves and flowers set with small coloured stones [63] and (from about 1910) often with the addition of minute chased silver birds. A necklace commissioned by the City of Birmingham to be presented to Queen Alexandra, which was designed and made by Mr. and Mrs. Gaskin, shows this style at its most complex and successful. This same style was used by Gaskin, in a very simplified form, in the designs he made for the Liberty 'Cymric' range of jewellery; however, these designs did not adapt well to commercial production and are not particularly successful when made up. He only rarely departed from his own characteristic and highly successful formula to make excursions into more experimental work, often done in collaboration with W.T. Blackband using filigree wire decoration in the spiral forms inspired by early British Iron Age jewellery. These pieces, including a casket, again commissioned by the City of Birmingham appear to date from the period after 1912.

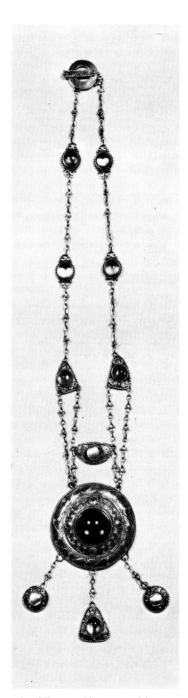

183 Silver necklace set with amethysts, designed by Gaskin and executed by Blackband, c. 1912.

Gaskin succeeded R. Catterson-Smith as head of the Vittoria Street School of Jewellers and Silversmiths in Birmingham in 1902, and remained there until 1924. His influence on his students was considerable, with the result that a large number of very 'Gaskinesque' pieces were made in the period between 1902 and about 1918.

Marks: G (engraved); A J G (engraved or pricked)

Germer, George E. (1868–1936)
American silversmith and jeweller

Son of a Berlin jeweller, Germer was taught by Otto Gericke of Berlin. He emigrated to the United States in 1893 and worked for various firms in New York City, Providence, Rhode Island and Boston. In 1912, he set up business independently in Boston, specialising in ecclesiastical silver. Toward the end of his life, he moved to Mason, New Hampshire, where he continued to produce silver for churches. The Cooper-Hewitt Museum in New York owns designs for his jewellery.

Gilbert, Sir Alfred (1854–1934)
English sculptor and metalworker

One of the most famous English sculptors at the turn of the century, Gilbert also designed two important official pieces of jewellery which represent the high point of the English involvement with continental Art Nouveau, a movement from which Gilbert, perversely enough, was at pains to dissociate himself as one who deeply despised all its manifestations. These pieces were the badge and chain for the Mayor and Corporation of Preston (made in 1888 and exhibited at the Royal Academy in 1892) and the presidential badge for the Royal Institute of Painters in Water-colour (made between 1891 and 1896).

184 A design for jewellery by Alfred Gilbert, c. 1890.

He made a number of drawings for other pieces of jewellery which reinterpret the neo-Renaissance style in terms of the *fin-de-siècle* idiom: a number of these are collected in an album in a private collection [184], and a few more are in the National Museum of Wales in Cardiff. In addition, there are some experimental pieces made in silver and iron wire with glass and beads which he bequeathed to the Victoria and Albert Museum; and he is supposed to have designed the jewellery worn by Mrs. Samuel Wilson in the portrait occupying the ornamental space over the Wilson mantelpiece, now in the Leeds Art Gallery. All the jewellery designs use ideas already incorporated by Gilbert into his

sculpture which emphasises the similarity between his work and that of such continental artists as Lalique and Wolfers.

Giuliano, Carlo (*d.* 1895)
Italian-born goldsmith and jeweller
Born in Naples, Giuliano went to London in about 1860, where he was sponsored by Robert Phillips and also worked for Harry Emanuel [169]. He is also known to have collaborated with Castellani on one piece. An accomplished 'archaeological' jeweller and outstanding enamellist, he usually avoided making exact copies of antique jewellery and evolved an easily recognizable style of his own which was widely imitated in the 1880s and 1890s, though without his particular success. Though his Italian-born assistant, Pasquale Novissimo, was technically and artistically his equal, the incredible delicacy of the enamel decoration made Giuliano's Renaissance-style pieces extremely difficult to copy, and the work by other firms in his style is usually technically inferior. Giuliano established his own business in 1861 at 13 Frith Street, where he traded as a manufacturing goldsmith and jeweller. In 1875 he acquired the retail premises at 115 Piccadilly, where he passed the rest of his working life. The Frith Street premises were retained as a workshop until 1877. Federico and Ferdinando Giuliano, generally said to be his sons but more likely his brothers, opened their own workshop as manufacturing jewellers at 24 Howland Street in 1882, moving in 1886–7 to 47 Howland Street. From 1896 the business at 115 Piccadilly, which had been bequeathed to his actual sons, was known as 'Carlo and Arthur Giuliano'. In 1903 Federico and Ferdinando gave up the Howland Street premises, the family retaining only the retail business at 115 Piccadilly. In 1911–12 the business, still called Carlo and Arthur Giuliano, moved to 48 Knightsbridge as manufacturing jewellers and by 1914–15 they had closed down.
Marks: C G; C & A G (for Carlo and Arthur Giuliano 1896–1914)

185 Gem-set enamelled gold Renaissance-style pendant by Carlo Giuliano; c. 1880.

Gorham Corporation, Inc.
firm of silversmiths and jewellers, Providence, Rhode Island, U.S.A.
The firm was founded in Providence *c.* 1815–18 by Jabez Gorham, who was born in 1792. It made jewellery, and was especially notable for the 'Gorham chain' which was said to be unequalled for its quality, until 1831. Jabez Gorham went into partnership with his son, renaming the firm the

186 *Silver and copper buckle set with mother-of-pearl made by the Gorham Corporation, marked 'Martelé'; c. 1900.*

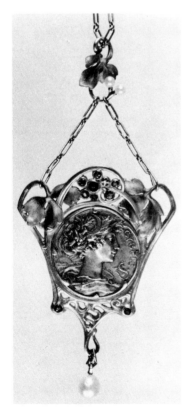

187 *Pendant by Grasset set with a medal by Louis Bottée; the medal was made in 1892, the pendant in 1898.*

Gorham Manufacturing Co. in 1842 and he retired in 1847.

The Gorham firm was one of the first to introduce factory methods into silver manufacture and this early experience of mass-production was to be very advantageous in the production of fashionable jewellery which was resumed in the later years of the nineteenth century. At the end of the nineteenth century, Edward Holbrook, a director, instituted a small specialist group of silversmiths who showed particular promise of unusual technical skill, and these were set to make up the designs of a group of artists under the leadership of William C. Codman, an Englishman who had worked for the silversmiths, Cox and Son, in London before going to Providence in 1891. The silverwork and jewellery produced by this group was marketed under the trade name '*Martelé*', appropriate to the hand-hammered finish on most of the pieces from about 1900. They also began experimenting with jewellery made in mixed metals set with either very few or no stones; the few stones used were mostly opaque quartz in unusual colours, or freshwater pearls, inspired in part by the then influential American craft revival movement and also by French Art Nouveau in the same style— though somewhat watered down—as the work of Lalique or medallists like Oscar Roty and L. Böttee. The best of these pieces (usually made in a mixture of silver, silver-gilt and copper) though derivative, have a distinct and recognisable personality of their own; despite having no great intrinsic value, they are highly effective ornaments which the American jewellery trade at the time was most suited by experience to produce.

Mark: Lion, anchor and capital G surmounted by a spread eagle with *Martelé* above

Grasset, Eugène (1841–1917)

Swiss-born painter, illustrator and decorative artist

Born in Switzerland, Grasset worked with an architect in Lausanne, later going to Paris where he studied with Viollet-le-duc. He travelled in Egypt and was an early admirer of Japanese art, particularly the prints and paintings. The first work completed by him which brought him general recognition was the illustration of 'Les Quatre Fils Aymon' begun in 1881. He designed a series of highly original pieces of jewellery for Vever and a number of his drawings for these are now in the Cooper-Hewitt Museum in New York.

Mark: as Vever

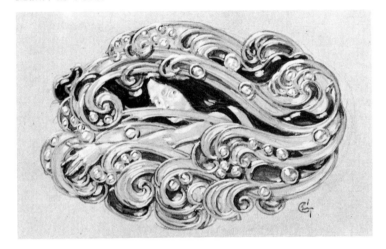

188 Grasset's design for a brooch incorporating a woman's head; c. *1900.*

Hahn, Karl Karlovitch

firm of goldsmiths and jewellers, St. Petersburg

Holder of the Royal Warrant, Hahn made the diadem worn by the last Czarina, Alexandra (Princess Alix of Hesse-Darmstadt) wife of Nicholas II, at her coronation in 1896. The mark 'A.T.', used by one of his chief jewellers, A. Tillander, who specialised in *objets de fantaisie* carried out in gold, silver and enamel, is similar to that of one of Fabergé's workmasters and principal jewellers, A. Thielemann. After the Revolution Tillander left Russia and set up business in Helsinki.

Mark: K. Hahn (in Cyrillic)

Hancocks and Co.

firm of manufacturing and retail jewellers, London

The firm was established at 29 Burton Street (on the corner

of Bruton Street and New Bond Street—the address is often given in contemporary periodicals as New Bond Street) in 1848, by Charles Frederick Hancock (d. 1891). C.F. Hancock had been trained by Paul Storr and had worked for Storr and Mortimer; his bill headings describe Hancocks as 'a successor to Storr and Mortimer'. The firm received the Royal Warrant from Queen Victoria in 1849 when it had only been open a few months, and the *Record Book*, still preserved by the firm today, testifies to regular commissions by the Queen and other members of the Royal Family to supply valuable orders for plate and jewellery. The firm exhibited at the Great Exhibition in 1851, and subsequently at the other international exhibitions, including the Paris Exposition in 1867, where it attracted the attention of Napoléon III, who bought 'a gold collar, bracelet, rings etc.'. In 1855 Hancocks were commissioned by the Duke of Devonshire to mount part of a collection of antique cameos as a number of wearable pieces of jewellery (see p. 120). The mounts were made by the firm in enamelled gold in imitation of the Tudor setting of one of the cameos, a portrait of Elizabeth I attributed to Nicholas Hilliard. In 1857 Hancocks were chosen by Lord Panmure, the Secretary for War, to make the Victoria Cross, the newly instituted award for conspicuous bravery; the crosses have been made by the firm ever since.

In 1866 C.F. Hancock's eldest son Charles (d. 1909) was taken into partnership with his father and in 1869, the year of his marriage, Mortimer (d. 1901) joined his father and brother. C.F. Hancock retired in the same year, and in 1870 a new partnership deed was signed and the name of the firm was changed from 'C.F. Hancock' to 'Hancocks and Co.'.

In 1899 Hancocks supplied a number of the presents given to Princess Louise on her marriage to the Duke of Fife, and also made the eight bridesmaids' bracelets in gold and diamonds designed by the Princess herself.

Apart from valuable plate and precious jewellery Hancocks also made a speciality of the reverse crystal intaglios which first became popular in the 1860s (they are still made in Germany and Hancocks still stock them). From 1864 many of these intaglios were supplied by Thomas Bean, one of the most skilful of the craftsmen employed in this work. Thomas was succeeded by his son Edgar; Edgar by his son Edmund (d. 1959), who supplied Hancocks with intaglios well into the present century.

Hancocks remained at the Bruton Street premises until 1917, when they moved to Vigo Street. They have moved only once since then, to the premises they still occupy.

Hardman, John and Co.

firm of ecclesiastical metalworkers, Birmingham, England

Originally a Birmingham button-making firm called Hardman and Iliffe, Hardman's was taken into partnership by the great Birmingham manufacturing and electroplating firm, Elkington and Co.

When John Hardman (1811–1867) ventured into the manufacture of church furnishings in the Gothic manner in 1838, A.W.N. Pugin became his chief designer. This branch of the business was known as the 'Mediaeval Metalworkers' and they were later to carry out much of the metalwork designed by Pugin for the Houses of Parliament as well as his ecclesiastical designs and his famous marriage jewellery. The mark of John Hardman and his brother-in-law and partner in the mediaeval metalworking venture, William Powell, was registered in 1845; prior to that date, the mark of the family button-making business had been used. After Pugin's death in 1852, Hardman's continued to make jewellery in the same style as the marriage jewellery, possibly adapted from Pugin's own designs which were taken to Birmingham by his son, Edward, at the end of his father's life, or from designs by William Burges. The jewellery shown by Hardman's at the International Exhibition in London in 1862 is very Puginesque in manner, and pieces of this same character, one at least of which is recorded in the firm's day-books, have come to light marked with the initials 'A P' in Gothic letters—possibly in imitation of Pugin's own monogram, 'A.W.P.', with which some of his metalwork (but not the jewellery) is marked.

Mark: J.H. & Co. (in a rectangular shield with chamfered corners)

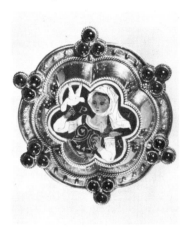

189 A gold Gothic-style brooch with an enamelled centre by Hardman; 1870–80.

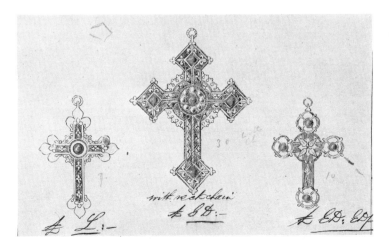

190 Drawings in pencil and water-colour of medieval-style crosses from the stockbooks of J. Hardman and Co.; 1860–70.

Hennell Limited
firm of goldsmiths, silversmiths and jewellers

This firm was established in 1735 by David Hennell (1712–1785). In 1766, he was joined by his fifth son, Robert (1741–1811) as a partner, and later, by another son, Samuel (his mark was entered, with that of his brother, Robert, at Goldsmiths' Hall in 1802). Samuel died in 1837 and two years later, his son, Robert George (1800–1884)—a jeweller—was established in his own business by wealthy patrons.

It was R.G. Hennell who introduced the manufacture of jewellery into the business, which he carried on with his two sons, Edward and Montague, under the name R.G. Hennell and Sons. The surviving stock books, dating from 1887, contain coloured drawings of jewellery executed by the firm—elegant fashionable pieces of the type made by firms like Chaumet and Garrard. The firm is still in existence and an exhibition of jewellery and silver made by them was held at the Victoria and Albert Museum in 1973. A fuller account of the firm is given in an article, 'The Hennells, a Continuity of Craftsmanship', in *The Connoisseur* of February 1973.

Mark: R G H (in a rectangular shield, from 1844)

191 A page from the nineteenth-century design books of Hennell Limited, now Hennell, Frazer and Haws.

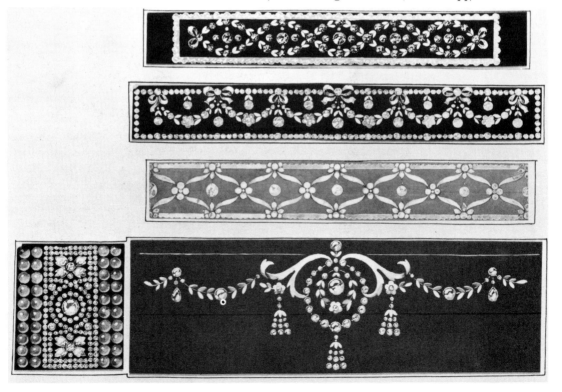

Hirzel, Hermann Robert Catumby (*b.* 1864 in Buenos Aires)

painter, graphic and commercial artist and jewellery designer

Hirzel went to the Berlin Academy School in 1893. He designed jewellery from about 1897 for Louis Werner, the Berlin jewellery manufacturer, and for Liberty's 'Cymric' range of jewellery and silverwork (one of his designs originally appeared in the Cymric catalogue for 1902). He spent two periods in Italy and after returning from the second trip he began designing jewellery in mosaic and dull gold in an attempt to revive a declining technique; the designs are simple stylised insects and flowers in light settings. He worked with the Vereinigten Werkstätte in Munich.

192 Gold brooch with enamel decoration by Hirzel; c. 1905.

Hoffmann, Josef (1870–1956)

German architect, interior designer and decorative artist

Hoffmann studied painting in Munich before becoming a pupil of Otto Wagner, the Austrian architect, at the Academy in Vienna. He was a founder member of the breakaway Secession Movement in 1897, and of the Wiener Werkstätte-Productiv-Gemeinschaft von Kunsthandwerkern in Wien in 1903, with Koloman Moser and Fritz Warndorfer, described as 'a man of culture' and a 'capitalist', who was a banker. They were later joined by C.O. Czeschka. The movement had the sympathy and support of such artistic-establishment figures as Wagner and Klimt. The workshop was founded on the same lines as Ashbee's Guild of Handicraft which Hoffman much admired. But whereas many of the members of the English guilds were without any formal training at all, the employees of the Wiener Werkstätte were required to show their *Befahnigungsnachweis* which proved that they had served their apprenticeship and journeymanship and had acquired their master's certificate.

Hoffmann designed a number of pieces of jewellery made by the Wiener Werkstätte, mostly of linear geometric forms in enamelled metal set with semi-precious stones in unusual colours. He taught at the Imperial Arts and Crafts School in Vienna. In 1912, he founded the Österreichische Werkbund. The Wiener Werkstätte continued to function until the 1930s when the demand for their specially designed and made ornamental objects was killed by the slump.

Marks: w w (monogram in a square, for Wiener Werkstätte); j h (monogram)

193 Silver and gilt buckle set with semi-precious stones, designed by Josef Hoffmann and made by the Wiener Werkstätte in 1905.

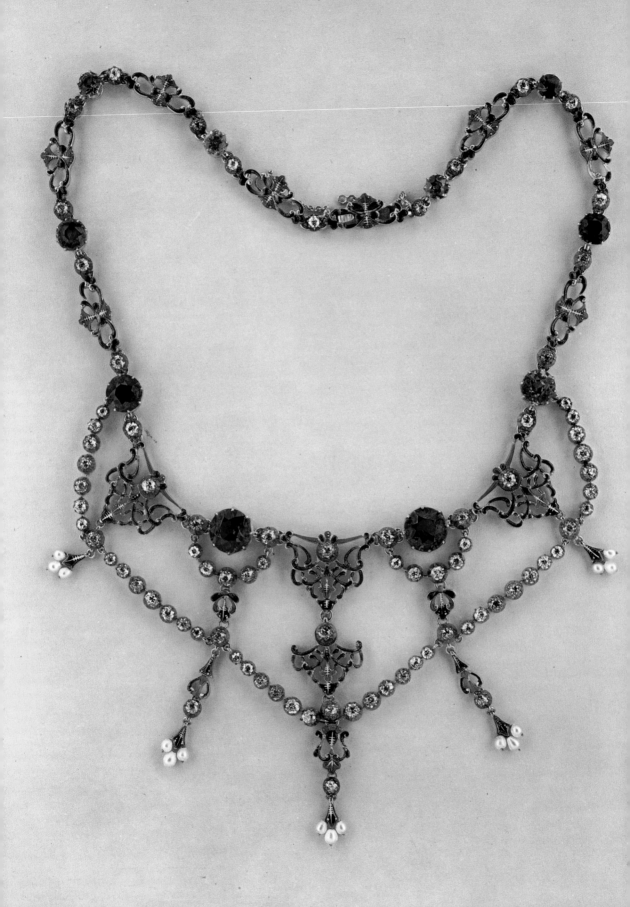

Holmström, August Wilhelm (1829–1903)

Russian goldsmith and jeweller

Born in Helsinki in Finland, Holmström bought a workshop in St. Petersburg in 1857. He became principal jeweller for Fabergé's St. Petersburg firm. After his death, he was succeeded by his adopted son, Albert, who continued to use the same maker's mark as his father.

Mark : A.H.

194 opposite: Festoon necklace in gold, decorated with translucent enamels and set with red zircons, diamonds and pearls, made by Giuliano; c. 1890.

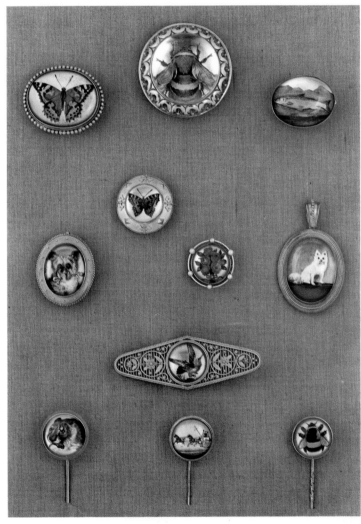

195 Group of the reversed crystal intaglios carved with naturalistic insects, animals and birds, set as jewellery, which were a speciality of Hancocks; the brooch with a humming bird set in a mount in three-coloured gold was made by Tiffany & Co., c. 1880; otherwise the pieces are English, made in the second half of the nineteenth century.

Huber, Patriz (1878–1902)

German architect and craftsman

Huber studied in Munich and went to join the artists' colony established by the Grand Duke of Hesse in Darmstadt in

196 Silver brooch with blue paste stone designed by Huber and made by Fahrner; c. 1900.

1900. He made several jewellery designs for Theodor Fahrner. At the early age of twenty-four, he committed suicide in Berlin.

Hunt and Roskell
firm of goldsmiths and jewellers, London
Formerly Storr and Mortimer, the firm became Hunt and Roskell in 1846. Their exhibit of jewellery at the Great Exhibition in London in 1851 was one of the most lavish, reputedly being worth £100,000, and their name one of the best known in London throughout the nineteenth century. They employed several French craftsmen and were capable of doing work which equalled that of the French both technically and artistically. The firm was acquired by Alfred Benson and Henry Webb, who merged in 1897 with J.W. Benson.

197 Bracelet in gold, decorated on both sides with cloisonné *enamels in the Japanese taste, made by Hunt and Roskell in 1867. This bracelet was made to go with the set of* cloisonné *enamelled jewellery by Falize bought in Paris in 1867 by John Hunt's son-in-law, H. F. Makins.*

Jensen, George (1866–1935)
Danish goldsmith, silversmith, ceramic artist and sculptor
Trained as a goldsmith and silversmith, Jensen served his apprenticeship in Copenhagen, partly under Holm, and became a journeyman in 1884. He also studied sculpture at the Royal Academy in Copenhagen. In the late 1890s, he met the painter and designer, Mogens Ballin, one of the most interesting artists working in the Danish capital at that period. He spent some time in Ballin's workshop, where experimental work in silver and pewter was being done from 1899, and he started making jewellery of silver and semi-precious stones in collaboration with Ballin in 1901. In 1904, Jensen opened his own shop, where he sold jewellery and silverware which he had started to design and make in the same year. The distinctive style he established has been developed over the years and is still apparent in the work of the firm today.
Marks: JENSEN; G J

Kerr, William B. and Co.

firm of goldsmiths, silversmiths and jewellers, Newark, New Jersey
The firm was established by William B. Kerr in 1855, and made silver tableware, gold toilet articles, and gold and silver jewellery. Much of the silver jewellery was produced by a stamping process to make imitation *repoussé*-work. The few motifs employed were combined in a number of ways to produce the different pieces and the hollow back of each piece was usually covered by a thin flat plate of silver giving an appearance of substance to this very flimsy work. The designs appear to have been lifted almost unaltered from continental periodicals, widely used in the United States in the same way as the pattern books published in the seventeenth and eighteenth centuries were used in Europe. The firm produced jewellery in the neo-Renaissance style and in a modified Art Nouveau manner, very much influenced by contemporary French work at the turn of the century. To judge from the large number of pieces that survive, this silver jewellery was mass-produced on a large scale by Kerr's, whose pieces can be recognised by their marks (see below), as well as by other firms, like Unger Bros., who were meeting the demand created at the end of the nineteenth century by the prosperity of the American urban middle class. In 1906 the firm was purchased by the Gorham Corporation and moved to Rhode Island.
Marks: Hatchet bound with crossed ribbons (usually very indistinct); fleur-de-lis (from 1892)

198 An example of American Art Nouveau by Kerr: a silver brooch in the form of a girl's head.

Keswick School of Industrial Art

Keswick, England
This institution was founded under the direction of Canon and Mrs. Rawnsley in 1884 as an evening institute, and expanded to include daytime classes in 1898. Harold Stabler and Herbert J. Maryon, the metalworker and jeweller, were both full-time directors and designers connected with the school. Keswick School jewellery was very simple and unsophisticated in design and technique, consisting mainly of clasps and buckles in silver set with turquoises.
Mark: K S I A (in a square)

King, Jessie M. (1876–1949)

Scottish designer and illustrator
Trained at the Glasgow School of Art where she later taught, Jessie M. King became a prominent and respected member

199 *Two pendants and a brooch in enamelled gold, designed and made by Madeleine Martineau; c. 1910.*

of the 'Glasgow School' of artists and designers. She designed several pieces for the Liberty range of 'Cymric' jewellery and silverwork.
Mark: as Liberty

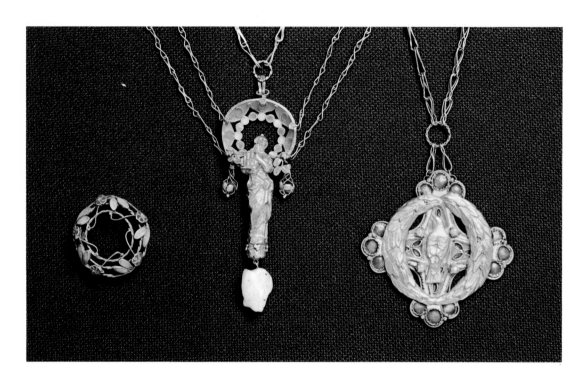

Knox, Archibald (1864–1933)

painter and designer of jewellery and metalwork

Born in the Isle of Man, Knox remained faithful to the Celtic inspiration of his Scottish heritage in all his designs, and his complex interlaced motifs were widely copied by artists of the craft revival movement in England. He came to London in 1897, where he designed silverwork and jewellery for Liberty's 'Cymric' range, and pewter tableware for the 'Tudric' range, reputedly providing over 400 different designs for them. He taught at the Kingston School of Art for a period before the First World War, but left after being reprimanded for his 'advanced' ideas in the teaching of design. His pupils at the school founded the Knox Guild of Craft and Design; one of the members managed to salvage a large number of designs which were discarded by Knox when he left the school, and some of these designs—among them a number for pieces of jewellery—were exhibited at the Victoria and Albert Museum. Also in the exhibition

were actual pieces of jewellery, silver and pewter made after Knox's designs, including the necklace made for Liberty's and now in the Victoria and Albert Museum.
Mark: as Liberty

200 Design in pencil and water-colour for a tiara, by Archibald Knox; c. 1905.

Koehler, Florence (1861–1944)

American artist-craftswoman, designer and jeweller

Florence Koehler was one of the leaders of the craft revival movement in America. She lived and worked in Chicago, the city which contained the work of the architect Louis Sullivan, some of the earliest and most exciting architectural work in the Art Nouveau style which predated much

201 A tortoiseshell comb with an enamelled gold mount set with pearls, part of a set by Mrs. Florence Koehler; c. 1905.

202 Brooch in gold set with a very fine mosaic panel depicting a revolutionary tricoteuse *(Mme. Defarge?), made by Mrs. Philip Newman; c. 1890.*

of the European work in the same vein. The Chicago Arts and Crafts Society was founded in 1897 and after the turn of the century, craft jewellery of the type designed and made by Florence Koehler was fashionable in 'aesthetic' and intellectual circles. Most of the American craft jewellery owes its inspiration to the work of Colonna and L.C. Tiffany and is thus more French in style than English, though Gustav Stickley, the first editor of *The Craftsman*, a magazine devoted to discussing the work of the American craft revival artists, was an admirer and disciple of Morris and Ruskin.

LaCloche
firm of manufacturing and retail jewellers, Paris
Established in 1897 by the brothers Fernand, Jules, Leopold and Jacques LaCloche, the firm specialised in elegant precious jewellery enriched with enamelling using oriental styles derived from Indian jewellery. The name is better known in connection with striking Art Deco-style jewellery produced in the 1920s.

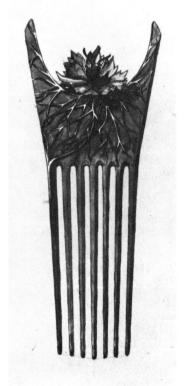

203 Design in pencil and watercolour for a decorated comb, by René Lalique; c. 1900.

Lalique, René Jules (1860–1945)
French jeweller, enamellist, and decorative designer
Lalique was arguably the best, certainly the best known, jeweller of the turn of the century; his work is reproduced, with good reason, in every study of Art Nouveau design. Lalique was the son of a trader dealing in the attractive, but inexpensive, trifles known as *articles de Paris*. His father died when he was sixteen and he was apprenticed to the Parisian jeweller, Louis Aucoc who made some of Lalique's own designs. His early work, very conventional in style and somewhat unsophisticated in technique, is illustrated in Vever (see bibl.). He spent two years in England, 1878–1880; exactly where or how he was occupied during this period is still a matter of speculation. On his return to Paris he worked for various manufacturers of jewellery and provided designs for the monthly magazine of jewellery trade, *Le Bijou*. In 1884 he was introduced to Jules Destape, the proprietor of a small but successful jewellery *atelier*, which he offered to Lalique for a reasonable price, an offer which Lalique wisely accepted. For some time after this he continued to produce work for a number of Parisian jewellers, among them his old master Aucoc, Cartier, Boucheron and others. He moved the *atelier* first in 1887, to larger premises, and again in 1890 to 20 rue Thérèse. In the following years he began to develop his own artistic personality. From 1891 to 1894 he made

much of Sarah Bernhardt's stage jewellery, and the large 'Egyptian' tiara in aluminium and glass for Mme Barthet, which is illustrated in Vever, and is now in the Musée Lambinet in Versailles. In 1894 he exhibited for the first time under his own name. In 1896 he began to assemble the spectacular series of 100 pieces which he exhibited at the centennial exhibition in Paris in 1900. He became a Chevalier de la Légion d'Honneur in 1897. From 1895 to 1912 he was occupied with designing the great series of 145 pieces, the most fantastic and original in his entire *oeuvre*, for Calouste Gulbenkian, which are now in the Foundaçion Gulbenkian in Lisbon. In 1902 he exhibited in Turin; and in London at the Grafton Galleries in 1903 and at Agnew's in 1905. He continued to make jewellery for a few more years, but his interest in glasswork, which started at the time of his earliest experiments with enamelling in the 1890s, began to claim more and more of his attention from about 1910 onwards. Many of the late pieces of jewellery are simply small glass plaquettes mounted as pendants or brooches, with shallow intaglio designs worked in the back.

Marks: LALIQUE (in various scripts both engraved and stamped); R.L. (stamped)

Lettré, Emil (1876–1954)

German artist-craftsman, silversmith and jeweller

Lettré was born in Hanau, Germany and worked in Vienna, Budapest and Paris before moving to Berlin. H.G. Murphy went to work with him in Berlin for a time in 1912. Lettré's jewellery was of very simple geometric design, mostly in silver. In 1933, he became the director of the Staatliche Akademie in Hanau.

Mark: E L

Liberty and Co.

firm of drapers, oriental warehousemen, retail jewellers and silver-smiths, London

The firm was founded in 1875 by Arthur Lasenby Liberty (1843–1917) to sell oriental art and artefacts. From 1862 until 1875 he had been oriental manager at Farmer and Rodgers' Great Cloak and Shawl Emporium, where some of the Japanese exhibits were auctioned off after the closing of the International Exhibition held in 1862. He numbered among his customers such enthusiasts for oriental art as E. W. Godwin, William Burges, Rossetti, Burne-Jones and Whistler. The success of his well-timed venture was thus

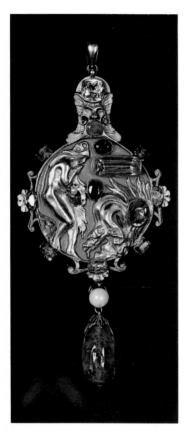

assured and after only twelve months, he was able to expand. Among the oriental goods imported by Liberty's were examples of Japanese metalwork and Indian enamels which were mounted in Britain.

Arthur Liberty foresaw early on the popularity of craft metalwork and he turned from dealing entirely in imported goods to commissioning work from English designers and craftsmen. The Liberty 'Cymric' jewellery venture dates from 1899, and the talents of a number of the artists connected with the Arts and Crafts movement were employed in providing the designs which were manufactured especially for the shop. Among those now known to have designed for Liberty are Oliver Baker, Arthur Gaskin, Bernard Cuzner, Archibald Knox, Jessie M. King and Rex Silver (1879–1954).

The jewellery and silverwork was made for Liberty's in Birmingham by W.H. Haseler* and bears either the mark of this firm or one of the Liberty marks (see below), and identical pieces were also made by a number of other firms including Murrle, Bennett and the unidentified Birmingham firm whose mark is L.C. & Co. The extent of Liberty's influence on the decorative art of the turn of the century both in England and on the Continent is indicated by the fact that in Italy one of the names by which the Art Nouveau was known was *Stile Liberty*.

Marks: Ly & Co (in a triple diamond, registered in 1894); L & Co (in a triple diamond); CYMRIC (trademark registered with the Board of Trade in 1901); W.H.H. (for W.H. Haseler*)

204 Pendant, depicting 'Psyche descending into Hell', in enamelled gold set with pearls and semi-precious and heavily flawed stones, designed by Charles Ricketts; c. 1900.

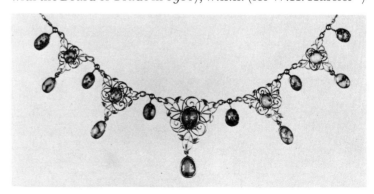

205 Gold necklace set with turquoises by Liberty, illustrated in a catalogue for 1902.

*The greater part of the silverwork and jewellery was manufactured by W.H. Haseler and Son, a Birmingham firm in which Liberty had a large shareholding from about 1900 until the mid-1920s. From 1894 to 1900 William Hair Haseler, manufacturing jeweller, had premises at 34 Hatton Garden. It is possible that the early Liberty jewellery and silverwork which bears a London mark was made here. Haseler must have moved to the Hylton Street premises in Birmingham in 1900. From 1901 to 1904 a firm known as 'Haseler Bros. silversmiths' occupied 89 Hatton Gardens.

206 opposite: Necklace in gold decorated with translucent enamels, set with opals, designed by L. C. Tiffany; c. 1914.

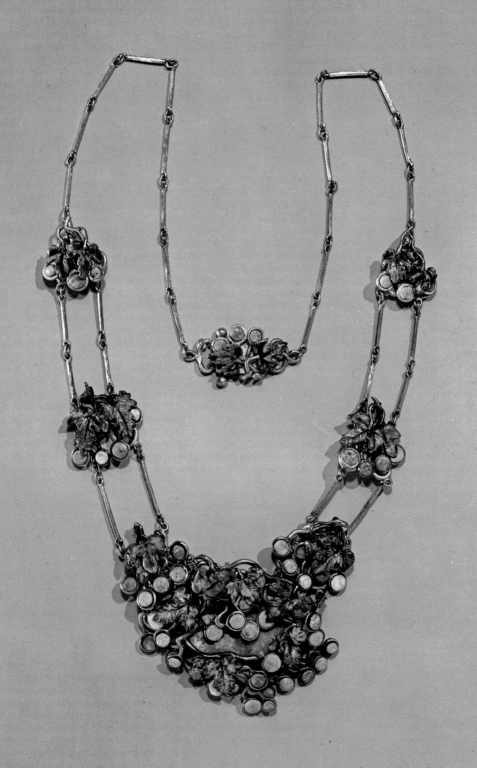

Macdonald, Frances (1874–1921)

Scottish designer and metalworker

Frances Macdonald studied at the Glasgow School of Art at the same time as C.R. Mackintosh and J. Herbert MacNair; she married the latter in 1899. She exhibited at the Arts and Crafts Exhibition in 1896, and at the VIIIth Secession Exhibition in Vienna in 1900. She taught enamelling and gold- and silversmithing at the Glasgow School. In 1901, she exhibited some pieces of jewellery at the Education Exhibition held at St. George's Hall, Liverpool, along with other pieces by her husband. In 1902, she exhibited jewellery and two *repoussé* silver panels at the Turin Exhibition. Her designs for leaded glass and for plaster and wire wall-decorations were as influential in the world of *fin-de-siècle* jewellery design as her few pieces of jewellery, as the work of one of the Glasgow pupils, Agnes B. Harvey, shows.

Macdonald, Margaret (1865–1933)

Scottish designer, metalworker and embroideress

Margaret Macdonald studied at the Glasgow School of Art, where she met C.R. Mackintosh; they married in 1900. She made a small number of pieces of jewellery, mostly in collaboration with her sister, Frances, including the necklace and pendant designed by her husband. She exhibited with the rest of 'The Four' at the Arts and Crafts Exhibition in London in 1896, at the Vienna Secession Exhibition in 1900, and at Turin in 1902. Her influence can be clearly seen in the work of her husband from the time of their marriage.

Mackintosh, Charles Rennie (1868–1929)

Scottish architect and designer

Born in Glasgow, Mackintosh was apprenticed to the architect, John Hutchison, in 1884. In 1889, he went to the firm of Honeyman and Keppie where he met and became friendly with J. Herbert MacNair; both of them attended evening classes at the Glasgow School of Art and two of their fellow students were the sisters Margaret and Frances Macdonald.

The work of 'The Four', as they came to be known, in design, book illustration, leaded glass, furniture, metalwork and jewellery, developed a recognisable and distinctive style which came, after initial incomprehension, to be regarded as typical of the 'Glasgow School'.

Mackintosh designed only two pieces of jewellery, a necklace and pendant in the form of a flight of birds going

through storm clouds with raindrops below (made by Margaret Macdonald) which, as a key piece of *fin-de-siècle* jewellery design, has been much exhibited and reproduced, and a ring; he also made a small number of boxes, but it was his influence on other designers that was so widespread and important. His work was greatly admired abroad— particularly in Vienna. He became a great friend and mentor of the gifted Viennese architect and founding member of the Vienna Secession movement, Josef Hoffmann, exhibiting at the VIIIth Secession Exhibition in Vienna in 1900, along with Margaret Macdonald, whom he married in the same year, and J. Herbert and Frances (Macdonald) MacNair, who had married the year before.

All of Mackintosh's major architectural works contain decorative elements which were, like the architectural work of Louis Sullivan in Chicago, the basis for much experimental work carried out in jewellery design at this period.

MacNair, J. Herbert (1868–1955)
Scottish architect and designer
MacNair was the most obscure of the group known as 'The Four' which included C.R. Mackintoch and the Macdonald sisters. Not particularly happy as an architect, he transferred his attentions to decorative art.

His work is influenced by the same Celtic forms and mysticism which inspired the Macdonald sisters, and from the time of his marriage in 1899 to Frances Macdonald, his work becomes almost indistinguishable from hers, much of it probably being done in collaboration. Jewellery designed and made by MacNair (or possibly *made* by his wife who taught enamelling and metalworking at the Glasgow School of Art) was shown at the Arts and Crafts Exhibition in London in 1896. At Turin, he and his wife exhibited two show tables with glass tops, one containing jewellery designed and made by themselves, the other with enamel work by Miss Lily Day, enamellist and jeweller who taught at Liverpool University in the department of architecture and applied art. Sadly, it seems that none of these pieces— and there must have been a number of them—have survived.

Martineau, Sarah Madeleine (*b*. 1872, working 1908–1919)
English goldsmith, silversmith and jeweller
Of Huguenot descent, Madeleine Martineau came of a family of artists. She studied at the Liverpool School of

Art and subsequently exhibited there and in Cambridge. She won first prize in the *Studio* prize competition in 1911, and her work is quite often illustrated in volumes of *Studio* of this period, but she seems to have made only a very small amount of either jewellery or silverwork, and was clearly not working on a commercial basis at any time.

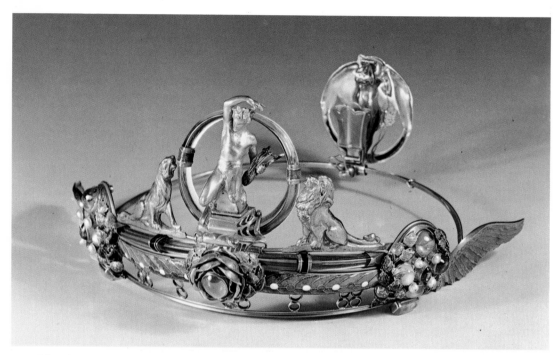

207 Tiara in gold and rock-crystal set with pearls and semi-precious stones and decorated with enamels; designed and made by Henry Wilson. The roundel at the back, which is detachable, is designed to hold the three ostrich feathers worn at Court.

Masriera, Luís (1872–1958)

goldsmith, jeweller and designer, Barcelona, Spain

Son of a painter and goldsmith, Luís, with his brother, inherited the family firm of jewellers and goldsmiths, a firm which specialised in making traditional Spanish ornaments and had been founded by their grandfather in 1839. The firm was called 'Masriera y Hijos' in 1872, but the name was changed to 'Masriera Hermanos' in 1886.

Luís studied at the School of Art in Geneva under the famous enamellist, Lossier, and is reputed to have melted down the entire stock of the family firm when he returned home after visiting the Centennial Exhibition in Paris in 1900. The shop remained closed for six months thereafter, re-opening with an entirely new stock of Art Nouveau designs by Luís Masriera. These new jewels were an instant success and the first collection was sold out within a week. He won

the Grand Prize for jewellery at the Saragossa Exhibition in 1908 and a further prize in Ghent in 1913. The firm continued to use Luís Masriera's Art Nouveau designs for many years, but with a noticeable decline in the high standard of technical quality that had been set by the early works.

Mark: MASRIERA Hs

Mellerio (or Meller), Maison
firm of goldsmiths and jewellers, Paris

Jewellers or jewellery salesmen of this family had been established in France since the time of François I. In 1815, François Mellerio moved from the rue du Coq St Honoré to 22 rue de la Paix. In 1836, François and his brother, Jean Jacques, bought 5 rue de la Paix and the firm remained there until 1914, passing during that time down five generations of the family.

In 1914, the firm moved to 16 rue de la Paix, next to Vever. The account of the family which appears in Henri Vever's book (see bibl.) mentions a number of other members, nephews and cousins and remote relations concerned with the business, and the exact sequence of employment is very hard to work out. The author of the albums of drawings in the Metropolitan Museum [209] which date from 1850–60, is given as Antoine, who committed suicide at his country property in Normandy in 1870.

The firm's most prosperous period was immediately after the restoration of the monarchy in France, and during the reign of Louis Philippe. They received Royal Warrants in 1830 and 1840. A good account of the firm's history is given in Joseph Mellerio's *Les Mellerio, leur origine et leur histoire*, published in Paris in 1895.

208 Pendant and chain, 'Freesia'; enamelled gold with a topaz, emeralds, diamonds, and pearls, designed and made by Philippe Wolfers.

209 Design for a bracelet by Mellerio, from a stockbook; 1860–70.

Morel, Jean Valentin (1794–1860)

French goldsmith, silversmith and jeweller

Morel was the son of a lapidary from Piedmont. He came to Paris at an early age and was apprenticed to Vachette, a goldsmith and box-maker well known at the time of Napoléon I. He was chosen by Jean-Baptiste Fossin (see under Chaumet) as his *chef d'atelier*, but he left the firm in 1833 to set up his own business. In 1842 Morel et Cie. moved to 39 rue St Augustine. His affairs were in considerable financial confusion by 1848 when he went to London at the time of the revolution in Paris. He set up shop at 7 New Burlington Street, and exhibited a large bouquet made of diamonds and rubies at the 1851 Great Exhibition which was awarded a medal and excited much admiring comment. He returned to Paris in 1852. In 1855 he exhibited his technical *tour de force*. the famous green jasper neo-Renaissance 'Hope' vase. His business affairs continued in total confusion and at his death the firm disappeared, his son Prosper being provided for by his succession to the business of the childless Jules Fossin (see Chaumet).

Morris, May (1862–1938)

English designer, embroideress and craft-jeweller

May Morris received her artistic training from her father, William Morris (see p. 67). She designed and made a number of pieces of jewellery, many of them bead necklaces strung in interesting combinations of colour and texture. One piece designed and made by her came to the Victoria and Albert Museum, London, in a small collection of jewellery which had belonged to her mother. A number of other pieces were left to the National Museum of Wales, Cardiff [210]. She was one of the founders of the Women's Guild

210 Two necklaces designed and made by May Morris.

of Arts in 1907, and lectured in 1910 in the United States on embroidery, jewellery, costume and pattern-designing.

Morris, Talwyn (1865–1911)

Scottish designer and metalworker, Glasgow

Trained as an architect, Talwyn Morris became a member of the group of artists known as the 'Glasgow School' with Mackintosh, MacNair, the Macdonald sisters and Jessie M. King. He made jewellery in beaten copper, aluminium (one of the very rare craftsmen to use this metal for jewellery though it was quite in favour at this period for use in making small pieces of sculpture), and silver decorated with enamel and coloured glass. A buckle made at the turn of the century is in the Victoria and Albert Museum.

Moser, Koloman (1868–1918)

Austrian artist and decorative designer

Founder member with Hoffmann of the Wiener Werkstätte, Moser designed a number of pieces of jewellery for the workshop. His style is the most strictly geometric of all; these linear forms remained a central preoccupation with the workshop artists until Moser's withdrawal in 1906, and continued to be a hallmark of the Wiener Werkstätte style until at least 1912–14. He designed jewellery for the Viennese jewellers, Rozet and Fischmeister.

Marks: K M (in a square monogram); W W (for Wiener Werkstätte)

Mucha, Alphonse Maria (1860–1939)

Czech-born painter, illustrator and decorative designer

Mucha was born in Czechoslovakia where he also received part of his early artistic training. He went to Munich in 1885 and then to Paris in 1887. His first poster for Sarah Bernhardt, which was to make his name famous overnight, was made in 1894. He designed a number of pieces of jewellery for Bernhardt which were made by Georges Fouquet, for whom he also produced a number of other designs, as well as the interior of Fouquet's shop in the rue Royale. He visited the United States in 1904 and he is said to have collaborated with L. C. Tiffany over some designs for jewellery of which one piece remains. His work was highly influential both through his famous posters and through the designs in *Documents décoratifs*, the pattern book of designs (including several sheets of jewellery designs) which he published in 1902.

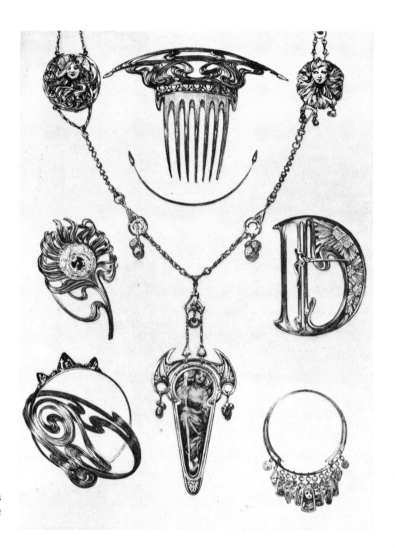

211 A page from Documents décoratifs *by Mucha, published in 1902.*

Murphy, H. G. (1884–1939)

English artist-craftsman, jeweller and teacher

Murphy was apprenticed to Henry Wilson in 1898 and later worked with him, assisting with ecclesiastical commissions. From 1909, he taught at the Royal College of Art and then at the L.C.C. Central School of Arts and Crafts. In 1912, he went to work with Emil Lettré in Berlin returning in 1913 to work in London again. He became the principal of the Central School in 1937. During the years after the First War, he moved away from the Arts and Crafts style which, strongly influenced by Henry Wilson, he had used and evolved, and began designing in the Art Deco style fashionable in France although less so in England.

Murrle, Bennett and Co.

firm of manufacturing jewellers, London

This was one of the many firms producing jewellery in the 'modern style' which sprang up at the turn of the century—possibly inspired by the success of the Liberty 'Cymric' venture. Murrle, Bennett produced an extensive range of designs and an unusually large number were carried out in gold; these were of uniformly good quality workmanship but less reliable artistic quality than the Liberty work, much of which was designed by leading artists in the Arts and Crafts Movement. The designs seem to be divided into two groups: plagiarisms of Liberty designs, which are so like Liberty pieces that they might be mistaken for them, and versions of the Darmstadt and Munich *Jugendstil*

212 Group of pieces made by Murrle, Bennett between 1900 and 1914.

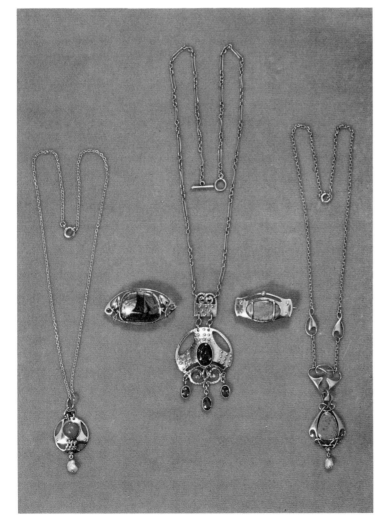

designs, which are in some cases identical to the pieces sold by the Pforzheim jewellery firm of Theodor Fahrner.

In their advertisement [132] Murrle, Bennett, whose premises were at 13 Charterhouse St., claim that the designs are their property and that the jewellery is made by them, and this is certainly the implication in the short note on the firm which appeared in the *Studio* (vol. XXXVI p. 160–1) where the names of their designers are given as F. Rico and R. Win. They may have imported some pieces from Pforzheim and used their own mark on them, though all the pieces bearing their mark appear to be English-made; or they may have been manufacturing the *Jugendstil*-style jewels for Theodor Fahrner and exporting them.

Mark: M B Co (in a circular monogram)

Newman, Mrs. Philip (working 1870–1910)

English goldsmith, jeweller, and designer

Pupil of and assistant to John Brogden, Mrs. Newman specialised in the styles of jewellery for which her master was known and admired: 'archaeological' jewellery, and neo-Renaissance and Holbeinesque work mainly in gold and enamel. She exhibited with him and at the time of the Paris Exposition of 1867, and in 1878, when Brogden was awarded the Légion d'Honneur, she obtained a unique distinction in being given a *médaille d'honneur* as a *collaboratrice*. After Brogden's death (*c.* 1885) she continued to work mainly in the same styles retaining several of his skilled workmen, the models and designs from his workshops, and a number of recipes for metalworking and enamelling techniques evolved by Brogden during his long working life. She set up her own business (as 'Mrs. Newman, Goldsmith and Court Jeweller') at 10 Savile Row, London, where she employed a number of apprentices, making mainly commissioned pieces from her own designs. Few replicas were made of any of her designs, and it is rare to find two alike.

Mark: MRS N (in a rectangle)

213 Gold brooch designed by Nienhaus; c. 1910.

Nienhaus, Lambert (1873–1960)

Dutch ceramic artist, enamellist and jewellery designer

From 1905 Nienhaus taught enamelling in Haarlem. He later taught in The Hague and at the School of Applied Arts in Amsterdam. He designed a number of pieces of jewellery for the Amsterdam silversmithing firm of W. Hoeker, very much in the *Jugendstil,* in the period between 1905 and 1918, as well as some silverwork.

Olbrich, Joseph Maria (1867–1908)

Austrian architect and designer

Olbrich studied architecture at the Vienna Academy under Otto Wagner, and joined Hoffmann in the Secession movement in 1897. In 1899 he joined the artist's colony at Darmstadt, which had been established by the Grand Duke of Hesse, a great admirer and patron of the modern craft revival movement. Olbrich designed buildings and furniture for the colony, and a number of pieces of jewellery for D. and M. Loewenthal and Theodor Fahrner which were often set with mother-of-pearl and opaque stones.

Partridge, Fred. T. (working *c.* 1900–*c.* 1908)

English metalworker and jeweller

Partridge was a chemist's son from Barnstable in Devon, who went with Ashbee to Chipping Campden when the Guild of Handicraft moved there from Essex House in 1902. He exhibited with Ashbee and the Guild of Handicraft in 1903 at the Arts and Crafts Society—see *Der moderne Stil*, vol. V, plate 41. He appears to have already been a member of the Barnstable Guild of Metalworkers (established by G. Lloyd Morris in 1900), and to have remained with the Barnstable Guild while working with Ashbee. He was married to May Hart Partridge who did some of the enamelling for Ashbee's jewellery and silverwork.

Partridge was one of the few English craft jewellers to be strongly influenced by French Art Nouveau, particularly by the work of Lalique and C. Desrosiers (see p. 181); combs made by him in horn might easily be mistaken for French work of the same period, but he fortunately took the precaution of signing them.

Mark: PARTRIDGE

214 Gold and enamel brooch by Robert Phillips, 1860–70.

Phillips, Robert (*d.* 1881)

English goldsmith and jeweller

Robert Phillips's was one of the first English jewellery firms to make 'archaeological' jewellery in the Italian style. He exhibited a necklace in the 'Greco-Etruscan' style in the International Exhibition in London in 1862, probably made by one of the Italian craftsmen employed by the firm. Both Carlo Giuliano and Carlo Doria worked for Phillips, and it is possible that other Italians were working for him as well. His shop and the type of stock he carried are described by Mrs. Haweis in *The Art of Beauty* (published in 1878).

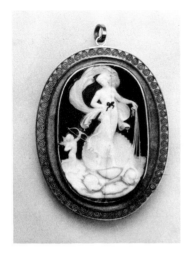

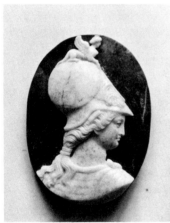

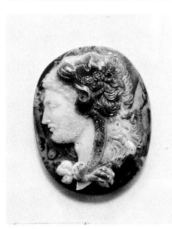

Pistrucci, Benedetto (1784–1855)

Italian-born gem engraver and medallist

Born in Rome where he managed to build up a considerable reputation for himself as a cameo portraitist, Pistrucci came to England after he had been finally disillusioned by the fiasco of his arrangements with the dealer Bonelli, who was selling his cameos of antique subjects at vastly inflated prices as genuine antiquities. He became chief engraver at the Royal Mint, an unusual appointment for a foreigner which caused considerable adverse comment. He received several valuable portrait commissions through the good offices of his sponsor and patron, Sir Joseph Banks. He designed the Waterloo medal of 1819, the coronation medal and cameo portrait of George IV in 1821, the medal for the coronation of Queen Victoria in 1838, and the marriage medal of 1840, which was shown at the Royal Academy in that year. The coronation medals for George IV and Queen Victoria were made by the Royal jewellers, Rundell, Bridge and Co. Pistrucci's own, incomplete, account of his life is included in *The Science of Gems*, by A. W. Billing, published in 1867.

Marks: Greek letter Λ; PISTRUCCI (engraved or scratched on the stone)

Pistrucci, Elena (1822–1886) and Eliza Maria (1824–1881)

Italian gem engravers and shell-cameo cutters

Daughters of Benedetto Pistrucci, both returned to Italy with their mother as young girls. They became accomplished gem engravers and also made a certain number of the shell-cameos which were immensely fashionable everywhere in the mid-nineteenth century.

Powell, John Hardman (1827–1895)

English jewellery and metalwork designer

The son of John Hardman's partner, William Powell, John Hardman Powell was apprentice and assistant to A. W. N. Pugin from 1844. In 1850, he married Pugin's daughter, Anne. He succeeded his father-in-law as chief designer to John Hardman and Co. at the time of Pugin's death in 1852, and continued to produce designs very much in the Pugin manner. Hardman first registered separately the mark of Hardman Powell in 1883.

Marks: as Hardman (1852–1883); H P & C (from 1883)

215 *Three onyx cameos: top, by Benedetto, centre by Elena, and bottom, by Eliza Maria Pistrucci.*

Prutscher, Otto (1880–1961)
pupil of Josef Hoffmann

Prutscher exhibited in Turin in 1902. He joined the Wiener Werkstätte for a period soon after they were founded in 1903. He also designed jewellery for the firm of Viennese jewellers, Rozet and Fischmeister. His designs were usually decorated with enamel.

Mark: O P (in a square monogram)

Pugin, Augustus Welby Northmore (1812–1852)
English architect, designer, writer and antiquarian

Son of the architectural historian and draughtsman, Auguste Charles Pugin, A.W.N. Pugin was trained as an architectural illustrator by his French-born father. At the age of fifteen, he was already designing silverware for the royal goldsmiths, Rundell and Bridge and furniture for Wyattville, who was employed on the restoration of Windsor Castle. He also worked for two years as a scenery designer at Covent Garden. In 1835, when he had already been married twice and widowed once, he was converted to Catholicism and had begun work on his most controversial and influential book, *Contrasts*—published in 1836 at his own expense.

During part of 1835 and 1836, he was working with Charles Barry on the designs for the new Houses of Parliament; this collaboration was resumed in 1844 and continued sporadically until the end of his life. In 1836, he also published his *Designs for Gold and Silversmiths. The True Principles of Pointed or Christian Architecture* appeared in 1841, followed by *The Glossary of Ecclesiastical Ornament and Costume* in 1844 and *Floriated Ornament* in 1849. In these works (only a small proportion of his whole *oeuvre*) one can find the sources of inspiration for Pugin's jewellery and metalwork designs, as well as for the greater part of English Victorian Gothic ornament and decoration.

The decorative motifs in Pugin's jewellery are taken almost unaltered from his ecclesiastical metalwork (see particularly the Westminster Cathedral Mitre, designed and made in 1848) and the flattened decorated knops on the stem of the chalice exhibited by Pugin in the Great Exhibition of 1851 are very similar to the links of the necklace which formed part of the famous set of marriage jewellery designed by Pugin in 1846–7. This set of jewellery, made, like the other metalwork pieces mentioned above, by John Hardman and Co., was worn by Pugin's third wife, Jane Knill, at their marriage in 1848, and subsequently shown in

216 Pendant cross in the medieval style by J. Hardman Powell, exhibited at Bingley Hall in 1886.

217 Pugin's design for the dress to be worn with the jewellery [218] illustrated on the next page.

the Mediaeval Court at the 1851 Exhibition. In his published work, Pugin repeatedly stressed his distaste for mechanical manufacturing processes and commercial compromise; but he can hardly have been unaware of the many unmediaeval technical processes used to carry out the huge volume of work produced each year by Hardmans. He was certainly aware of the firm's defects in respect of making fine-quality precious jewellery—an area in which they were very in-

218 Illustration of the wedding jewellery designed by Pugin for his intended third wife, Miss Lumsden, with other Gothic-style jewellery; these pieces were all exhibited in 1851.

experienced. His correspondence with them, dealing with problems arising over the execution of the marriage jewellery designs, shows that various compromises were made with some of the more complex details of the original conception. After the 1851 Exhibition, Pugin's Gothic jewellery was widely copied and plagiarised by firms whose workshop practice was far from mediaeval. It is a measure of the excellence of his designs that they survived this without serious deterioration of quality.

In 1851, despite his many achievements, he wrote: 'I have passed my life in thinking of fine things, studying fine things, designing fine things and realising very poor ones.'

Mark: A W P (monogram in Gothic letters)

Ramsden, Omar (1873–1939)

English designer, goldsmith and silversmith

Born in Sheffield, the son of a manufacturer of silver and electroplate ware, Ramsden was apprenticed as a youth to a Sheffield firm of silversmiths. He started attending evening classes at the Sheffield School of Art in 1890, where he met his future partner Alwyn Carr, and in 1894 he won a Corporation Scholarship to the school. In 1897 he won First Prize in the open competition for the design of a mace for the City of Sheffield, and then turned to his friend Alwyn Carr for help with the execution of this important commission. They went to London and established themselves in Stamford Bridge Studios, on the borders of Chelsea and Fulham, where the work on the mace was carried out and completed in 1899.

219 Clasp in silver set with amethysts marked on the back 'Omar Ramsden me fecit'; c. 1910.

In the early years of the partnership, the two men were joined by three assistants, Walter Andrews, Leonard Burt and A.E. Ulyett. During the First World War, a period of considerable prosperity for the business, the number of assistants increased still further and during the 1930s, Ramsden appears to have had nearly twenty assistants working for him. Very little of the designing and none of the actual execution of the very large number of pieces which bear his signature (the misleading words 'Omar Ramsden Me Fecit') or the firm's mark, was undertaken by Ramsden himself, but he was an accomplished salesman and entrepreneur, and can claim the commercial success of the business as his own.

Marks: RN & CR (in a rectangular shield with chamfered corners) ; OMAR RAMSDEN ME FECIT

Ricketts, Charles de Sousy (1866–1931)

English painter, sculptor and decorative artist

Founder with Charles Shannon of the Vale Press, his chief interest from about 1906 was theatrical design. He designed and had made a small number of pieces of jewellery for his friends. The drawings for a number of pieces which still exist are collected in a tiny sketchbook dated 1899 now in the British Museum. Ricketts was almost always disappointed with the completed jewels which failed to interpret his elaborate designs with sufficient delicacy in spite of the fact that they were made by Carlo Giuliano.

Rouchomowsky, Israel (working *c.* 1870–1906)

Russian goldsmith

Rouchomowsky is notorious as the maker of the famous 'Tiara of Saitapharnes' bought as an antique work of art by the Louvre in 1896. Vested interests and political manoeuvring long prevented its public recognition as a forgery though it had been doubted by experts and antiquarians even when it first appeared on the market in 1895. Rouchomowsky denied that he had made the tiara as a deliberate fake, but the record of the Odessa workshops seems to indicate that this was not true. He was summoned to Paris at the expense of the French Government to demonstrate his authorship of the tiara and other articles of spurious antique jewellery made by him and acquired by the Louvre. He settled in Paris with his family and exhibited in the Paris Salon from 1904 to 1906. He continued to make elaborately wrought gold objects in the antique manner; one of these, a minute gold skeleton in a coffin, was shown at the Salon in 1904 next to the most eclectic Art Nouveau pieces by Lalique whose workmanship he greatly admired; it appeared completely incongruous.

Rückert, Feodor

Russian goldsmith and jeweller

From the end of the nineteenth century until the revolution, Rückert's was the most important workshop for the production of objects in the 'Old Russian' style: these included pieces decorated with painted enamels in seventeenth-century fashion, and pieces decorated with filigree wire patterns using the traditional Russian *skan* technique. Part of Rückert's production was sold through the Fabergé branch in Moscow, which opened in 1887, and these pieces bear the Moscow State mark, a head in profile to the left

220 A gold pendant set with a green turquoise designed by Charles Ricketts; c. 1900.

221 The miniature gold replica of the tiara of Saitapharnes made by Rouchomowsky; c. 1904.

wearing a *kokoshnik* (the traditional Russian head-dress), as well as Rückert's own mark.
Marks: RUCKERT; FR (in Cyrillic)

Rundell, Bridge and Co.

firm of court jewellers and goldsmiths, London

The firm was established by Philip Rundell, who was born in Bath in 1747 and came to London in around 1769. In 1781, he became a partner in the business of Theed and Pickett, goldsmiths and jewellers of Ludgate Hill, where he had at first been employed as a shopman in 1772. He gained sole control of the firm in 1786, and two years later, was joined by a partner, John Bridge (born 1754) the brother of a successful West Country farmer. Bridge had attracted the notice of King George III and through him, the King's attention was drawn to the firm of Rundell and Bridge, whom he made Jewellers, Goldsmiths and Silversmiths to the Crown.

The firm reached the height of its popularity in about 1800, having profited greatly from the impecunious state of a number of emigrés fleeing from the Revolution in France, whose jewellery and precious stones could be bought at highly advantageous prices. In 1811, the silversmith Paul Storr, who had apparently been working for Rundell and Bridge since 1808, was taken into formal partnership with Philip Rundell, John Bridge, Edmund Waller Rundell and William Theed.

Theed died in 1817 and Storr left in 1819, neither having profited greatly by their association with the firm, although the business itself was by then exceedingly prosperous with agencies in Paris, Vienna, St. Petersburg, Constantinople, Calcutta, Bombay, Baghdad and in South America. Their many valuable Royal Commissions included the executing of large orders of plate and jewellery for George IV, the making of presentation bracelets for various favoured guests at the coronation of William IV and of the crown and ring for the coronation of Queen Victoria.

In 1827, John Bridge discovered the young Augustus Welby Pugin working in the Print Room at the British Museum, and later commissioned him to design some church plate for the firm; in the same year, Philip Rundell died, leaving the enormous sum of £1,500,000. The firm continued in business until 1843, when they were succeeded as Royal Goldsmiths by R. and S. Garrard. Further information may be found in *An Account of Rundell, Bridge & Co.*, an unpublished memoir by G. Fox in the Library of the Victoria and Albert Museum, London.

Sedding, George Elton (1882–1915)

English art metalworker and jeweller

Son of J.D. Sedding, the architect in whose office Henry Wilson was chief assistant, George Sedding was himself apprenticed to Wilson, working with him first at 447 Oxford Street, London, and then moving with him down to St. Mary Platt in Kent, where he shared rooms in a local farmhouse with his sister, who also worked in Wilson's studio. In 1907, after spending nearly two years in Kent, Sedding moved back to London and opened his own small workshop at 11 Noel Street, near Oxford Circus, where he concentrated on the production of simple decorative objects and jewellery in silver and copper set with semi-precious stones in a style strongly influenced by his master. Later as the demand for his work increased he took on first one and then a second assistant, and began to make more ambitious and elaborate pieces, mainly ecclesiastical commissions still very much in the manner of Wilson.

Mark: G E S

Spencer, Edward (1872–1938)

English architectural metalworker, silversmith and jeweller

Simpson designed jewellery in a style very much influenced by C.R. Ashbee; he was admired by contemporary critics who may have found that his emasculated version of the work of his more adventurous contemporaries was easier to digest. His work is illustrated in *Modern Design in Jewellery and Fans*, and in *Der moderne Stil*, alongside that of Ashbee and the Guild of Handicraft; it is possible to compare the work of both together. An album of his designs in pencil and water colour which is now in the Metropolitan Museum in New York confirms still more strongly the extent to which he plagiarised Ashbee's work. Simpson designed jewellery for various commercial silversmithing firms, among them Charles Horner of Chester, a firm specialising in jewellery of

222 *Drawing from an album of designs for jewellery by Edgar Simpson, c. 1900.*

223 *Cloak clasp in silver by Edgar Simpson; 1901.*

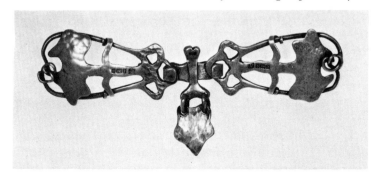

silver with mother-of-pearl or enamel very much in the manner of Liberty's 'Cymric' range.

Simpson, Edgar (working *c.* 1896–1910)
English designer and metalworker
Spencer was a junior designer at the Artificers' Guild when it was founded in 1901 by Nelson Dawson. He appears to have quarrelled with Dawson at the time when the Guild was taken over by Montague Fordham, one-time director of the Birmingham Guild of Handicrafts and owner of a Gallery in Maddox Street in London. Spencer became the chief designer to the Artificers' Guild after Dawson's departure.

In 1905, he founded the Guild of St. Michael which lasted for only a short time; he was still working for the Artificers' Guild at this time and unless he left for a short period, must have been violating the rule that guildsmen must work only for the Guild.

Spencer made a number of pieces of jewellery which are illustrated in reports of Arts and Crafts Society shows, at which he exhibited regularly, and in reports of Artificers' Guild exhibitions in Maddox Street.
Mark: as Artificers' Guild with EDWARD SPENCER DEL in a circle

Stabler, Harold (1872–1945)
English artist, craftsman, silversmith and jeweller
Born in Westmoreland, Stabler served his apprenticeship as a cabinet-maker. He turned his attention to designing metalwork and jewellery, and to working in precious metals, brass and copper. He showed a great aptitude for this work and was put in charge of the metalwork section of the Keswick School of Industrial Art by Canon Rawnsley. After he left the Keswick School in 1902, he went to work in Liverpool with R.L.B. Rathbone who also designed jewellery as a sideline. He later succeeded Henry Wilson as a teacher at the Royal College of Art in London.

He exhibited in London with the Arts and Crafts Exhibition Society, at the New Gallery and at the Albert Hall, as well as in Germany and Austria. Like H.G. Murphy's his style in the years after the First World War moved away from the Arts and Crafts manner and his designs from this period are some of the most successful of the English Art Deco movement.
Mark: H S

Storr and Mortimer

firm of goldsmiths and silversmiths, London

The firm was established in 1823 by Paul Storr and John Mortimer. Paul Storr had left Rundell and Bridge in 1819, having been a partner since 1811, and set up on his own in Harrison Street, off the Gray's Inn Road. The 26 Harrison Street premises were apparently retained as a workshop when he formed his partnership with Mortimer, who had been a salesman and chief assistant in the goldsmith's shop in New Bond Street which they took over. The new business was nearly ruined by over-stocking, but was saved by a substantial loan from John Hunt, a nephew of Storr's wife, who invested £5,000; he was taken into the partnership and the business was known from 1826 to 1838 as Storr, Mortimer and Hunt. In that year, Storr retired from the business after a quarrel with Mortimer over the terms of the partnership, and went to live in Tooting, where he died in 1844. In 1839, the firm's name was altered again to Mortimer and Hunt, and in 1846, became Hunt and Roskell.

Thielemann, A.

Russian goldsmith and silversmith

With Holmström, Thielemann was one of Fabergé's chief jewellers in the St. Petersburg workshops. He specialised in diamond and enamel jewellery, the highly characteristic small round brooches with a single coloured stone asymmetrically set, which used to be sold for between £7 and £40, and the miniature Easter eggs made of Siberian and other hardstones which were bought as souvenirs by visitors to Russia; these were designed to be worn hanging from a gold chain either as a pendant or a bracelet.

Mark: A.T. (with a Fabergé mark)

Tiffany, Charles Lewis (1812–1902)

founder of Tiffany and Co., firm of manufacturing and retail goldsmiths, silversmiths and jewellers, New York

Born in Connecticut, Tiffany went to New York City in 1837 where, in partnership with an old school friend, John B. Young, he opened a fancy goods and stationery shop at 259 Broadway. In 1841, the premises were enlarged to include the house next door; Parisian jewellery as well as Bohemian glass, French and Dresden porcelain, clocks and cutlery were added to the original stock of bric-à-brac and stationery. In this same year, Tiffany and Young were joined by a new partner, J.L. Ellis, and from then on, Young was able to travel to Europe on buying trips to find out at first hand

what was available. The original stock of cheap jewellery from Hanau and Paris was replaced with better-quality English stock, Florentine and Roman mosaic jewellery which was very fashionable at this period, and high-class Parisian pieces.

Shrewd investment at the time of the political unrest in Paris in 1848, when the price of diamonds fell by half, probably enabled the firm to start manufacturing jewellery on its own account and, by 1850, a branch was established in the rue de Richelieu in Paris. Soon after being joined by J.L. Ellis, the firm had moved to 271 Broadway as Tiffany, Young and Ellis, but in 1853, Tiffany took over the whole firm and from that date it was known as Tiffany and Co.

In 1850, Gideon F.T. Reed (formerly of Lincoln Reed and Co., a leading Boston jewellery firm) was taken into partnership by Tiffany to run the Paris branch, which was known as Tiffany, Reed and Co. From 1848 onwards, they continued to make enormously valuable purchases of diamonds and diamond jewellery in Paris. In 1850, they bought diamonds reputed to have belonged to Marie Antoinette, spent $100,000 at the Esterhazy sale, and at the sale of the French Crown Jewels in 1887 they bought twenty-four lots at a cost of $500,000.

In 1854, the firm moved to a new building in New York at 550 Broadway, and in 1870 moved again to the junction of Union Street and 15th Street; in 1868, the London branch was opened. Tiffany's exhibited at the Exposition Universelle in Paris in 1867, where the firm received an award of merit, at the Philadelphia Centennial Exposition in 1876, and again in Paris in 1878 (winning a gold medal); in 1889, they won another gold medal in Paris for their exhibit of the precious stones of North America. This pattern of success continued at the Chicago Columban Fair and the Paris exhibition in 1900.

Tiffany's were among the earliest in the field with the commercial exploitation of the Japanese mania which was to sweep through Europe and America in the second half of the nineteenth century. This was probably because Edward C. Moore, who had been working for Tiffany since 1851, and who had become his chief designer and director of the silver department in 1868, was a passionate and knowledgeable *amateur* and collector of Japanese art objects. Unlike English metalworkers, the American jewellers and silversmiths were not prevented by law from combining gold and silver with metals of lesser value, and they exploited their ability to use oriental damascening and inlaying techniques to great advantage for small *Japonaiserie* ornaments and jewels. Like many other American and Euro-

pean firms at this period, Tiffany's employed Japanese craftsmen to do some of this work.

Towards the end of his life, C.L. Tiffany took his son into the firm: Louis C. Tiffany took over the direction of the jewellery workshops at the time of his father's death in 1902.

Mark: TIFFANY & CO. (with current address, e.g. 550 Broadway from 1854 to 1870)

Tiffany, Louis Comfort (1848–1933)

American glassmaker, designer, jeweller, painter, and interior decorator

The accomplishments of L.C. Tiffany, eldest son of Charles Lewis Tiffany, were compared (in a publication ordered and paid for by himself) to those of a Florentine Renaissance artist. He spent the period 1868–1869 in Paris and Spain, painting, and he continued to paint in both oil and water-colour throughout the rest of his career; however, he was aware of his own deficiencies as a painter and in 1879, finally decided to devote himself to decorative work. In that year, he founded the interior-decorating firm, Associated Artists, with Samuel Colman, the painter and first President of the American Watercolour Society, Mrs. Candace Wheeler, founder of the Society of Decorative Art in New York, and Lockwood de Forest, another painter.

Tiffany was certainly familiar with the decorative work of his compatriot, J. McNeill Whistler—the famous Peacock Room which is now in the Freer Gallery in Washington was completed in 1877, and the Primrose Room was exhibited in Paris in 1878—and his own decorative work reflects the influence of Japanese art, almost to the same extent as Whistler's. Early contact with his father's chief designer, Edward C. Moore, who collected all kinds of Japanese art objects, turned the young Tiffany's attention towards oriental art and he made a collection of *tsubas* (Japanese sword guards) which he later incorporated into some of his elaborate and exotic decorative schemes.

In 1889, he began his association with Samuel Bing and the Maison de l'Art Nouveau; the 'Favrile' trademark for his famous glass was registered in 1894, and in 1900, Tiffany Studios started making metalwork and jewellery. At the time of his father's death in 1902, L.C. Tiffany took over the management of the firm's jewellery workshops. He was responsible for convincing rich American society people, who heretofore had shopped almost exclusively in Europe, that *objets d'art* (jewellery, for instance), schemes for interior decoration, and fantastic art glass could be produced perfectly satisfactorily in America.

Marks: Louis C. Tiffany (in italics); L C T; Tiffany and Co.

Unger Bros.

firm of silversmiths and jewellers, Newark, New Jersey

The firm was founded in 1878 as H. Unger and Co. by three brothers, Herman, Eugene and Frederick. The following year Frederick died and the business was reorganised by the surviving brothers and opened in 1881 as Unger Bros., at 18 Crawford Street. They eventually moved to large premises at 412 Halsey Street, and also maintained an office in New York at 192 Broadway. In 1901 the family of Eugene Unger visited the Exposition Universelle in Paris, and soon after their return (in 1903) a series of patents were taken out in the name of Philomen Dickinson, Eugene Unger's chief designer and brother-in-law, for a series of Art Nouveau designs to be used for the decoration of various silver articles, including pendants, brooches, buckles and clasps. From 1904 the firm produced a considerable quantity of this silver jewellery in imitation *repoussée*, in a technique similar to that used by William Kerr and Co. The naturalistic flower and leaf forms and the Art Nouveau designs, based mainly on an ideal female head with flowing hair, exploited the current fashion for jewellery in the French style at a very low cost. Most of the jewellery was made of plain undecorated silver, with a small amount of work partly gilt and set with semiprecious stones. Eugene Unger died in 1909, and the production of Art Nouveau silver ceased in 1910. The firm continued to make silverware in severe rectilinear forms until 1914, when this side of the business was finally abandoned in favour of the manufacture of aeroplane parts and components.

Mark: U B (in a cruciform monogram)

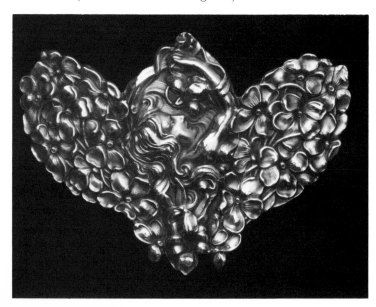

224 An American Art Nouveau silver buckle by Unger Brothers of Newark, New Jersey; c. 1905.

Van de Velde, Henri Clemens (1863–1957)

Belgian architect, painter and designer

Van de Velde studied architecture and painting in Paris and Antwerp but was forced to turn his attention to decorative design owing to ill-health. He made a name for himself as a daring avant-garde designer with Victor Horta in Belgium before going, in 1899, to Germany, where he stayed until 1917. After spending a period of years first in Switzerland and then in Holland he returned to Germany in 1925 where he founded the Ecole des Beaux-Arts de la Cambre, of which he remained director until 1938. He designed a number of pieces of jewellery, some for Theodor Fahrner; some of these were made by the Weimar firm, Müller. His work was widely influential, particularly in Germany where the deceptively simple linear compositions of his work were frequently imitated.

Vever, Maison

firm of goldsmiths and jewellers, Paris

The firm was founded in 1821 by Paul Vever in his native town of Metz. He was joined in the *atelier* in Metz by his eldest son, Ernest, in 1848. After the annexation of Alsace-Lorraine by Germany in 1871, Ernest Vever went to Paris where he was able to acquire Maison Marrett et Baugrand, 19 rue de la Paix. This business was founded in 1850 and formerly owned by Paul Marrett, who died in 1853, and Gustave Baugrand, the famous Second Empire jeweller who had died during the siege of Paris in 1870.

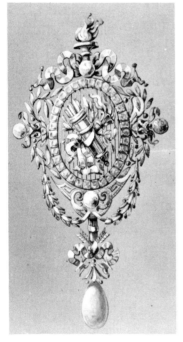

225 Design for jewelled pendant by Gustave Baugrand, 1867. This firm was acquired by Vever in 1871.

Ten years later, Vever handed over the business to his two sons, Paul (1851–1915) and Henri (1854–1942) who had been working for the firm since 1874; the latter was the author of the standard work on nineteenth-century French jewellery (see bibl.). The designs used by the firm in this later period were a complete contrast to the conventional work of the 1870s and their originality and daring modernism were to give the firm a reputation almost comparable with that of Lalique and Fouquet. Tourrette, the enamellist, and L. Gautrait, the chief engraver for the Parisian firm Leon Gariod, both appear to have worked for Vever, and the workshop also executed a remarkable series of jewels designed by Eugène Grasset.

In 1904, the business was moved to a building specially designed and built at 14 rue de la Paix. After the death of Paul Vever in 1913 and the retirement of Henri soon after, André and Pierre Vever (Paul's sons) ran the business.

Mark: VEVER PARIS

Wainwright, C. J. (1867–1948)

English silversmith and jeweller

Colbran Joseph Wainwright joined the firm of jewellers owned by his father Joseph (1832–1902), in the early 1890s. He specialised in the production of fine quality enamelled jewellery in the manner of Giuliano, though his sympathies lay with the Arts and Crafts movement and the ideas of William Morris. He became a shareholder in the Birmingham Guild of Handicrafts in 1896, selling his shares in 1917 to R. Hugh Roberts, the secretary of E.R. Gittins, the jewellery firm which had amalgamated with the Guild in 1910. C.J. Wainwright married Ellen Dora Bragg, a member of the family who owned the Birmingham jewellery firm of T. and J. Bragg, and her brother, Wilfred Bragg joined the Wainwright firm later. The firm remained in existence until 1943.

Wièse, Jules (1818–1890)

German-born goldsmith and jeweller

Principal artist to the firm of F.-D. Froment-Meurice until about 1860 when he set up his own business, Wièse exhibited under his own name at the 1862 exhibition in London. He worked in the sculptural style developed by Froment-Meurice, in a modified 'archaeological' manner without the elaborate fantasy of Fontenay, and in the Japanese taste in the years immediately preceding his retirement in 1880.

Mark: J W (with a star above and below in a lozenge)

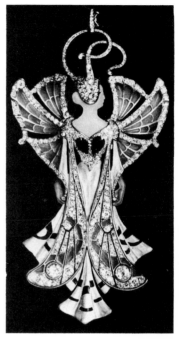

226 *'Sylvia' pendant by Vever made in Paris in 1900; enamelled gold set with brilliants, rubies and agates.*

Wilson, Henry (1864–1934)

English architect, sculptor, metalworker and jeweller

Wilson was a pupil at the Kidderminster School of Art and then articled to an architect in Maidenhead. After completing his articles and working in the offices of John Oldrid Scott and John Belcher, R.A., he went to work for the architect J.D. Sedding as his chief assistant, succeeding to the practice at the time of Sedding's death in 1891. He completed work left unfinished by Sedding at his death.

Wilson's interest in metalworking dates from about 1890 and it led him to set up a workshop at about that date, which was to absorb more and more of his time. He joined the Art Workers' Guild in 1892 and taught metalworking under W.R. Lethaby at the Central School of Arts and Crafts from 1896; he followed Lethaby to the Royal College of Art in about 1901. He was examining students at the Vittoria Street School of Jewellers and Silversmiths in

227

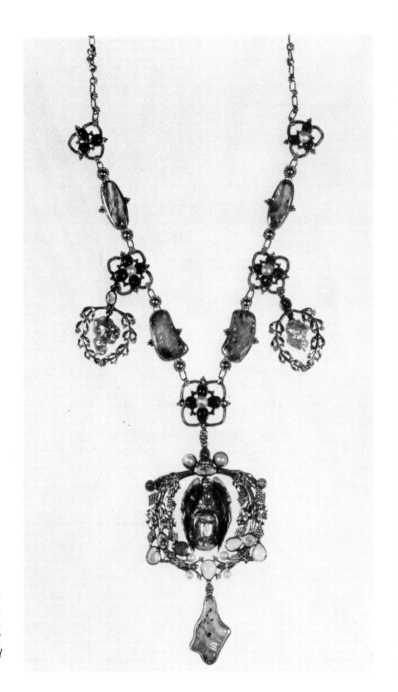

Birmingham from about 1902. Wilson exhibited regularly with the Arts and Crafts Exhibition Society from 1889, becoming the President of the Society in succession to Walter Crane in 1915. He became the Master of the Art Workers' Guild in 1917. J. Paul Cooper worked with Wilson

before setting up his own workshop and H.G. Murphy was apprenticed to him in 1898 and became his assistant. Wilson published *Silverwork and Jewellery* in 1903; this was a handbook on design and techniques. The second edition (1912) contained a new chapter on Japanese metalworking techniques based on a series of lectures and demonstrations given by Professor Unno Bisei of the Tokyo Fine Art College and Professor T. Kobayashi.
Mark: H.W. (in a monogram)

228 Drawing for a necklace and pendant by Henry Wilson; c. 1905.

Wimmer, Eduard Josef (1882–1961)
Austrian designer and craftsman
Wimmer studied from 1901 to 1907 at the Kunstgewerbeschule in Vienna. He became a member of Hoffmann's Wiener Werkstätte in 1907, and designed a number of pieces of jewellery for them. He remained with the workshops until they closed down in 1932. From 1918 until 1956 he taught at the Vienna Arts and Crafts School.
Marks: E J W (monogram in a square or a rectangle)

Wolfers, Philippe (1858–1929)
Belgian sculptor, goldsmith and jeweller
Wolfers studied at the Académie Royale des Beaux Arts in Brussels and with the sculptor, Isidor de Rudder, before entering his father's jewellery and silversmithing workshop to learn the family business. He designed a number of pieces of silver for the firm, and from 1893 onwards worked in ivory from the Congo. At about this time Wolfers set up his own workshop in the Square Marie-Louise in Brussels. Between 1897 and 1908 he designed a series of fantastic jewels in gold enamel and precious stones; only 109 of these are recorded and they were marked 'PW exemplaire unique' to distinguish them from the pieces he designed for the family firm. After 1908 he turned his attention almost exclusively to sculpture.
Mark: P W (in a shield, with the words 'exemplaire unique')

Wolfers Frères
firm of court jewellers, Brussels
Founded in 1812, from 1910 the firm occupied a vast building containing both shop and studios in the rue d'Arenenburg, Brussels, specially designed by Victor Horta.
Marks: W (surmounting the cross of the Légion d'Honneur from 1812; with a boar's head from *c.* 1850)

Glossary

AIGRETTE a French term, literally a tuft, of feathers, used to describe a small upstanding hair ornament in the form of a spray of plumes or flowers.

À JOUR SETTING a French term for an open-backed setting which allows light to pass through the stone. Hence the term *plique à jour* for open-backed enamel.

ALLOY a mixture of precious metal with a base metal to give greater strength or malleability.

ARCHAEOLOGICAL STYLE a style of jewellery made mainly from gold, copied from or based on the designs of Greek, Roman, Assyrian etc. metalwork and sculpture.

BANDEAU a worked gold or gem-set head ornament in the form of a flat band worn straight across the forehead, fashionable during the period of the Gothic revival.

BANGLE an inflexible bracelet, either in the form of a solid circlet or hinged to open with a catch.

BENOITON CHAIN a chain designed to hang from the bonnet in place of the more usual ribbons; it was adapted to hang from hair ornaments worn in the evening, and was named after the nouveau riche family in Sardon's play *La famille Benoiton*—the family were renowned for their eccentric fashions.

BERTHE NECKLACE a French term for a large collar-shaped necklace made of a network of stones decorated with other drop-shaped stones or pearls.

BEZEL strictly the setting of the central stone of a ring, now used to describe both the stone and the setting. The points where the shank of the ring joins the bezel are called the shoulders.

BIJOUTERIE a French term used to describe work of gold and enamels, as distinct from *joaillerie* (see below).

BRACELET CLASP a round or oval, gem-set or enamelled clasp with slots at the back through which a ribbon could be threaded, often found in pairs. Portrait miniatures were often set as bracelet clasps.

CAMEO HABILLÉ cameo (usually a portrait cameo) set with precious stones as part of hair ornaments or necklaces, briefly fashionable in the 1860s and 1870s when cabochon stones set with diamond or pearl stars were also popular.

CARAT (or KARAT) the unit of weight used for precious stones. One carat = $\frac{1}{5}$ gram. Also a measurement of fineness in gold. Pure gold is expressed as 24 carats.

CARBUNCLE the cabochon form of garnet.

CHÂTELAINE originally a decorative hook suspended from the belt or waistband, designed to hold a number of small, useful household objects; the term was also used in the nineteenth century to describe a heavy brooch from which a watch or vinaigrette could be hung.

CHOKER a necklace designed to be worn closely up to the neck.

CLAW or CORONET SETTING an open-backed setting in which the stone is secured in a ring of claws which are rubbed over the girdle.

CLOAK CLASP a heavy clasp in two parts which hook together with small loops at the back by which it could be sewn to the outdoor cloak fashionable at the turn of the century.

COLLET SETTING an open-backed setting where the stone is held in place by a plain band of metal round the girdle.

COMMESSO the rarely used technique in which coloured semi-precious stones are carved and assembled on a hardstone background to form an elaborate cameo.

DOG-COLLAR a many-stranded choker necklace sometimes incorporating a central pierced and decorated *plaque-de-cou*. These necklaces were made fashionable by Queen Alexandra.

DOUBLET a stone made up of two layers, one of precious stone such as emerald, the other of colourless quartz (see soudé stone, below).

ETERNITY RING a plain circle ring set all round with precious stones, given as an anniversary present or at the birth of the first child.

ETRUSCAN STYLE an archeological style of gold jewellery decorated with granulation or filigree.

FEDE RING a betrothal ring with a central motif of clasped hands. The name comes from the Italian 'mane in fede'.

FERRONIÈRE a French term for a head ornament in the form of a chain with a central pendant stone, called after the similar ornament worn by the blacksmith's wife in Leonardo da Vinci's portrait *La Ferronière*.

FILIGREE gold or silver wire-work in complex patterns, used both for jewellery and small ornaments, particularly posy-holders (see below). Filigree is found in almost all local and traditional jewellery and was revived in the nineteenth century to meet the demand created by interest in primitive and folk art.

FOILED STONES precious stones or pastes whose colour and brilliance have been improved by backing with highly burnished metallic foil.

GIRANDOLE a type of brooch or earring with three drop-shaped stones hanging from a central stone.

GRAIN the unit of weight used for pearls. One grain = $\frac{1}{4}$ carat.

GRANULATION the characteristic decoration of Etruscan gold-work with patterns carried out on the surface in minute grains of gold.

HARLEQUIN RING a ring set with stones whose initial letters spell a word or name; the 'Regard' rings are an example (see below).

JOAILLERIE a French term used for work in precious stones, as distinct from *bijouterie* (see above).

KARAT *see* carat.

LACE PIN a small bar brooch decorated with a small gem-set motif used to pin the lace collar or *fichu*, fashionable at the turn of the century.

LAVA CAMEO cameo carved, usually in high relief, from solidified volcanic ash. Lava has a characteristic matt surface and a range of colours from a very pale fawn to a dark brownish grey.

MALTESE CROSS a cross with four broad arms of equal length, usually with decorated trefoil or leaf-shaped finials.

MANCHETTE BRACELET broad bracelet in the form of a cuff.

MORSE large gem-set cope clasp (ecclesiastical) sometimes made in two or three sections, the central section decorated in heavy relief.

PAVÉ SETTING the method of setting in which a whole area of metal is covered or paved with small closely set stones secured by grains of gold. The stones should be set in clusters of seven.

PIETRA DURA hardstone inlay used in 'Florentine' intarsia (described earlier in the book).

POSY-HOLDER a trumpet-shaped filigree or pierced-work decorative container for the bouquet of real or artificial flowers which it was fashionable to carry in the evening. Posy-holders were sometimes lined with a small water-glass to keep the flowers fresh.

'REGARD' RING a ring set with stones whose initial letters spell the word 'Regard' (see Harlequin ring, above).

RIVIÈRE necklace of single stones, sometimes all of the same size, sometimes graded from a large central stone.

SAUTOIR a long necklace or chain, sometimes used in the early nineteenth century to suspend a watch or eyeglasses, usually shown in portraits of this period looped up and pinned to the waistband.

SHAWL PIN a large circular brooch with a heavy pin used to pin the cashmir and paisley shawls worn in the mid-nineteenth century.

SIGNET RING a type of ring, usually worn by men, of engraved gold or set with an intaglio, bearing the crest or personal cipher of the owner and used for sealing letters and documents.

SOUDÉ French adjective used to describe a made-up or soldered stone.

STOMACHER large ornamental brooch designed to cover the whole central front panel of a dress, fashionable in the eighteenth century and revived in the late nineteenth century.

TREMBLANT SETTING a French term applied to the spring-mounted settings which cause the jewel to tremble and move when worn. Such settings were much used from the end of the eighteenth century onwards for botanical and other naturalistic jewellery.

TRIPLET a stone made up of three layers, the outer layers of valuable precious material such as emerald or sapphire, the inner layer of quartz (see soudé stone, above).

Bibliography

AMAYA, M. *Art Nouveau*. London, 1966.
Liberty and the Modern Style. *Apollo*, vol. 77 (1963), p. 109.

AMES, W. *Prince Albert and Victorian Taste*. London, 1968.

ARMSTRONG, Nancy. *Jewellery, an Historical Survey of British Styles and Jewels*. London, 1973.

ASHBEE, C.R. *Modern English Silverwork*. Essex House Press, 1909.
A Short History of the Guild and School of Handicraft. *Transactions of the Guild and School of Handicraft*, vol. 1 (1890), pp. 19–31.

BAINBRIDGE, H.C. *Peter Carl Fabergé*. London and New York, 1949.

BAPST, G. *Histoire des Joyaux de la Couronne de la France*. Paris, 1889.

BENEDITE, L. Lalique. *Revue de l'Art Décoratif*, July 1900.

BILLCLIFFE, R. J.H. Macnair in Glasgow and Liverpool. Walker Art Gallery, Liverpool, *Annual Report and Bulletin*, vol. 1, 1970–71.

BING, S. *La Culture Artistique en Amérique*. Paris, 1896.

BLAKEMORE, K. (ed.) *The Retail Jeweller's Guide* (section on hallmarks with facsimiles). London, 1973.

BLOCHE, A. *La Vente des Diamantes de la Couronne*. Paris, 1888.

BOTT, G., and CITROEN, K. *Jugendstil, Sammlung K.A. Citroën*. Hessisches Landesmuseum, Darmstadt, 1962.

BRADFORD, E. *English Victorian Jewellery*. London, 1959.

BULGARI, C.G. *Argentieri, Gemmari e Orafi d'Italia*. Rome, 1958.

BURTY, P. *F.-D. Froment-Meurice, Argentier de la ville de Paris*. Paris, 1883.

BURY, Shirley. A Liberty Metalwork Experiment. *Architectural Review*, 1963.
An Arts and Crafts Experiment, the Silverwork of C.R. Ashbee. *Victoria and Albert Museum Bulletin*, vol. III no. I (Jan. 1967), p. 18.
Pugin's Marriage Jewellery. *Victoria and Albert Museum Yearbook*, 1969.

CASTELLANI, A. *Della Oreficeria Italiana*. Rome, 1859.
Antique Jewellery and its Revival. London, 1861.

CLIFFORD, Anne. *Cut-Steel and Berlin Iron Jewellery*. Bath, England, 1971.

COLONNA, E. *Essay on Broom Corn*. Privately printed, Dayton, Ohio, 1887.

CUNNINGTON, C.W. and Phyllis. *Handbook of English Costume in the Nineteenth Century*. London, 1966.

DARLING, Ada. American Victorian Jewelry. *American Collector*, vol. 12 (Nov. 1943), pp. 10–11.

DAVENPORT, C. *Cameos*. London, 1900.

de KAY, C. (pub. anonymously). *The Art Work of Louis C. Tiffany*. Privately printed, New York, 1917.

d'OTRANGE, M.L. The Exquisite Art of Carlo Giuliano. *Apollo*, vol. 59 (1954), pp. 145–152.

DUMONT, F. Froment-Meurice, le Victor Hugo de l'Orfevrerie. *Connaissance des Arts*, vol. 57 (1956).

EVANS, Joan. *A History of Jewellery, 1100–1870* (contains very full bibliography). London and New York 1923; rev. ed. London, 1970.

FERRIERA, Maria T.G. René Lalique at the Calouste Gulbenkian Museum, Lisbon. *Connoisseur*, vol. 177 no. 174 (1971), pp. 241–49

FLOWER, Margaret. *Victorian Jewellery*. London and New York, 1951; rev. ed. London, 1967.

FORRER, L. *A Biographical Dictionary of Medallists*. London, 1919.

GERE, Charlotte. *Victorian Jewellery Design*. London, 1972.

GILBERT, Ruth. American Jewelry from the Gold Rush to Art Nouveau. *Art in America*, LIII (1965–66), no. 6, p. 80.

GRIGORIETTI, G. *Jewellery Through the Ages*. London and New York, 1970.

HEYDT, G.F. *Charles F. Tiffany and the House of Tiffany and Co.* Privately printed for Tiffany and Co., 1893.

HOFFMANN, J. (ed.) *Der Moderne Stil*. Stuttgart, annual vols. 1897–1916.

HOLME, C. (ed.) Modern Design in Jewellery and Fans. *Studio* special number, 1901–02.

HONOUR, H. *Goldsmiths and Silversmiths*. London, 1971.

HUGHES, G. *Modern Jewelry*. London, 1963; 2nd ed. 1964.
Modern Silver. London, 1970.
The Art of Jewelry. London, 1972.

JANSON, Dora. *From Slave to Siren*. Duke Museum of Art, North Carolina, 1972.

KOCH, Robert. *Louis C. Tiffany, Rebel in Glass*. New York, 1964.

KRIS, E. *Catalogue of the Post-Classical Cameos in the Milton Weil Collection*. Vienna, 1932.

LAURVIK, J.N. *René Lalique*. New York, 1912.

LEWIS, M.D.S. *Antique Paste Jewellery*. London, 1970.

MADSEN, S.T. *Art Nouveau*. London, 1967.

MASSIM, O. Lucien Falize, Orfevre, Joaillier. *Gazette des Beaux Arts* (1897), p. 343.

MEUSNIER, G. *La Joaillerie Française en 1900*. Paris, 1901.

NAYLOR, Gillian. *The Arts and Crafts Movement*. London, 1971.

NEWARK MUSEUM. Silver in Newark. *Newark Museum Bulletin*, 1966.

PETER, Mary. *Collecting Victorian Jewellery*. London, 1970.

RAINWATER, Dorothy T. *American Silver Manufacturers* (facsimiles of marks and trademarks). Hanover, Pennsylvania, 1966.

READE, B. *Alphonse Mucha and Art Nouveau*. H.M.S.O. for the Victoria and Albert Museum, London, 1964.

ROCHE, J.C. The history, development and organisation of the Birmingham jewellery and allied trades. Suppl. to *Dial*, 1927.

ROSS, M.C. *Fabergé and his Contemporaries*. Cleveland Museum of Art, 1965.

SCHMUTZLER, R. *Art Nouveau*. New York, 1962.

SMITH, H.C. *Jewellery*. London and New York, 1908; repr. London, 1973.

SNOWMAN, K. *The Art of Carl Fabergé*. London, 1953.

STEINGRABER, E. *Antique Jewellery, 800–1900*. London, 1957.

SUTHERLAND, C.H.V. *Gold*. London, 1959.

TWINING, Lord. *A History of the Crown Jewels of Europe*. London, 1960.

VEVER, H. *La Bijouterie Française au XIXe Siècle*. Paris, 1904–08.

WOODHOUSE, C.P. *Victorian Collector's Handbook*. London, 1971.

Exhibition Catalogues

AGNEW'S, London. *René Lalique.* 1960.

BIRMINGHAM MUSEUM AND ART GALLERY, Birmingham, England. *Gemstones and Jewellery.* 1960.
Birmingham Gold and Silver, 1773–1973. 1973.

COOPER UNION MUSEUM, New York (Cooper-Hewitt Museum of Design). *Italian Drawings for Jewelry* (intro. Rudolph Berliner). 1940.
Nineteenth Century Jewelry. (intro. William Osmun). 1955.

FINE ART SOCIETY, London. *Nelson Dawson.* 1899.
The Arts and Crafts Movement. 1973.

HOTEL SOLVAY, Brussels. *Le Bijou, 1900.* 1965.

KUNSTGEWERBEMUSEUM, Berlin. *Werke um 1900.* 1966.

METROPOLITAN MUSEUM, New York. *19th Century American Furniture and other Decorative Arts.* 1970.

ÖSTERREICHISCHES MUSEUM, Vienna. *Die Wiener Werkstätte, 1903–1932* (facsimiles of marks). 1967.

PRINCETON UNIVERSITY ART MUSEUM. *The Arts and Crafts Movement in America, 1876–1916.* 1973.

REUCHLINHAUS MUSEUM, Pforzheim. *Goldschmeidekunste des Jugendstils.* 1963.

ROYAL ACADEMY, London. *Vienna Secession, Art Nouveau 1897–1970.* 1971.
Victorian and Edwardian Decorative Art, the Handley-Read Collection. 1972.

VICTORIA AND ALBERT MUSEUM, London. *An Exhibition of Victorian and Edwardian Decorative Art.* 1952.
Victorian Church Art. 1971.

WORSHIPFUL COMPANY OF GOLDSMITHS, London. *International Exhibition of Modern Jewellery.* 1961.
Omar Ramsden, 1873–1939. 1973.

Periodicals

Art Journal. 1848–1916. See also the *Art Journal Illustrated Catalogues,* souvenir catalogues of the international exhibitions from 1851.

La Renaissance de L'Art Français, vol. 6, 1923 (modern French jewellers).

Studio, monthly magazine of art. Founded 1894. See also the *Studio* special number, The Art Revival in Austria (1906); and the *Studio Yearbook of Decorative Art* (1909).

Index

Page numbers in *italic* numerals indicate references contained in picture captions.